Herbs

for the Pacific Northwest

Herbs

for the Pacific Northwest

Moira Carlson

STELLER
press limited

Published by
Steller Press Limited
1 – 4335 West 10th Avenue
Vancouver, British Columbia
V6R 2H6

Illustrations by Moira Carlson

Printed in Canada

Canadian Cataloguing in Publication Data
Carlson, Moira
 Herbs for the Pacific northwest

 Includes index
 ISBN 1-894143-05-1
 1. Herb gardening—Northwest, Pacific 2. Herbs—
 Northwest, Pacific I. Title
SB351.H5C37 2000 635.7'09795 C00-900217-0

For Barry

More in the garden grows
Than the gardener sows.
—Spanish folk saying

Contents

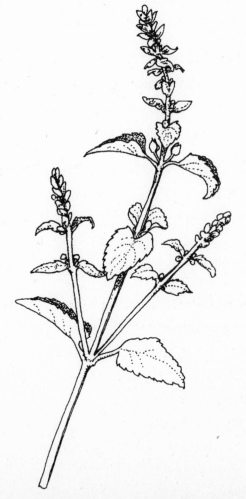

Introduction

I have always needed a connection to nature and to growing things. Even when I was living in an apartment with nothing more than a sunny windowsill I found that I could have the pleasure of growing and using herbs. My container collection of annual herbs and vegetables always expanded to fill whatever balcony or patio I had access to. Every winter the windowsills were stuffed with herbs that I was trying to winter over. In the middle of the gray city on a cold winters day I could still brew a pot of herb tea or cut fresh chives for my soup. It got me through.

When my husband and I moved to the country the containers came with me. I have a photo of myself grinning from ear to ear as I unpot sage and oregano and thyme and plant them in "real" dirt for the first time. I still use herbs in the kitchen, herbs to make teas, herbs as gifts and herbs to make sleep pillows and sachets but now there is the added pleasure of seeing how well herbs can function as landscape plants. There are herbs that I would grow even if I never used them, simply because they complete a picture; they fit into the landscape in such an attractive way.

What exactly is a herb? There is no simple answer and every herbalist with whom you speak will give you a slightly different definition. To me a herb can be annual, biennial or perennial or it can be herbaceous like Basil or shrubby like Lavender. The defining characteristic is that the plant is useful—in the kitchen, as a dye plant, medicinally or in some other fashion. These are the plants that were brought to the new world, or discovered already growing here, the plants whose history of use by mankind goes back thousands of years.

One of the wonderful things about herbs can be expressed in the words used to describe them, words like tough, hardy, carefree and low maintenance come to mind. I have no patience with finicky plants. If something is delicate, tender and requires coddling, you will not find it in my garden. Some herbs require more care than others, but most are sturdy workhorses that can give you pleasure for years with very little effort. They can also help you to experience the worlds of nature and how they interrelate in a garden. That message is reinforced when you observe the herbs that self-seed. Usually the young seedlings show up down wind of the mother plant but in a few cases, Borage is the classic example, the seedlings can show up anywhere in your garden.

Many of the herbs that I grow are not native to the Pacific Northwest. Our cool wet winters and late summer droughts can be a far cry from the conditions to be found in a herb's original habitat. Our climate allows us to grow many wonderful plants, but to do it successfully we need to take into account the herb's origins, its likes and dislikes, and then to consider how we can adapt our conditions to fit that profile. Herb books written for the English or Eastern North American gardener can be misleading or confusing because they do not taking our local conditions into account. Not everyone lives in a place where it can rain for four months and then be bone dry for two. Not everyone is familiar with heavy clay soils, acidic soils or even the mighty slug. We live in a rainforest climate. A plant that is listed as a "good groundcover" in another location can become an aggressive nightmare in the Pacific Northwest. Plants that are treated as annuals in a colder part of the country may winter-over outdoors in our climate. We need knowledge that is based on our local conditions if we are to get the most from our gardens.

I want to introduce you to a few herbs that are native to this area. For too long we have been importing plants from other countries while ignoring the wonderful plants that are indigenous to this region. Most herb books have had a very "Eurocentric" point of view. It is not that I don't think that talking about Parsley is important, but shouldn't we also be mentioning Vanilla Leaf and Salal? Not only do we have some home-grown beauties, but they have had millennia to learn to live and prosper in our particular climate.

I am lucky enough to come from a long line of gardeners. My mother was naming flowers for me before I could walk. My wonderful uncle, Tom Brawn, made every garden at the houses in which he lived into a child's paradise of rich colors, fascinating smells, mysterious paths, magic fishponds. They passed on to me their enjoyment and interest in gardening and I am forever grateful. I hope that I can cultivate and add to that legacy. I know from experience that your love of gardening and respect for nature can be passed on to your children and it is one of the greatest gifts that you can ever give to them.

A couple of experiences in the last few years have made me realize yet again how rich are the pleasures of gardening and how much there is to learn. One of these was reading Sara Stein's marvelous book "Noah's Garden: Restoring The Ecology Of Our Own Back Yards". It asks some serious questions about what we are doing in our gardens and how we can make them more 'user friendly' for the other species who share our planet and need our help if they are to survive and thrive. The other seminal experience was taking part in the Advanced Master Gardener Training Program, specifically a course on Native Plants of the Pacific Northwest taught by Richard Hebda. Richard is Curator of Botany and Earth History at the Royal British

Columbia Museum and he is an inspiring teacher. As we learned in the classroom and went on walks through VanDusen Botanical Garden's native plant collection I discovered plants that had been before my eyes all of my life but that I had never really seen and appreciated. It was a humbling and deeply moving experience.

My experience with growing herbs has all taken place here in the Pacific Northwest. Some things grew the way they said they would in the books. Some thing didn't. Some plants died because I was careless or neglectful or just plain ignorant. I sometimes thought that the only reason anything survived was because the plants were on my side. They wanted to live. I think that I have learned a few of the basics for helping them along and I would like to share those with you. Here are some of my favorite herbs. I encourage you to experience the many pleasures of growing them.

Choosing Your Herbs

One of the delights of growing herbs is that you don't need a garden—or even a balcony—to become a herb gardener. Your herb garden can be a deck, a patio or perhaps just a windowsill. Many herbs are easy to grow and are undemanding in their requirements so long as you are familiar with their basic habits and needs. You can have fresh herbs for the kitchen and you can make your own potpourris and herbal vinegars. Or maybe you have a dream of brushing past fragrant leaves on a summer's evening. With herb gardening all this and more is possible.

Most nurseries have a section for herbs, so finding the more common ones is quite easy. It does help to have an idea of the look and growth habit of the herb in order to make your selections with care. For example, if you know that a herb has a taproot, pick a smaller specimen because it will survive the transplanting shock much more easily than a larger plant. Buy your herbs for the garden in the spring or the fall when they will transplant easily and remember that the tender ones like Basil cannot manage outside if the weather is too cold. If the nursery plants are coming from a greenhouse they may have difficulty enduring chilly nights and you will want to harden them off by introducing them to the weather outdoors only gradually. Also beware of any plants that have roots thrusting out the bottom of the container. This is a sign that they have been held in that size of container too long and it will be difficult, if not impossible, to remove them without breaking off a lot of the roots.

With some of the rarer herbs you may want to look for a specialty herb nursery. Joining a garden club or a herb society is a good way of meeting people with

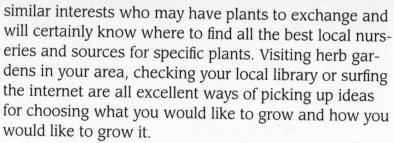

similar interests who may have plants to exchange and will certainly know where to find all the best local nurseries and sources for specific plants. Visiting herb gardens in your area, checking your local library or surfing the internet are all excellent ways of picking up ideas for choosing what you would like to grow and how you would like to grow it.

In some instances the answer is to grow the plant from seed. If the plant is rare, this may be your only choice. Often a nursery's seed packet display will offer a wider range of varieties than are offered as young plants. Seeds are also the easiest way to go for cross-boarder shopping where importing a live plant would be difficult and expensive. Finally, seeds are fun. There is a great feeling of accomplishment to growing your own from seed.

Another issue to consider is how much time you want to spend with your herbs. Although many are very easy care there is really no such thing as 'no maintenance' gardening and this is particularly true of plants in containers. I tend to go overboard in early spring having great fun potting up all sorts of herbs and other plants in containers. It becomes a good deal less fun in late August when all those containers require watering on a daily basis. If you are just starting out you would be wise to start conservatively. You can always expand your garden as you gain experience.

Doing your early planning on paper and researching the specific herbs that you want to grow before going out to buy them can save you from disasters, financial and otherwise. Once you have your herbs, keep on learning about them from the best teachers of all, the plants themselves. Regardless of what you read in a book or magazine or what is on the plant label, each garden is a unique space and your concern must be how those plants manage in your garden, under the

conditions that you provide. There is no substitute for your direct care.

Herbs for the Kitchen

If you want to plant herbs to use in the kitchen, one of the questions to ask is just how close to the kitchen can they be planted. Many cooks, myself included, cook on the fly. It is in the middle of making the soup that you realize that a bit of fresh Oregano would be the perfect addition. It is nearly always raining when you think of these things. Having the herbs that you use as close as possible to the kitchen door, either in the ground or in containers, saves time, keeps you drier and increases the chance of you really using them.

If you are buying your culinary herbs from a nursery you will sometimes run across plants that seem to have no fragrance where one should be expected. This happens particularly with plants labeled "Oregano" and "Tarragon". These plants will not develop a fragrance later and should be avoided if you plan to use them in the kitchen.

Many of the culinary herbs are very attractive and worth growing for appearance alone, but for your "kitchen door" garden give priority to the herbs that you really do use for cooking. Of course in the winter, regardless of where you garden the rest of the time, it is always a delight to have at least a few pots of fresh herbs in the kitchen. A windowsill is a good spot and if the lighting conditions aren't right you might consider adding a full spectrum florescent light. Make a list of the herbs that you already use in your cooking and the ones that you would like to experiment with. Thyme for your soup stock or Basil for Pesto Sauce? If so, then Thyme and Basil should be on the top of your personal list. The following is a list of herbs that I think are particularly useful in the kitchen but remember, this is a

matter of personal taste and my favourites may not be yours. If you are limited to growing your herbs in containers, don't worry. The majority of culinary herbs grow very well that way.

- ꙮ **Kitchen Herbs for Flavouring Foods:** Basil, Bay, Caraway, Cayenne, Chervil, Chives, Cilantro, Dill, Fennel, Garlic, Ginger, Marjoram, Oregano, Parsley, Rosemary, Sage, Savory, Spearmint, French Tarragon, Thyme
- ꙮ **Kitchen Herbs for Teas:** Agrimony, Bergamot, Chamomile, Echinacea, Ginger, Lemon Balm, Lemon Verbena, Peppermint, Spearmint, Yerba Buena
- ꙮ **Kitchen Herbs to add to Salads:** Borage (flowers & chopped young leaves), Calendula (flowers), Nasturtium (flowers), Salad Burnet, (young leaves)
- ꙮ **Kitchen Herbs—medicinal:** Aloe Vera

Herbs For the Vegetable Garden

Herbs that are annual—or are grown as annuals— can be planted right along with the vegetables they will be used to flavour. You can plant the Basil with the Tomatoes and the Summer Savory with the Beans. Borage is terrific planted in amongst some of the larger vegetables like Spaghetti Squash. In France the tradition is to grow the herbs with the vegetables and the fruits in an ornamental walled garden, the *jardin potager.* Gardeners learned long ago that herbs can help to make your vegetable garden very attractive both to you and to the bees, birds and beneficial insects that you want to attract. Some herbs, Bergamot, Borage, Hyssop and Lemon Balm as examples, are known to be particularly attractive to honey bees. I have heard that the smell of Parsley can confuse the Carrot Rust Fly so that he misses the freshly planted Carrots and that Dill goes well with broccoli. For

perennial herbs you will want an area where you will not be digging the soil each year, a section of a bed or use the herbs as a border. A number of the culinary herbs, Basil (in summer), Chives, Parsley, Thyme and Savory in particular make a very attractive edging for a vegetable bed.

I must admit to being quite skeptical about companion planting, the idea that some plants have the ability to effect the vitality of the others growing nearby. The idea that some herbs grow particularly well with some vegetables is of very long standing, and my previous mention of Basil with tomatoes and Savory with beans are examples. Marjoram is good with everything and Sage is good for cabbages but bad for cucumbers. As mentioned, none of these ideas is new and the list of what goes well together, or doesn't, is endless. In some cases it may be that a strong smelling herb, Rosemary for example, repels certain unwanted insects. People also noticed that a "bee plant" like Lemon Balm attracts pollinating insects. Just as some plants are said to get along well together, others are believed to come into conflict. Herbs like Lovage or Fennel that get big or others like Mint that have an aggressive root system are best kept out of the vegetable garden. I suspect that many of the companion planting ideas are really a combination of good observation and common sense. If you are interested in knowing more about companion planting, I suggest starting with Louise Riotte's very comprehensive book on the subject "Carrots Love Tomatoes".

Since bees and other pollinators are so important in fruit and vegetable gardens, it is worth making a note of the herbs that have a reputation as "bee plants". These are: Anise-Hyssop, Basil, Bergamot, Betony, Borage, Catnip, Comfrey, Hyssop, Lavender, Lemon Balm, Marjoram, Mints, Rosemary, Rue, Sage, Summer

and Winter Savory, Southernwood, Sweet Cicely, Thyme and Wormwood.

Herbs For The Classic Garden
The Knot Garden

The most classic of all herb gardens is the knot garden and the concept of using interwoven knots as a design element goes back to antiquity. The knot that never ends is a symbol of infinity and is used as a decorative device in Roman, Celtic, Islamic and early Christian art Its use as a design for herb gardens goes back to at least 1499 when the first known diagrams for such a garden were published in Venice. The style spread and reached its most important flowering in Elizabethan England.

In a typical knot garden the beds are laid out in geometric shapes — squares, rectangles, triangles, half circles — even star shapes have been used. These beds are bordered with the plants used for the interlacing lines of the knots, typically dwarf evergreens. Originally many different plants were used and it wasn't until the Victorians that Box species became so extremely popular. Box is particularly suitable because it grows so evenly and can easily be kept clipped and tidy and Green Box, Golden and Variegated Box have all been used. Other herbs which have been used for the knots are: Chamomile, Germander, Hyssop, Lavender, Lavender Cotton, Pennyroyal, Rosemary, Rue, Southernwood, Thyme, Winter Savory and Wormwood.

The idea is to choose herbs that are compact in habit, can withstand regular pruning and are of a variety of colors and textures so that the ribbons of the knot pattern are easily distinguished. Knots can be closed, with the various ribbons interlaced so that the knot can not be walked within, or open, with ribbons that do not interlace. In this type there would be tidy

paths between the beds, a pleasant part of the design, as well as adding to the ease of maintenance and harvesting. In these early knots the interior portion of the knot was often filled with colored gravels, pebbles or shells to show off the carefully clipped edges of the knot. Later it became more popular to fill these areas with a variety of herbs. By the 17th century the term "knot garden" referred to a garden with hedged, geometric beds which could be filled with herbs, vegetables, flowers or a combination of these plants.

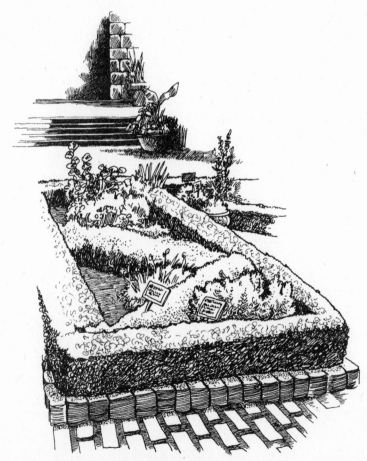

Herb Garden
VanDusen Botanical Garden

The classic knot garden is an appealing formal style and can be a most effective way of showing off your herbs. It can be a good style for a small garden where the regular lines, well delineated paths and tidy appearance can make the space look larger than it really is. If you want to display your herbs in this way the first step is to look at a variety of patterns for these gardens. Find books on 16th and 17th century English gardens or, easier still, go on the internet and do a simple search on "knot garden". This will pull up a variety of photos and information about knot gardens all over the world. Then plan out your design on graph paper, using a few colored pencils to delineate the various ribbons of the knot. Once you have your design you can get out in the garden with stakes and string and start marking out your beds. Here are several additional points to think about:

Simple is Better: It isn't necessary to use every single shape ever used for knot gardens nor is it required that the knot be overly complicated. Particularly in a relatively small space a simple design will look better and be far easier to maintain.

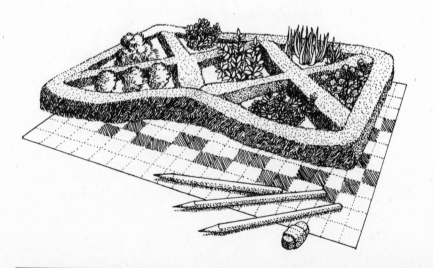

Focal Point: As much as our eyes appreciate the symmetry of a good knot design, we still psychologically have a need to know where to look. This type of garden looks its best when there is an interesting focal point to the design. Try incorporating a sundial, birdbath, a lovely pot or some taller element, a plant grown as a standard for example, into your design. Standards are taller perennial plants that are pruned so that they have a single bare stem and a round and dense head of leaves on the top. Box, Bay, Holly, Privet, Roses and Rosemary are all good candidates for this treatment. You can choose your focal point and then place your beds of herbs symmetrically around it.

Viewing Point: Originally knot gardens were designed so that they could be seen from a higher vantage point, a castle window perhaps. Seen from above the design can be picked out easily—not always the truth when you are at ground level. Consider siting your knot garden so that it can be appreciated from a higher viewing point, perhaps a window of your house.

The Site: Choose a site for your knot garden that gets as much sun as possible and has good well drained soil. Remember that before you start on the beds the ground should be absolutely level.

Choice of Herbs: The herbs for the beds are usually small and compact and, as mentioned, the lines of the knot are best picked out in a plant that is evergreen and will take to regular pruning without difficulty. The plants for inside the knots are often designed with a particular theme in mind—culinary herbs, a dyer's garden, a fragrant garden, a medicinal herb garden—the choice is yours and can be entirely personal. You might choose to use a larger plant like Fennel inside a knot and this could also serve as a focal point. When choosing herbs, think about their various colors, textures and growth habits.

Using Box as an Edging: Since Victorian times Box has been the classic edging plant but be careful about the variety of Box you choose. (see Page 101 for more information about Box varieties) Your edging plants should be planted about 1 foot (.3m) apart and then left to grow until they start to touch each other at a height of about 2 feet (.6m). At this point clipping can start by evening off the tops of the plants. Be sure to water thoroughly after pruning, particularly in warm weather.

A Word of Caution: Before going ahead with your garden there are two other considerations to take into account—expense and time commitment. Knot gardens can be fairly expensive to put together so budget carefully. Those bulk quantities of dwarf evergreen plants that you will need for your knots are not cheap. Also, remember that a knot garden requires a level of tidiness, cleaned paths, pruned shrubbery , that demands an ongoing commitment to maintain. This style may look very spare and clean but it is certainly not low maintenance.

The Wheel Garden and the Square

If you are attracted to classic garden styles and think that they would work well in your garden, you are not limited to variations on the knot garden. Think about clean spare lines, geometric shapes and objects placed symmetrically and you can soon create a formal or semi-formal look. One other classic way to place herbs (one that always makes me think of western pioneers and perhaps originates in America), is the wagon wheel. A large wooden wheel is laid on its side and a different herb is grown in each of the spaces left between the spokes. Another look can be created by taking a space, perhaps a square or oblong and paving it—bricks in a herringbone pattern is particularly

effective—leaving square spaces at regular intervals in the paving for planting your herbs.

Herbs in the Mixed Perennial Garden

Herbs do not need to be segregated into a kitchen garden or a special herb garden. They can easily fit into a mixed perennial garden and are well suited to the cottage garden.

Many herbs do not have spectacular flowers but do have interesting shapes, textures and colors that can be a most effective addition to your garden. The tall and feathery foliage of Bronze Fennel, the medium-height delicately rounded leaves of blue-green Rue, the smaller fingers of Lavender Cotton can all add colour and interest. When considering adding herbs to your perennial garden be sure to check on the height and spread of the mature plant. Lovage for example can get to be 6 feet (1.8m) high and, in a few years if left undisciplined, can attempt to get just as wide. This might be ideal at the back of the perennial bed but be a complete disaster in the front.

Typically in a perennial garden the taller plants go to the back, the medium-sized plants go in the middle and the small plants go to the front. If you are dealing with a round bed, the tallest plants would be at the center of the circle and the plants would lessen in height from that point. This tradition is based on the very practical point that you want to be able to see what you have planted without taller plants obscuring the view.

As with any other plant, along with height and spread, color and texture, it is important to be aware of the growth needs of the individual herb. A herb that requires full sun and a sandy soil is going to want those conditions regardless of where you plant it. Observe if your perennial bed is sunny or shady and

decide if you can provide the basic care that the herb will need in this setting. Another point to consider is the ease of harvesting if you intend to use the herb in that fashion. In a large perennial bed it is necessary to maintain pathways so that you can get into the bed to work on it without stepping on anything precious. It is so easy to get carried away with the planting and to forget that in a few years when the plants have reached their mature size the spaces between them will be much smaller. Particularly if you want to be able to harvest a herb be sure to leave paths or situate it so that this will be possible with some amount of ease.

Although many herbs do not have spectacular flowers, some do and it is worth taking special note of them because they would be lovely garden plants regardless of their herbal uses. Valerian is the plant that Christine Allen, author of "Roses for the Pacific Northwest", tells me seems to stop people in their tracks as they appreciate its tall spikes of delicate and fragrant white flowers as it grows in the midst of some of her Old Garden Roses. The candidates that I would put in this "beautiful flowers" category (some annual and some perennial) are: Bergamot, Betony, Bistort, Bog Rosemary, Borage, Bunchberry, Calendula (an annual), Catmints (but not Catnip), Chives, Garlic Chives, Echinacea, Evening Primrose, Feverfew, Germander, Hyssop & Anise-Hyssop, Lavender, Nasturtium, Oregon Grape, Orris Root, Pinks and Carnations, Sage (only the old fashioned type, not the cultivars), Clary Sage, Valerian & Red Valerian, Violets and Yarrows.

The Ones To Avoid: Just as there are herbs that I would welcome in a perennial garden, there are others that I would avoid. Unless you are a glutton for punishment, you don't want to put any plant into a mixed

perennial garden that has bad habits—an aggressive rampaging root system or a tendency to self-seed absolutely everywhere. The following perennial herbs would be on the top of my list to avoid in this setting: Comfrey, Horehound, Lady's Mantle (except at an edge where its self-seeding can be controlled), Lemon Balm, all of the Mints, Salal, Soapwort, Sweet Woodruff and Tansy.

Herbs for Containers

A large number of herbs not only adapt beautifully to container growing but look extremely attractive presented this way. Single herbs in separate pots or a grouping of herbs in a single container can make an instant kitchen garden. A strawberry pot full of sun-loving Mediterranean herbs or a large container full of Echinacea or spilling over with Lady's Mantle can make a stunning addition to a deck or balcony. This is also the most trouble free way to grow herbs that need moving indoors or to a sheltered location for the winter. A look at containers would be a good place to start.

Finding Containers: Containers for plants are available in a wide range of materials — wood, concrete, terra cotta, plastic, hypertufa, stone and fiberglass resin to name a few. The container might be a free-standing tub, a grouping of attractive terra-cotta pots, the holes in cinder blocks, a hanging basket or a wooden window box. It is possible to make creative and very individual containers from items that were not originally meant to hold plants—interesting tins, wicker baskets, ceramic pots and even old shoes have all been turned into holders for herbs. Anything that can hold sufficient soil can, at least theoretically, be considered for its possibilities as a container for herbs.

When planning your garden decide if you want all your containers to look very similar or whether you

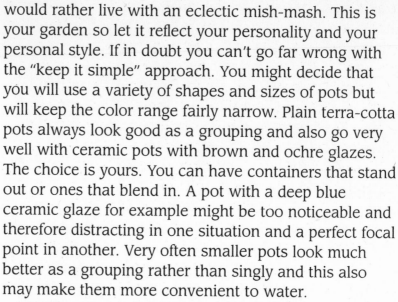

would rather live with an eclectic mish-mash. This is your garden so let it reflect your personality and your personal style. If in doubt you can't go far wrong with the "keep it simple" approach. You might decide that you will use a variety of shapes and sizes of pots but will keep the color range fairly narrow. Plain terra-cotta pots always look good as a grouping and also go very well with ceramic pots with brown and ochre glazes. The choice is yours. You can have containers that stand out or ones that blend in. A pot with a deep blue ceramic glaze for example might be too noticeable and therefore distracting in one situation and a perfect focal point in another. Very often smaller pots look much better as a grouping rather than singly and this also may make them more convenient to water.

In all cases I cannot over-emphasize the importance of good drainage. Never plant anything in a container that does not have holes in the bottom. One of the leading causes of plant death in containers is over-watering and in a closed pot the water cannot drain out and is sure to rot the roots of your plants. If you want to use a container without holes, a ceramic jar or an interesting old tin for example, place a layer of gravel in the bottom of the container and then plant the herbs in a smaller pot that has a proper drainage hole that will fit inside the larger pot and sit on top of the gravel. Never let the inner pot sit in water for more than 15 minutes after you water. Remember too that unless your plant is under a house overhang or in another sheltered space that it will be watered nat-urally when it rains. Unless you are there to rescue them, pots without holes can easily fill up and drown your plants.

The frequency of watering your container plants will depend not only on the weather and the time of year and the plant itself (since some like drier conditions

than others) but also on the type and size of container that you have used. Containers made of porous materials like terra-cotta will need watering more often than will plants in non-porous containers, plastic pots or ceramic pots with glazes for example. Very small pots will require watering much more often than larger pots will. When considering unusual containers take into account how long the container will last if it is subjected to watering on an ongoing basis. Wicker will rot out and tin will rust in only a few years.

Even if you can't prevent these problems, you can slow them down. If your containers are sitting on a deck or other hard surface, particularly if they are made of wood, you will want to provide an air space under the container for the sake of both the container and the decking. The pot or tub may come with "feet"

attached or you may want to provide them. Depending on the size and type of container you might find that a few wooden blocks or a brick or two will do the job. Quite a few nurseries now carry terra-cotta "feet" for this purpose.

Filling Containers: Big containers once planted can be very heavy, so consider moving them to the place that you want them before you fill them with potting soil. If your garden is an apartment balcony you must be aware of the weight bearing capacity of your outdoor space before proceeding. When planting up your container allowing for good water drainage is essential. Typically the drainage holes at the bottom of containers are covered with a few pieces of gravel or shards from clay flowerpots, just enough to stop anything falling out the bottom and not so tightly as to stop the water getting out. You can also put a small piece of fine mesh hardware cloth over the hole and this can have the added advantage of stopping insect pests from getting into the pot from the bottom. Now cover the rest of the bottom of the pot with a layer of gravel. Some gardeners swear that the soil in their pots stays sweeter if they add a few small pieces of crushed charcoal to this level. You can then fill the container with your soil mix.

See the section in Chapter Two for suggestions on the types of soil mixes best suited for containers. If you are filling a large container with plants that do not have very deep root systems you can fudge things a bit and make the gravel layer deeper so that you don't have to use quite so much expensive potting mix. If you are growing your plants on a balcony and are concerned about the weight of the planted container you might want to substitute styrofoam "peanuts" for some of the gravel. They make a fine drainage material and are much lighter than gravel. Remember that if you are planting up something that will grow large and tall that

the container must have some amount of weight to it for the sake of stability. If the pot is too light it can easily become topheavy. Always water your containers as soon as you have planted them up to help the herbs settle into their new home.

Herbs for Containers: Theoretically almost any herb can be grown in a container, at least for some length of time. They were, after all, in containers when you brought them home from the nursery. Some of the key questions to ask when considering a herb for a container is the mature size of the plant and the room needed for its roots. Plants with taproots need deeper containers than do plants with relatively shallow root systems. A plant that has a big root system and also grows tall will not only be unhappy in a small container but is almost guaranteed to become topheavy, causing the container to fall over and possibly break. If you want to grow some of the more invasive herbs— and growing these herbs in containers is usually the best plan—either plant them up singly or, just for fun, plant up a few of them together and watch them duke it out. Invasive plants are bullies wherever they are situated and they will take over the container if you plant them up with more peace-loving species. I would, for example, put Comfrey (only in a very large and deep pot!), any of the Mints, Soapwort and Tansy in this category.

If you are doing a herb grouping in one pot, then think of it as a tiny perennial bed, putting the tallest plant in the middle or the back (depending on where you will situate the pot) and the smaller plants in front. Some herbs are at their best when planted right at the edge of a pot because their natural habit sends them cascading down the sides in a most attractive way. Some of the herbs that tend to work well at the edge are: Catmints, Germander, Hyssop, Lady's Mantle,

Nasturtiums, Pennyroyal, Pinks (the larger and more floppy cultivars), prostrate and creeping forms of Rosemary, the Savories and most Thymes. The herbs just mentioned come in a range of sizes so not all are suitable for smaller containers.

Containers in Winter: Winter can be hard on plants and on containers. That terra-cotta pot may crack if the damp earth in it freezes and thaws a few times. A plant whose roots are above ground held in a small container is much more vulnerable to freezing than is a plant grown in the garden. Some containers, usually the larger ones, will manage just fine but many of your container herbs will need some sort of winter protection if they are to make it through the cold time. In some cases bringing the container indoors is the answer. If you plan to do this, things will be better if you do it gradually, giving the plants the opportunity to adjust to the new situation. For a few days leave the plants outside during the day and bring them inside for the evening. You should also do this in the spring when you are moving the plants outdoors. When you bring your plants indoors it is also a good idea to take a very good look at them and to segregate them from your other house plants for a few days so that any pest problems are quickly discovered and not allowed to spread.

If containers are to be left outside you will want to protect them and the plants they contain. I have successfully brought fairly small containers through the winter by burying them in the garden in soil up to the rim and then covering the top with a portable cold frame. You can also try wrapping the plant and container with a chicken wire cylinder which you stuff with straw, dried leaves or whatever insulating material is handy. This is then covered with a waterproof cover. At one point I managed to keep a half barrel of goodies doing well throughout the winter

by wrapping the barrel in old carpeting and then covering that in plastic. Sometimes the answer is to remove the plant from the pot, plant it in the garden and then store the container undercover. As long as the soil in the container is kept dry you shouldn't run in to a freezing and thawing problem. For larger containers it is a good idea to set them on a styrofoam block or equivalent so their bases are not in touch with the damp earth.

Watering Containers: Since there are so many factors to consider—size and type of pot, weather conditions, etc.—you can't make a hard and fast rule about watering. You don't want things to dry out to the point that the plants wilt and you don't want them waterlogged either. As a very general rule with most plants you will want the plant to become moderately dry before you give it a thorough watering. In the winter containers typically need less watering than in the summer and some plants have a relatively dormant period—Ginger, Lemon Verbena and Scented Geraniums as examples—and are best kept on the dry side during that time. My 'rule of thumb' is to look at and feel the soil. If I stick my finger into the pot and the soil feels dry two inches down it is usually time to water. If the pot has a saucer under it you can water from the bottom and this is generally preferable. Don't let the pot sit in water, empty the saucer of any excess water after half an hour. If you are watering from the top you will find that a watering can with a long spout is very handy as it allows you to direct the water carefully. If you are watering outside with a hose make sure that you are in control of the amount and pressure so that the soil is not blasted from the pot. The best time to water is during the morning and, particularly with containers kept indoors, make sure the water is tepid rather than cold.

Herbs To Grow Indoors

Most of the herbs that can be grown in containers can be grown indoors either year round or during the winter months although many will do better if they can be pushed outside for the summer months. The two major issues to consider in regards to bringing plants indoors are light and humidity. All plants need light to grow but some need more than others. Plants that like full sun outdoors will appreciate the sunniest spot you can give them indoors. When evaluating the possibilities, look not only at the position of your windows but also at the opportunities now made available by full spectrum fluorescent light fixtures. Even the darkest corner can become your indoor herb garden if you are willing to make the investment.

Where to Put Them

Any spot more than five feet from a window: Unless your windows are huge, these spots are almost guaranteed to have poor light levels and will likely be unsuitable for healthy plant growth.

South facing window: If the window is unobstructed you can expect about six hours of sun per day. This is the most light of any window but watch for high temperatures generated in this area. You may want to shade the window in mid-day to protect your plants. Watch for any scorching or other signs that the plants are having trouble.

West facing window: This window, if unobstructed, gets the next largest amount of light. Afternoon sun is hotter and harsher than morning sun so again, watch for scorching or any sign that the plants are having difficulty. In general a lot of plants that can manage on less than full sun will do fine in a west window.

East facing window: This window gets morning sun and many foliage plants adapt well to it.

North facing window: This window gets the least light, only suitable for shade lovers.

The other important factor to consider along with light levels is humidity. Plants need moisture in the air as well as in their saucers. One of the easiest ways to increase the humidity around plants is to place the pots in a plastic tray filled with gravel and then flooded with water. The pots sit on top of the gravel but are not in contact with the water. Keeping the pots in groupings rather than separately will increase the humidity around them. You can also get an atomizer, fill it with luke-warm water, and spritz the herbs from time to time. Fertilizer should be used sparingly, perhaps once every month in the summer and even less in the winter. Try a formulation of 10-8-22 (NPK) but read the side of the container carefully so that you can make a weak solution. This is one instance where more is not better.

When a plant growing indoors does not thrive there is a shortlist of most likely reasons: There may be too little light where the plant is situated. There may be too much heat or the atmosphere may be too dry. The pot could be too small. In the majority of circumstances you can do something to make your space more plant-friendly. If there is too little light you could move the plant to another window, add a full spectrum florescent light fixture or perhaps bump up the light using reflective surfaces (mirrors, aluminum foil etc.) If the atmosphere is too dry you can group the plants on a tray or spritz them more often. Most plants are not going to be happy for any length of time in a container that has a depth of less than eight inches so repotting may be the answer.

Here are a few tips about the individual herbs that you might want to try growing indoors. You will find more information on the individual herbs in Chapter Six.

The Herbs

- **Basil:** Likes full sun but don't let the soil dry out completely. Keep pinching back so it can't bloom or set seed. Don't try to grow it in a pot smaller than six inches in diameter.
- **Bay:** Excellent container plant. Enlarge size of container slowly as plant grows larger. Watch for scale. Be sure to harden your Bay tree off for several days before putting it outside in the spring.
- **Borage:** Manages fine in a container but does get big and rangy so don't try to plant it in anything smaller than a pot eight inches in diameter. Give it as much sun as possible and let it get very dry between waterings.
- **Catnip:** Needs moist soil. If you have a cat the plant will need protection!
- **Cayenne:** Does very well in a container, particularly if you can put it outdoors for the summer.

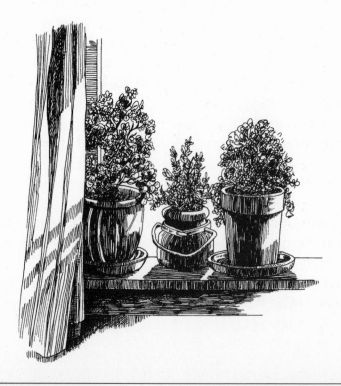

It does best in full sun. Keep it somewhat drier in winter.

- **Chervil:** Grows quite well in indirect light and does well in an east window. This would be worth a try in a north window. Put extra sand in the potting mix for good drainage. Plant from seed and then thin the seedlings to about four inches apart.
- **Chives:** Does the best if the pot is left outside for a few frosty nights before it is brought in.
- **Coriander:** Grown indoors for leaves only, not for seeds.
- **Curry Plant:** Makes an attractive foliage house plant but needs lots of sun. It is more tolerant of dry indoor air than many herbs.
- **Dill:** Sew seeds in the pot late in summer and sow fairly thickly as germination isn't always good. The pot should be at least eight inches deep and Fern Leaf Dill is the best variety. Grown indoors only for the leaves. Dill needs lots of sunlight.
- **Fennel:** Needs a big and deep container and lots of light. Never let the soil get too dry.
- **Garlic:** Garlic is best if it goes through a cold period so stick the pot outside for at least a few frosty nights if that is possible. Let the soil become quite dry between waterings.
- **Germander:** An easy care houseplant, needs sun and good drainage.
- **Horehound:** Dig out of the garden in the fall and pot up. Cut back the blossoms.
- **Lavenders:** Great container plants. Keep somewhat on the dry side over the winter and does best in a sunny window.
- **Lavender Cotton:** Makes an lovely foliage house-plant. Clip it to retain an attractive shape and give it lots of sunlight.

- **Lemon Balm:** Dig up young plant in the fall. Keep cutting it back to keep it compact. Does best with other plants where humidity is high. Does well in an east window.
- **Lady's Mantle:** The attractive leaves make this a great foliage house plant. Give it a deep container and some shade. Keep it moist in the summer and dryer in the winter.
- **Lemon Verbena:** Does well in container but will lose its leaves in the fall. Prune back in late winter.
- **Lovage:** Needs a big container. Keep it cut back.
- **Marjoram:** Keep it trimmed and compact. Needs a sunny window and a limy soil. Keep the soil drier in the winter.
- **Mints:** Take root cuttings in fall. Does well in indirect light and must be kept moist. An east facing window works well.
- **Nasturtium:** Don't put it in a pot with less of a diameter than 8 inches. Nasturtiums grow easily from seed so put several seeds in one pot and then thin the seedlings to one plant. Nasturtiums need lots of sunshine if they are to flower, slightly less if you just want the leaves.
- **Oregano:** Dig up a young plant in the fall and pot it up. Cut back to keep it compact. A small Oregano can be grown in a pot with a six inch diameter but this herb will need a larger container to grow to mature size. It does well in a south or west window, growing faster if it gets more light. Reduce the amount of water in the winter.
- **Parsley:** Soak the seeds overnight to help with germination. Once the seedlings are up they should be thinned to 4 inches apart. Consider growing several pots so that you aren't taking too much from any one container at a time.

- **Rosemary:** Prefers a sunny window and a limy soil. Keep on the dry side during the winter.
- **Rue:** Although Rue is usually deciduous when grown outdoors (depending on how mild the winter is), it will stay green if grown indoors. Rue needs lots of light and a moist soil. Clip the plant to shape it and fertilize it once a month.
- **Sages:** Easily grown in pots while young but use a container at least 8 inches in diameter. It prefers full sun but can manage in less. Add extra sand for drainage to the planting mix. Tender varieties (Tricolour, Pineapple, etc.) are excellent as year round potted plants. Watch for whitefly however.
- **Salad Burnet:** Needs a wide pot, at least 10 inches in diameter, to accommodate the crown and fairly deep for the roots. Try growing it from seed and then pinch it out so that the plant branches.
- **Savories:** Need lots of sunshine—a south facing window is ideal. Also needs good drainage. If planting Summer Savory, sow it thick and then use the thinnings.
- **Scented Geraniums:** Excellent container plants. Keep them on the dry side over the winter.
- **Southernwood:** Makes a very attractive foliage houseplant. Clip to shape and give it lots of sun. Should be kept on the dry side during winter months.
- **Tarragon:** Needs a fairly large container. Add extra sand for good drainage.
- **Teaberry:** Needs to be kept fairly cool and moist and prefers a shady window. Add extra peat moss to the soil mix and don't fertilize.
- **Thymes:** Easy in containers if given enough sun. Good drainage is important so add extra sand. Water only when the soil is quite dry.

Herbs For the Butterfly Garden

A number of herbs are very attractive to butterflies and moths and if you want to encourage them to visit your garden you may be interested in specifically growing herbs that will attract them. It is important to note that caterpillars feed on leaves and the butterflies they grow into feed on nectar, not always from the same plant. If you want to encourage butterflies you need the plants that they like through all stages of their life cycle and you must be willing to put up with a certain amount of leaf damage when they are at the larval stage. The rewards are well worth it. The following is a list of

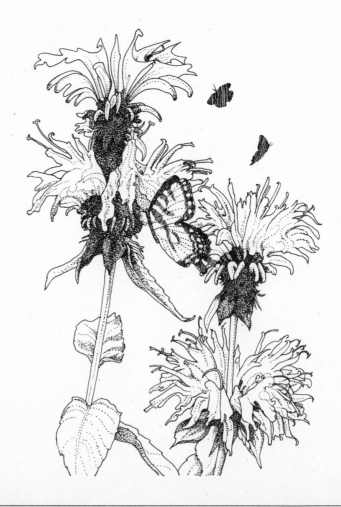

some of the herbs that appear to be particularly popular with our coastal species:

- ❧ **Larval Foods:** Borage, Dill, Fennel, Kinnikinnick, Labrador Tea, Marshmallow, Nasturtium, Parsley, Salal, Sorrel and Violets
- ❧ **Nectar Plants:** Anise-Hyssop, Bergamot, Chives, Garlic Chives, Echinacea, Evening Primrose, Garlic, Horehound, Hyssop, Labrador Tea, Lavender, Mints, Oregano, Pinks & Carnations, Rosemary, Sage, Thyme and Yarrow.

2 Some Basics

Plants For Sun and Shade

Some herbs love full sun and others prefer the shade. Some are quite flexible and will grow over a wide range of conditions even if they do have preferences. Lemon Balm for example will cheerfully grow in anything from full sun to almost total shade. In contrast Basil, if not grown in full sun, is soon unhappy and shows it by becoming spindly and disease prone. Of course I am referring to my experience growing these herbs in the Pacific Northwest. If you were growing that Basil in the sunny Southwest you would want to protect it from the noonday sun which would be too strong and could cause the plants to wilt.

When you buy herbs they often come with a tag in the pot which gives their preferred conditions. This is a good guideline, but it is still important to take local conditions into consideration. One of the benefits of gardening is that it teaches you to slow down and pay attention. Instead of considering the instructions on any tag or in any book (including this one!) as the last word, go out to your garden and pay attention to the plant. It will soon tell you if it is happy or unhappy in the conditions that have been provided. Scorched leaves, wilting plants and spindly growth are all messages from the plant about its growing conditions. As you live with the plants and gain in experience these messages will become easier to read and respond to.

Choosing the sunny and shady parts of your garden is not as obvious as it first appears to be. You can't simply walk out in the morning and make notes about which areas are in full sun and which are in shade and then assume that you now have a map of your lighting conditions. An area that is in full sun in the morning

may be in full shade in the afternoon when the position of the sun has changed and the house now blocks the light. The time of year can also make a significant difference. I have areas that are in full sun in early spring but only because the larger trees have not yet leafed out. Being as far north of the Equator as we are, we must remember that the angle of sunlight is quite different in the summer than in the winter and that this too changes the areas that are in sun or shade over the year.

Plants are living growing things and their sizes and shapes change. Over a few years a small shrub or tree will become larger and will throw much more shade than previously. One winter we lost a Japanese Plum tree to a wind storm. Over the next year I paid particular attention to that area to see how the sun and shade patterns had changed. I watched the plants that were growing there to see how they reacted to the different condition and to determine if any required moving. You can use logic and observation and make some good guesses, but there is no substitute for paying attention over time. Making notes, with dates and times included, is extremely helpful. A year's worth of notes and observations will give you a much better understanding of what is really going on in your garden.

Terms can be confusing. What is the difference between partial shade, dappled shade and full shade? My understanding, and the way I have used those terms in this book, is as follows:

Partial shade: means that the area is out of the sun during the five or six hours in the middle of the day, but may get early morning sun, late afternoon sun or perhaps both.

Dappled shade: is typically an open woodland condition where a changing pattern of shade thrown by the surrounding trees occurs throughout the day.

Obviously in some areas the "dappled shade" will be more dappled than in others. Again, it is easy to give general advice but it is your observation of the particulars of your own situation that is important.

Full shade: means that the area either gets no direct sun at all or gets extremely little—perhaps an hour in the early morning, but nothing else. Here is a list of general conditions that some of the herbs that I have mentioned prefer.

Herbs That Like Sunny Locations: Aloe Vera, Anise, Basils, Borage, Box & Oregon Box, Caraway, Cayenne, Chamomile, Chives & Garlic Chives, Coriander/Cilantro, Curry Plant, Dill, Echinacea, Evening Primrose, Fennel, Garlic, Scented Geraniums, Ginger, Hops, Horehound, Hyssop, Kinnikinnik, Lavender, Lavender Cotton, Lemon Grass, Lemon Verbena, Marjoram, Nasturtiums, Orris Root, Pinks & Carnations, Rosemary, Bog Rosemary, Rue, Sage, Clary Sage, Summer & Winter Savory, Sorrel, Southernwood, Tansy, Tarragon, Thymes and Wormwood

Herbs That Like Sun But Are Very Adaptable: Anise-Hyssop, Bay, Bergamot, Bistort, Catnip, Catmints, Costmary, Elecampane, Feverfew, Germander, Labrador Tea, Lemon Balm, Lovage, Meadowsweet, Oregano, Oregon Grape (*M. acquifolium*), Parsley, Salad Burnet, Salal, Soapwort, Sweet Gale Valerian, Red Valerian, and Yarrow

Herbs For Partial Shade: (many of the herbs in the above category would fit here as well) Agrimony, Angelica, Chervil, Comfrey and Pennyroyal

Herbs For Dappled Shade: Betony, Bunchberry, Lady's Mantle, Mugwort, Oregon Grape (*M. nervosa* and *M. repens*), Sweet Cicely, Sweet Woodruff, Sweet Violets and Yerba Buena

Herbs For Full Shade: Teaberry, Vanilla Leaf and Wild Ginger

Amending the Soil
In the Garden

I am rather fond of the old saying "If it ain't broke, don't fix it." It is impossible to know how, or with what, to amend your garden soil until you have a reasonably accurate idea of its current condition. It helps to have an understanding of basic soil quality as well as knowing how acidic or alkaline your soil is. If I had to describe a typical Pacific Northwest garden I would suggest that unless the soil has been amended it is likely to be a heavy clay poorly draining acidic soil. Although that would apply to many circumstances, you don't know if it is true for your garden until you do your own assessment. Here are the basics:

Is The Soil Acidic or Alkaline? A soil's acidity or alkalinity is called its pH and that is measured on a scale of 14, with 7 being neutral. The lower the number, the more acidic your soil is. You can find simple, practical test kits at most nurseries and if you do need to sweeten (make more alkaline) your soil, the recommended amendment is Dolomite Lime. Remember that many herbs, particularly the Mediterranean Herbs, like a soil that is in a range from neutral to sweet, sometimes referred to as a "limy soil".

What Does The Soil Look and Feel Like? For this test you need to go out to your garden and pick up a handful of typical garden soil. Squeeze this handful of soil into a ball. If it simply won't form a ball and crumbles instantly, your soil is probably on the sandy side. If the soil holds extremely well, forming a compact ball even after you have let go, it is most likely a clay soil. If the soil forms a ball but then crumbles fairly easily once you let go, you are most likely to have a friable soil in good condition. After all that work, the answer is really the same in all cases—add organic matter. Sandy soils will not hold moisture properly and

clay soils hold far too much. Clay soils are actually richer in nutrients than sandy soils, so I like them but they do need some help to open them up and make them really work for you. In both cases the addition of organic matter—compost, manures etc. will help your soil get closer to the ideal.

If amending the soil in the entire garden is out of the question, too much work and too expensive, consider the possibility of raised beds. Herb gardens do not have to be big to be bountiful and a raised bed with better soil than is available in the rest of your garden is often the solution. Raised beds are also a good answer when the 'hardpan' layer is too close to the surface or the garden is in a low spot and tends to be too boggy. Although some garden plants insist on rich, friable soil and will not perform in any less than prime conditions, most herbs are not in this group. Many will grow very well in less than optimum conditions. In fact many herbalists believe that when herbs are grown in poor soils they are richer in essential oils. This is usually true of Mediterranean herbs and the 'poor' soil tends to be on the sweet, dry and sandy side.

How Do The Plants Grow Now? This is a judgment call, but if the plants in your garden seem to grow badly or are stunted and puny and attract diseases and insect pests then your soil might be missing some important nutrients. You may want to get your soil tested at a laboratory. Any basic gardening book will give you a list of the most important nutrients, what they do and how to ensure your soil has enough of them. A book like "The Twelve Month Gardener" is particularly helpful because it deals with conditions in the Pacific Northwest.

The Mediterranean Herbs

A number of our most beloved culinary herbs come from the area around the Mediterranean where soil

conditions are quite different than what we are most used to in the Pacific Northwest. These herbs can grow successfully if we amend the soil to be closer to what they would experience in their countries of origin. Those soils are not always very rich, but they have two characteristics which we need to take into account. They are sandy and therefore fast draining and they are either neutral or alkaline when it comes to pH. We live in a rainforest climate and we get the majority of our rainfall over the winter. Many more herbs have been lost over this period because they got "wet feet" rather than because of the drop in the temperature. Good drainage is of critical importance. These herbs will not be happy growing in the low spot in your garden where water collects. If that is the only area available then consider making a raised bed or use containers. If you have an acidic clay soil, add some Dolomite Lime and Sand. Compost and manure will also help improve the drainage by breaking up the soil. Unfortunately amending the soil isn't a one shot deal. Our heavy rains are always washing the water soluble nutrients, including Lime, out of the soil. A spring amendment of Lime dug in around your Mediterranean herbs will help keep things on the sweet side. Wood ashes are naturally sweet, so if you have a fireplace or airtight stove that burns wood you can save those ashes for sprinkling around these herbs.

Along with the soil quality, these Mediterranean herbs love full sun and hot weather. Try to place them where they will get as much sun as possible. The trick here is to find a place that is very sunny but also has some protection from the wind. The wind is an important issue when it comes to winter protection. The breezes coming in from the Pacific are less of a problem than those bitingly cold winter winds that sometimes come funneling down from the Arctic. If we get

a good snowfall before the winds then the plants may be protected but our winters are so variable that you certainly can't count on this. If your herbs are in a particularly exposed spot be sure they are mulched and you might want to consider additional wind protection as well—wall, shrubs or temporary wind breaks (a portable cold frame for example) are all possibilities. Herbs that would do well with a Mediterranean type soil are: Aloe Vera, Borage, Catnip, Catmints, Chamomile, Coriander/Cilantro, Costmary, Curry Plant, Dill, Echinacea, Evening Primrose, Germander, Horehound, Hyssop, Anise-Hyssop, Kinnikinnick, Lavenders, Cotton Lavender, Lemon Balm, Lemon Grass, Marjoram, Nasturtium, Oregano, Oregon Grape (*M. aquifolium* only), Orris Root, Pinks & Carnations, Rosemary, Rue, Sage, Clary Sage, Salad Burnet, Southernwood, Tansy, Tarragon and Thymes.

Soil For Containers

A container can be thought of as a small controlled environment. Even if your garden soil is heavy and acidic, the soil in your containers can be of whatever type is most suitable to the plants that you are growing. Although you may have been amending your garden soil for years, it is still not going to be appropriate 'as is' for container plantings because it is simply too heavy and will compact far too much. The key words for successful container growing are aeration, water retention and good drainage, qualities for which you aim when putting together a soil mix for containers. If you are just starting out and don't want to mix your own soils, you are in luck. Nurseries now supply a variety of excellent soil mixes, a number of them made specifically for containers.

Another consideration is whether the soil is or is not sterilized. Sterilized soil is typically more expensive

than unsterilized but I think that it is a necessity for any container that you are planning to bring indoors. It is possible to sterilize your own soil and many basic gardening books will give you the method, but it is a messy, stinky job and best avoided. The commercially mixed soils, already sterilized and blended specifically for containers are a boon to anyone who is just starting out, is too busy or simply may not have the room or interest to start mucking about with soil additives.

If you are interested in making your own soil mixes for your containers, a fairly standard mix would be 1/3 good garden loam, 1/3 peat moss and 1/3 sand, perlite or vermiculite. Both perlite and vermiculite are much lighter than sand and this can be an important issue with large containers that need moving from time to time or if you are gardening on a balcony and must be careful about the combined weight of your container

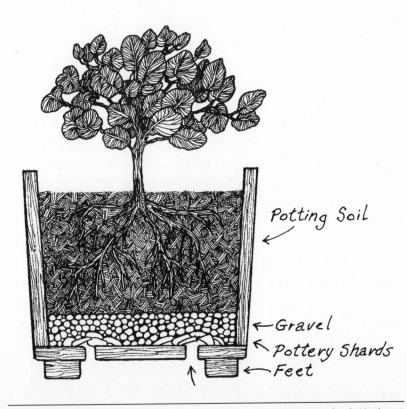

Potting Soil

Gravel
Pottery Shards
Feet

collection. Vermiculite is a flaky silicate that retains both water and air in the soil mix. Perlite is a volcanic sponge rock. It is good for aerating soil mixes but it will dry out faster than Vermiculite. Screened sand is good for drainage and aeration but it is heavy, so take this into account. Peat moss is light and retains water well, but only when it is once moistened. When it is dry it is hard to saturate and many gardeners will saturate their peat moss in warm water for several hours before adding it to the soil blend. For a container that I plan to leave outdoors throughout the year, I will get a little more creative with the mixes, very often adding screened compost and manure to the blend, but I never do this with plants that will come indoors. The indoor environment is tough enough on plants without the possibility of importing fungal or insect problems with your soil. Since peat is acidic and garden soils may be as well, I would also add a small amount of dolomite lime to the soil mix for containers which will hold the Mediterranean herbs.

Again, it will help if you keep notes on your soil mixes; what worked well and which plants in what soil blends seemed to thrive the best. Keep these same kinds of notes for your containers filled with commercial potting soil mixes, noting the brands and types that you used. Not all commercial mixes are the same—some in my opinion go much heavier on the peat moss that I think is ideal—so keep notes and buy your future supplies accordingly.

A Word About Slugs

Slugs and snails are the biggest pest problem that we have here in the Pacific Northwest. When choosing your plants it is worthwhile to consider carefully those plants that are particular slug favourites. Are you willing to spend the time and effort that it will take to protect

them? If not, you are best advised to steer clear of what will invariably be a disappointing performance. If you are willing to put some effort into the business, slugs can be controlled to some extent and you can grow their favourites. You will never get them all and obsessing over a few holes in the leaves is pointless. Just try to establish a tolerable level of damage. Here is a list of the control methods and my experience with them.

Commercial Slug Baits: Commercial baits typically use a poison called metaldehyde in a bran base. The smell of the bran is what attracts the slugs but it can also attract birds and pets. Apparently dogs are attracted to the smell of the metaldehyde itself and if they get into it they will likely die. If you are using a bait it is absolutely critical that it be put in a covered container. Perhaps the best is still the cottage cheese container which is made into a slug trap by cutting "doors" in the sides and then burying the container in the soil up to the bottom of the door. Placing the lid on the trap will keep out the rain and the pets.

Unfortunately it won't keep those big black beetles out of the trap. The beetles are a natural slug predator with a taste for slug and snail eggs. Also be careful how you dispose of the poisoned, and now poisonous, dead slugs.

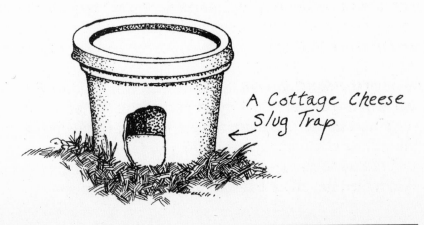

A Cottage Cheese Slug Trap

Beer Traps: This is the organic answer. Slugs are drawn to the smell of the yeast, crawl in to the trap and drown. If you have other uses for your beer you can try making up your own little batch of slug brew by mixing a bit of yeast and sugar or honey in a cup of water.

Barriers: Slugs and snails have tender tummies and they don't like crawling over gritty or sharp materials. For that reason putting a three inch wide barrier between your plant and the slug can be quite effective. The common substances used for such barriers are wood ash, lime, sawdust, crushed eggshells or diatomaceous earth but people have become very inventive on this subject. Lint from the dryer, animal and human hair and powdered ginger have all been tried. A plant barrier which has been used with some success is the hairy leaves of the Mullein (*Verbascum thapus*) plant. Don't use salt or copper sulphate because it can damage your soil. All these barriers will need checking and renewing over time. If you have a raised bed with a wooden edging that you wish to protect you can attach hardware cloth to the sides with about 2 inches sticking straight up above the wood.

Copper Tape: Copper tape works rather like an electric fence. There is an electro-chemical reaction when slugs try to cross the copper tape as the slug slime reacts to the copper and gives the slug an electric shock which usually discourages them. The tape is sticky on one side and can be used successfully around containers and small areas. Don't forget that slugs are very wily; if so much as a stick or a leaf is leaning up against the tape, enough to make a natural bridge, they will be sure to find it.

Trap Plants: There are some smells that slugs simply cannot resist and the particular fragrances of certain types of rotting vegetation are high on the list. I discovered this when I tossed a Kale leaf on a garden

bed and came back a day later to find it crawling with slugs, even though it was situated right next to a lettuce which they would otherwise prefer. Empty grapefruit or melon halves are other slug favourites and Comfrey leaves are the herbal solution. The trap plant will not kill the slug, but it will round up a bunch of them conveniently so that you can nab them.

Slug Patrol: If you have a large garden, this is the only really practical method. Slugs come out to feed at dawn or dusk although you can easily find them in the middle of the day if it is wet or overcast. There is a bit of an art to finding slugs and the whole process can be quite meditative. Patrol around the plants that you know are slug favourites. Look on the ground, in the plants and even on higher surfaces, those snails are great climbers. Wear rubber gloves if handling slugs bothers you. Friends who are concerned about the quality of the slug's death have been known to bag them and freeze them.

Propagating Your Herbs

Although many herbs are available at local nurseries, it is great fun, and a major cost saving, if you can propagate some of your own. There is also a sort of pride to it when you see a large and thriving plant that you personally grew from a seed or a cutting. Propagating your own plants also means that you have something to share, or barter, with other gardeners. My garden would not be nearly so varied and interesting if I hadn't had "trade goods" to swap with some of my gardening friends. I have an entire bed surrounded with a low Germander border, two years and many cuttings later, from just one plant bought at a nursery.

Some herbs are very easily grown from seed while others are not. Some can be grown from seed but take such a long time to germinate and then grow to any size that it hardly seems worth the trouble. Seed from any sort of hybrid or cultivar, Peppermint for example, may be sterile and certainly won't breed true. In some cases the easiest method of propagation is by dividing a plant, taking a cutting or layering. Propagation does not take a lot of expensive equipment, but it does take some knowledge of the individual plant, and plants are individuals. One type of seed may germinate easily while another may sit for months, need a cold period or perhaps a soaking in water. A cutting from a single plant may root very well at one time of the year and rot at another time. Some plants are easy to propagate and others are much more difficult.

Growing from Seed Indoors and Outdoors

Many herbs can successfully be grown from seed. Some tender herbs like Basil and Marjoram are best started indoors. Others, particularly ones with taproots

like Parsley or Angelica, are often started outdoors where they will grow so that the plant does not need to go through the shock of transplanting. Many plants can be started either indoors or outdoors although starting seed outdoors can be slow and for some herbs may not give you enough of a season. The changes in the weather alone from year to year guarantees that there are no hard and fast rules and that this isn't a static subject.

Planting Outdoors: If you plan to start some herbs outdoors be sure to prepare the soil first. This means getting out a spade or hoe and turning the soil over and making sure that it is friable and loose and that all the weeds have been removed. If the soil is not in excellent condition you may also want to add in compost, lime or other soil conditioners at this time. Before planting smooth the soil with a rake. Then make a furrow and plant your seeds, following the information given below under 'Planting Your Seeds'. Be sure to pop in a plant marker indicating the type of seed and where you have planted it. Lastly, water your herbs to settle them in. This is best done with a gentle spray—use a watering can or a hose set on a very light spray setting so that you don't wash the seeds away. Remember that the seedbed must not be allowed to dry out and, if it is not raining, keep watering on a regular basis until the seedlings appear. Then see the note below on 'Thinning Out'.

If you are planting outdoors in the fall it is sometimes sensible to plant in a container—for one thing it is easier to find next spring and for another it gives you the option of using a good container mix for your soil. I don't do this with taprooted plants, but the others are often planted in containers that will sit, buried up to their lips in soil, in what I call my "nursery bed". Be sure to label your pots with a waterproof marker.

Planting Indoors: If you want to grow plants from seed indoors you will need a place to do it with sufficient light. This might be the sun or a full spectrum florescent light fixture or a combination. It is possible to increase the light by adding reflective surfaces to the area around your seed flats and a piece of cardboard covered with aluminum foil can make an effective temporary prop for such purposes. Here are a few thoughts on the basics of indoor seed starting.

The Soil: Although I like experimenting with soil mixtures I find that using commercially made sterilized potting soil, specifically a mix that is made for starting seeds (usually called 'Starter Mix') is the way to go if you want to have a good rate of germination and healthy seedlings. A seed starting mix must be light-weight to provide air spaces and it must be able to absorb water which is essential for seed germination and plant growth. It should also be sterile. (See the note under Damping-off.)

Keep It Clean: Keeping your indoor growing environment as clean as possible can help you to avoid many problems, damping-off included. Before planting out your seeds soak your clean containers or flats in a 10% bleach solution (one part bleach to nine parts water) for half an hour. I also use this solution when scrubbing down used containers and disinfecting greenhouse tools. When you pot on your seedlings to a larger container, always scrub down that first flat before using it again.

Containers: Excellent seed starting container 'kits' are readily available. I particularly like the oblong plastic containers which hold a series of smaller flats and have a clear plastic cover. Many people use peat pots. They are very handy for herbs with taproots since they can be planted directly in the ground without the necessity of removing the pot and causing transplant

shock. The bottom line is that anything that will hold enough soil can be a container for seedlings. Egg cartons are too shallow but many a fine plant has started life in a cut-down waxed cardboard milk carton. Cottage cheese containers work well although the round shape is not always ideal if space is at a premium and you must cut holes in the bottom for drainage. Do not re-use any container that cannot be thoroughly cleaned.

When to Plant: Usually seed is planted in the spring with the general rule for indoor planting being that the more tender a plant is, the later it is started. The trick here is that you don't want to plant tender seedlings outdoors until after the last frost date, which is notoriously changeable. If plants are started too early and we have a late spring they can become too long and spindly if the light inside isn't totally adequate or

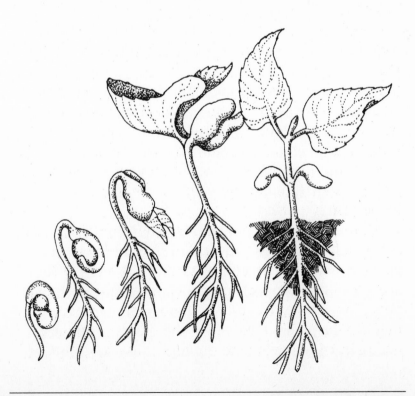

they will become big enough so that they need potting on a few times which is a lot of extra work. Remember when viewing your indoor growing space that seeds take up a lot less room than juvenile plants that must be kept inside because it is still too cold to move them out.

Some seeds need a cold period before they will reliably germinate. In nature it's easy, we call it winter. Many plants in this category are best sown outdoors in the autumn. Check the notes below for those seeds that are best sown in the fall. If you know that a plant needs a cold period but you want to plant it in the spring, the answer is to sow the seed in a flat, cover the flat with a plastic bag to keep things moist and to pop the flat into your fridge (not your freezer!) for a couple of months. Again, cold period timing can vary depending on the individual plant.

Planting the Seed: Some seeds need light to germinate and others need the dark. The most common mistake is to bury seeds too deeply. Imagine a tiny seed in nature where it might be blown away from the parent plant on the wind and would then fall to the earth and germinate with little or no cover. Another larger seed might be picked up by an animal and then buried for later use. Unless you know that a particular seed needs light to germinate, (in which case you simply sprinkle the seed on top of the soil in the flat) my general rule is to cover the seed with soil to a depth no greater than twice the width of the seed. Thus tiny seeds may need only the lightest dusting of soil on top and larger seeds will be planted deeper. When planting your seeds fill the flat with sterilized potting soil and then tamp the soil down gently. The soil mix should come to about 1/2 inch (1.27cm) below the top of the flat. The flat is now ready for sowing the seed. Try to sow the seed fairly lightly and with even distribution across the top of the flat and don't sow more than one

type of herb in any one flat. Then, if indicated, sprinkle a little more soil over the flat to cover the seed to the appropriate depth.

Watering: The seed will need moisture to germinate and it is now time to water the flat. If you are watering from the top, be very gentle so that you don't wash away the seeds. This is best done by using a spray mister full of lukewarm water. Many experts agree that watering from the bottom is a better idea and actually helps the plants to develop good roots. Stand the flat in a larger container and then fill the outer container with water to below the rim of the flat. Let the flat sit and soak for about one hour and then lift it out and let the excess water drain away.

Make it Cosy: Before a seedling emerges from the soil, the amount of light is far less important than the amount of heat. A cool soil temperature before emergence will encourage damping-off and supplying bottom heat definitely improves germination rates. Most nurseries now supply heating coils made for this purpose. Typically heating coils are kept right around 68°F (20°C). Although heating coils are the 'high tech' answer I have talked to many gardeners who have had great success starting their seed flats on top of their refrigerators. Hot temperatures (warmer than 77°F (25°C), particularly after the seedling has emerged from the soil, are not a good idea either as they can also help the damping-off fungi. A moderate temperature is ideal. Remember this also when watering your flats and use lukewarm rather than cold water.

Keep it Moist: A seed starts to germinate when water penetrates the seed coat. Seeds need a constant supply of moisture and the soil they are growing in must not be allowed to dry out. At the same time it must not become waterlogged. Until the plants emerge they need a moist atmosphere but once the seedlings

are up all that moisture can be too much of a good thing. Good air circulation is important and will, again, help prevent damping-off. I start my seeds in flats with clear plastic covers which maintains a moist atmosphere but once the seedlings emerge I take the cover off. It is quite possible to rig plastic covers for just about any container. If, for example, you are using a cut down milk container you can stick a chopstick into either side of the container and use that to hold up a clear plastic bag for a cover.

Label It: If you can't remember what things are it is difficult to know where to plant them. This sounds so obvious, but many times I have popped a few seeds into an extra flat and assumed that I would remember what I had planted. Very often young seedlings do not bear much resemblance to the adult plant so identification after emergence isn't always easy. Another good trick for getting yourself completely confused is to label things with whatever pen is handy at the time. Indelible waterproof ink is one of the better inventions of the twentieth century and availing yourself of a good waterproof marker can save a lot of later muddles. Now that you have a pen you need something to write on. Plastic markers made for the purpose are readily available but lots of people recycle by using bits of old window blinds or strips cut from plastic food containers.

Damping-off: The reason that using sterilized potting soil is so important when starting seeds is that untreated garden soil is too heavy, may contain insects and, even more importantly, may contain some of the fungi (*Pythium, Rhizoctonia* and *Fusarium*) which cause a disease known as damping-off. Seeds and small seedlings are most vulnerable to attack just before and after they emerge from the soil. Either the seedling will simply never come through the soil

or, even more depressing, it will emerge and then collapse right at the soil line. If you look closely you will discover a band of discolored tissue right at the base of the stem. Soil composition, cleanliness, temperature and moisture are all factors when it comes to damping-off. I have read that finely milled sphagnum moss added to the soil mixture or a thin layer of peat moss, vermiculite or a porous grit on top of the soil will help avoid damping off by soaking up excess moisture. There are also some commercial fungicidal preparations available. These are usually mixed with the water with which you water your seed flats. The herbal answer is Chamomile tea. Brew up a batch, let it cool and use that to water your seed flats. Which method is best? I would have to say that my own experience leads me to put the commercial preparations in the top spot, but the Chamomile tea does seem to have an impact so long as you have taken the other factors which encourage this disease into account.

Thinning Out: When the seedlings finally emerge it is tempting to get greedy and want absolutely all of them to grow. Unless you have planted very thinly or had a bad germination rate however the likelihood is that too many seedlings are competing in far too small a space. If they are to remain strong and healthy it will be necessary to thin them out and this should be done when the seedlings are about 1 inch (2.5cm) high. Very gently grasp the leaves of the plant to be pulled out and then pull straight up, hopefully not disturbing the seedlings that are to stay in the flat. As a generalization I normally do this first thinning so that no young seedling has another seedling closer than 1/2 inch (.63cm), but exact spacing will depend on the type of seedling with larger seedlings requiring more room than smaller ones.

Fertilizing: Most seed starting mixes don't contain much fertilizer, so once the seedlings are up it is a good idea to feed them. I give my plants a dilute feeding of a water-soluble all-purpose fertilizer, usually 20-20-20, when I water them. Read the side of the fertilizer box carefully as to the amount of fertilizer to use and when in doubt give less, not more. Typically I add a little fertilizer to the water about every two weeks.

Transplanting: Sometimes seedlings can stay in the flat until it is time to put them outdoors. At other times the seedling will outgrow the flat and need to be transplanted to an individual pot. Usually herbs are not transplanted until the "true" leaves have appeared. The first leaves which come up are actually the cotyledons, which is why they don't look like typical leaves of the herb that you are growing. Fill the new container with a sterilized potting soil (not Starter Mix) and make a hole for the roots of the plant to be moved.

A tool comes in very handy here such as a set of miniature greenhouse tools (spade, fork, dibber) or a small butter knife. Then, very gently holding the seedling to be transplanted by the leaves in one hand and your dibber in the other, dig out and carefully lift the plant from the soil and then lower it into the hole you have made in the new pot, lowering far enough that the roots and a bit of the stem are in the hole. Next gently push the soil so that it surrounds the stem reasonably firmly. Once the seedlings are transplanted they should be watered.

Putting it Out: Typically seeds are started in early spring and the temptation is to set the seedlings outside as soon as they are up. There is absolutely no point in starting a seed only to put the seedling outdoors too early so that it gets killed by a spring frost. When can the plant be put outdoors? It depends

on the individual plant and it depends on the year. Very tender plants like Basil and Marjoram should go out later than others like Parsley or Coriander that are hardier. Although the days may be warm in the spring the nights are often quite a bit colder and the new seedlings should not be put out before the last frosty night. When that happens depends on the year and your location. In my area the average date of the last frost is April 15, but averages can be misleading. This last spring we had frosts until the middle of May. The only answer is to pay attention to the weather in your area on a yearly basis and, if in doubt, keep the seedling indoors for a bit longer. Even when the weather warms up, plants that are going outdoors need a period of time to acclimatize. This may mean putting them outdoors during the day and bringing them inside at night for a week or two. It is during this time that cold frames and other plant protectors are so very handy as they allow you to leave the plant out-doors with a measure of protection.

Herbs to Try From Seed

- **Aloe Vera:** Sow seed indoors in late spring covered very lightly with soil. Plants will take more than a season to get to any size.
- **Angelica:** Seed must be fresh. Best planted in the fall where it is to grow or put seed flat in fridge for eight weeks. Press the seed into the soil, but do not cover. Thin plants to 3 ft. (.91m) apart.
- **Anise:** Sow outdoors in spring where it is to grow as it does not transplant well. Cover seed with 1/4 inch (.63cm) of soil. Thin plants to 6 inches (15.24 cm) apart. Do not plant too early as this herb needs warm weather.
- **Basils:** Sow indoors in late spring and cover seed with 1/2 inch (1.27cm) of soil. Germination is fairly

quick. Basil responds well to a warm situation and heating coils or a heated greenhouse works best. Ideal soil temperature is between 68–77°F (20–25° C).

- **Betony:** Sow outdoors in autumn or spring.
- **Bergamot:** Sow outdoors in autumn or spring.
- **Bistort:** Sow outdoors in autumn or spring but it is slow. Usually propagated by root division.
- **Borage:** Sow outdoors in autumn or spring, covering the seed with 1/2 inch (1.27cm) of soil. Thin to 20 inches (50.8cm) between plants.
- **Bunchberry:** Sow outdoors in fall (seeds require a cold period). Germination is slow and increase by division is more usual.
- **Calendula:** Sow indoors or outdoors in spring, covered with 1/2 inch (1.27 cm) of soil. Thin seedlings sown outdoors to 12 inches apart.
- **Caraway:** Start indoors or outdoors in spring with just a light dusting of soil as they need some light to germinate. Best planted outdoors where they are to grow.
- **Catnip:** Sow seed outdoors in autumn or indoors in spring and cover with 1/4 inch (.63cm) of soil. Thin plants outdoors to 18 inches apart.
- **Cayenne:** Sow seed indoors in spring covered with 1/4 inch (.63cm) of soil. If possible, keep seed at 75°F (23.8°C) to encourage germination. Do not put seedlings outdoors until the weather warms up.
- **Chamomile:** (Both perennial and annual Chamomiles are easy from seed) Plant indoors or outdoors in spring, covering seed very lightly. If planted indoors try to plant them out when quite young as older plants do not transplant very well.
- **Chervil:** Sow indoors for indoor growing or outdoors for outdoor growing but do not transplant. Cover with only a light dusting of soil. Seed must be fresh.

- **Chives & Garlic Chives:** Sow seed outdoors in spring covered with 1/4 inch (.63cm) of soil. Do not harvest in the first year.
- **Comfrey:** Sow seed outdoors in autumn or spring where it is to grow.
- **Coriander & Cilantro:** Sow indoors or outdoors in spring, covered with 1/2 inch (1.27cm) of soil. Sow seeds successively at three week intervals for a leaf crop.
- **Curry Plant:** Sow seed outdoors in autumn or spring.
- **Dill:** Dill is best sown outdoors where it is to be grown. Press seed into ground but do not cover as it needs some light to germinate. Sow at three week intervals for leaf crop. Thin plants to at least 8 inches (20.32cm) apart.
- **Echinacea:** Sow outdoors in spring.
- **Elecampane:** Sow indoors in spring or outdoors in autumn. Does better with a cold period. Seed looks like little 1/4 inch sticks. Lay them sideways and then cover with 1/4 inch (.63cm) of soil.
- **Evening Primrose:** Sow seed outdoors as soon as it is ripe in mid summer or purchased seed in the autumn.
- **Fennel:** Sow indoors or outdoors in spring covered with 1/2 inch (1.27cm) of soil. It is best sown where it is to grow. If started indoors, plant out before the seedlings get too big.
- **Feverfew:** Sow outdoors in spring
- **Garlic:** Plant individual cloves outdoors in autumn, covered with about 3 inches (7.62cm) of soil. Plant the clove so that the thin pointy end is upright.
- **Germander:** Sow outdoors in autumn or spring. This herb is quite slow from seed.

- **Ginger, Wild:** Seed must be fresh. Sow outdoors as soon as seed is ripe. Usually propagated by root division.
- **Horehound:** Sow indoors or outdoors in spring, covered with 1/4 inch (.63 cm) of soil. Germination is very slow.
- **Hyssop:** Sow seed outdoors in autumn or indoors in spring covered with 1/4 inch (.63cm) of soil.
- **Anise-Hyssop:** Sow seed indoors or outdoors in spring, covering only very lightly with soil.
- **Kinnickinnick:** Sow seed outdoors in autumn.
- **Labrador Tea:** Sow seed outdoors in autumn. Requires a cold period for germination.
- **Lady's Mantle:** Sow seed outdoors in autumn or spring.
- **Lavender:** Sow seed indoors in spring or outdoors in autumn. Germination is more reliable if this herb has a cold period of at least four to six weeks. Press seed into soil mix but do not cover as they need some light to germinate. Slow from seed.
- **Lavender Cotton:** Sow seed outdoors in autumn or spring. Usually propagated by cuttings.
- **Lemon Balm:** Soak seed in warm water for twenty-four hours before sowing. Sow seed indoors or outdoors in spring. Press the seed into the soil but do not cover as they need light to germinate. Seeds are fairly slow to germinate.
- **Lemon Grass:** Sow seed indoors in spring. Do not put seedlings outdoors until the weather has warmed up.
- **Lemon Verbena:** Sow seed indoors in spring. Do not put seedlings outdoors until the weather has warmed up.
- **Lovage:** Sow seed outdoors as soon as it is ripe in mid summer or in autumn if purchasing seed.

- **Marjoram:** Soak seed in warm water for twenty-four hours before sowing. Sow seed indoors in spring covered with 1/4 inch (.63cm) of soil. Seed is slow to germinate.
- **Marshmallow:** Sow indoors in spring or outdoors in fall, covered with 1/4 inch (.63cm) of soil.
- **Meadowsweet:** Needs a cold period. Sow seed outdoors in autumn.
- **Mugwort:** Sow seed outdoors in autumn.
- **Nasturtium:** Sow indoors or outdoors covered with 1/2 inch (1.27cm) of soil. Best sown where they are to grow.
- **Oregano:** Sow seed indoors or outdoors in spring, covered with 1/4 inch (.63cm) of soil.
- **Oregon Grape:** Requires cold period. Sow seed outdoors in autumn or put seed flat in fridge for eight to twelve weeks.
- **Orris Root:** Needs a cold period. Seed can be sown outdoors in autumn or put seed flat in fridge for six to eight weeks. Plants will take several years to reach any size.
- **Parsley:** Soak seed in warm water for twenty-four hours before sowing. Sow indoors in spring or outdoors. Seed sown outdoors can be sown in the autumn or early spring. Cover with 1/4 inch (.63cm) of soil. Thin plants grown outdoors to about three inches apart. Plants started indoors should be planted out while the seedlings are fairly small.
- **Pennyroyal:** Sow seed indoors or outdoors in spring, covered with 1/4 inch (.63cm) of soil.
- **Pinks:** Sow indoors in spring, covering seed with 1/8 inch (.32 cm) of soil. Thin to 2 inches (5.08cm) apart when the seedlings are large enough to handle.
- **Rosemary:** Sow seed indoors or outdoors. Seed from cultivars will not breed true. Slow from seed.

- **Rue:** Sow seed indoors or outdoors in spring, covered with 1/2 inch (1.27cm) of soil.
- **Sage:** Sow seed indoors or outdoors in spring, covered with 1/2 inch (1.27cm) of soil. Cultivars will not breed true.
- **Clary Sage:** Sow seed indoors or outdoors in spring, covered with 1/2 inch (1.27cm) of soil.
- **Salad Burnet:** Sow seed outdoors in spring or fall covered with 1/2 inch (1.27cm) of soil.
- **Salal:** Sow seeds outdoors in the fall and do not cover. Add extra peat to the soil mix. Very slow from seed.
- **Summer Savory:** Sow indoors or outdoors in spring. Press seed into soil but do not cover as they need some light to germinate. Germination is slow. Thin plants to about 6 inches apart.
- **Winter Savory:** Sow outdoors in spring or autumn, pressing seed into soil but not covering as they need some light to germinate.
- **Soapwort:** Sow seed outdoors in autumn or spring.
- **Sorrel:** Sow indoors or outdoors. Cover with 1 inch (2.54cm) of soil. Thin plants grown outdoors to about 12 inches (30.4cm) apart.
- **Sweet Cicely:** Needs a cold period. Sow outdoors in the fall or put seed flat in fridge for eight weeks. Cover with 1/4 inch (.63cm) of soil. Germination is slow.
- **Sweet Gale:** Sow outdoors in fall. Requires cold period.
- **Tansy:** Sow outdoors in spring or autumn covered with 1/4 inch (.63cm) of soil.
- **Teaberry:** Sow seeds outdoors in the fall and do not cover. Add extra peat to the soil mix.
- **Thyme:** Sow seed indoors or outdoors in spring, covered with 1/4 inch (.63cm) of soil.

- **Valerian:** Sow outdoors in autumn or spring, covered with 1/4 inch (.63cm) of soil.
- **Red Valerian:** Sow seed outdoors in autumn.
- **Vanilla Leaf:** Sow seed outdoors in the autumn.
- **Violets:** Some species are difficult. Sow outside in fall. May take two years to break dormancy.
- **Wormwood:** Sow seed outdoors in Autumn.
- **Yarrow:** Sow seed outdoors in spring where it is to grow, pressing the seed into the soil but not covering as they need some light to germinate.

The Magic of Division

Perhaps plant division could better be called 'plant multiplication'. Many clump or rosette forming herbs, or ones with rhizomatous roots, are suitable candidates for breaking up into a number of smaller pieces. With some, Bergamot as an example, the clumps need breaking up every few years in any case as they can get overcrowded and will become less vigorous if left alone.

For most plants the best time of year for dividing is either autumn or early spring. The idea is to avoid the more extreme weather conditions. Choose a day that is grey, mild and even a bit rainy, what I call "good transplanting weather". The equipment that you will need will depend on the size of the plant to be divided. A small shallow-rooted plant may take only a trowel but a big clump will need a sharp spade. Carefully dig up the root ball trying to break as few of the roots as possible. Now have a good look at the root ball and determine the best method for breaking it up. In some cases you will need to continue with the spade work, placing the spade in the middle of the clump and stamping down hard to split it apart. In other cases the roots will come apart quite easily and you can divide the clump by hand. The size of the newly divided plants will vary

by species, but each division needs a good piece of root so if in doubt go with larger rather than smaller pieces. Once divided the divisions can be potted up or replanted in a new spot. If you intend to replant a division in the spot where the original clump was growing, refresh the soil by adding compost or other additions before replanting. After planting your divisions they should be well watered. Keep an eye on them and on the weather and make sure that they receive enough moisture in the following weeks as the new plants establish themselves.

Herbs Propagated By Division

The following herbs can be propagated by division. All fall under the "best done in early spring or autumn" rule except Orris Root. This plant is best divided after it has flowered in late spring. Herbs that can be divided are: Bergamot, Betony, Bistort, Bunchberry, Catnip, Chamomile (perennial type), Chives, Garlic Chives, Costmary, Echinacea, Elecampane, Feverfew, Germander, Wild Ginger, Hops (suckers from the roots in autumn), Horehound, Hyssop, Anise-Hyssop, Labrador Tea, Lady's Mantle, Lavender Cotton, Lemon Balm, Lovage, Meadowsweet, Mints, Mugwort, Oregano, Orris Root, Pennyroyal, Pinks & Carnations, Rue, Sage, Salad Burnet, Winter Savory, Soapwort, Sorrel, Sweet Cicely (division of taproot), Sweet Gale, Sweet Woodruff, Tansy, Tarragon, Valerian, Red Valerian, Vanilla Leaf, Violets, Wormwood and Yarrow.

Taking Stem Cuttings

Many herbs can be increased by taking stem cuttings. There are basically three types of stem cuttings, all based on the maturity of the wood: softwood, semi-hardwood and hardwood, with softwood and

semi-hardwood (also called semi-ripe) cuttings usually being the easiest. Typically softwood cuttings are taken in the spring and early summer; semi-hardwood cuttings are taken in summer and early fall and hardwood cuttings are taken during the fall and winter. There are a number of factors which can have an impact on your success rate when taking cuttings but perhaps the most common mistake is to let a cutting dry out before you get it properly potted up. Here are the basics for taking a successful cutting:

Timing: Timing is important in two ways. The first is that individual plants have narrower or wider windows of opportunity when it is easiest to get a cutting to root. See the notes below on the individual plants. Secondly the time of the day when you take the cutting can have an impact. The best time is early in the day when the plants have the most water in their tissues.

Taking the Cutting: Before you take your cuttings make sure that the shears or knife that you use is both clean and very sharp. If you are taking several cuttings take a plastic bag and a water mister with you into the garden and mist each cutting and then pop it into the plastic bag immediately it is cut. (If you can't pot up your cuttings right away, put the plastic bag in the refrigerator—it should be fine for a few hours but avoid this if possible.) What you want for your cutting is normal tip growth—nothing spindly or too fat. Cuttings are usually taken at about six inches long (15cm) and each cutting should have at least 2 nodes on it. (See illustration). Cut the lower end of the cutting straight across and just below a node. Cut the upper end at an angle above a node, cutting off the growth at the tip of the shoot. This practice of angling one end of the cutting is particularly important if you are taking lots of cuttings as it isn't always easy to tell which end is up when looking at a cutting

and planting things upside-down will guarantee failure. Remove the leaves on the lower part of the cutting and dip the end to be planted in rooting hormone powder, tapping off any excess powder before planting the cutting.

Heeled Cuttings: Another common method is to take a side shoot, pulling the shoot away from the main stem so that as the shoot is detached some of the wood from the main stem will go with it. (See illustration) If the heel is long, trim it somewhat with a knife

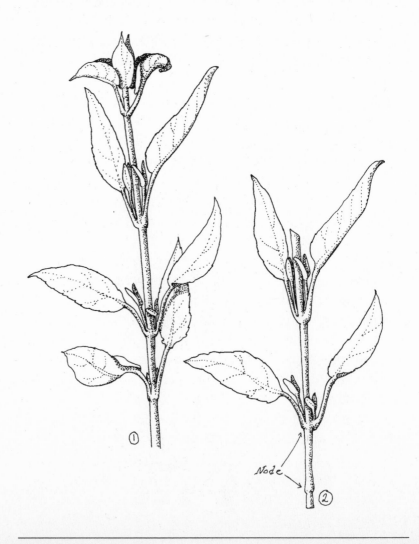

and then proceed as above, taking off the lower leaves and using rooting hormone.

Container Soil: I find that it is easier to get your cuttings started and to care for them if they are planted in a container, even if that container is to stay outside. Cuttings root best in a soil mix that is both gritty and fast draining. Use a mixture of 50% peat moss and 50% sand and have your containers ready and full of the appropriate soil mix before doing your cuttings so that the planting up process is as swift as possible. Make a hole in the soil for the cutting and after taking off the lower leaves and dipping the tip in hormone, plant the cutting up to the remaining leaves. Firm the soil around the cutting.

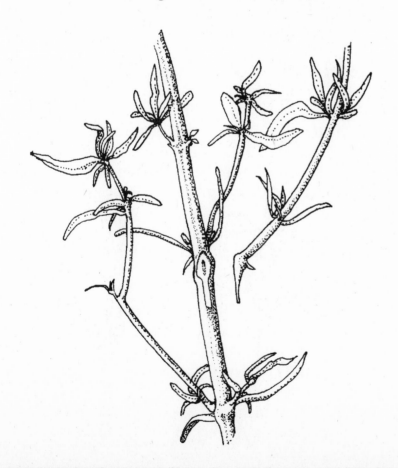

Rooting Hormone: For most herbs I use a #2 rooting hormone powder. This is an organic compound and will only remain strong and effective if you handle it properly, otherwise you are likely trying to root your cuttings in nothing but talcum powder which is quite useless. Buy a small bottle of rooting hormone since the ingredients are not likely to be active for more than two or three years and you need very little for each cutting. Keep your hormone powder bottle in the refrigerator for storage and, when you are ready to plant your cuttings just pour a small amount of powder from the bottle on to a plate, returning the sealed bottle to the refrigerator. Discard whatever hormone powder is still left on the plate when you finish planting your cuttings. If you handle the hormone powder in this fashion it can be kept active for several years and will not become contaminated.

Keep it Moist: Once your cuttings are potted up give them a good watering. As mentioned, it is important that the cuttings do not dry out and the easiest way to ensure this is to mist the plant and then to cover the pot with a plastic bag or other cover that will keep the air around the plants moist. Quite often for small cuttings I will use a pot with a 4 inch (10cm) diameter which I then cover with an upended glass quart canning jar, an instant mini-greenhouse. Place the cuttings where they will get light but are out of direct sunlight and each day take the bag (or jar) off for a few moments so that the plant gets some fresh air. At this time check for any cuttings that have obviously died or any fungal infections and remove such plants immediately.

Be Patient: How long a plant will take to root from a cutting can vary widely. When you see some new growth on the cuttings it is a good sign, but wait a little longer. If the new growth appears to be doing well then

it is time to pot up the rooted cutting. Be very careful as you loosen the soil around the new roots so that you do not disturb them more than is necessary. Then pot up each cutting in an individual container full of a good container potting soil mix. Water the new plants and leave them in a spot where they won't get direct sun until you are sure that they have settled in, and are growing well.

Herbs For Cuttings

The following notes give specific information on some of the herbs that can be increased by cuttings. The times given are for what is considered the best time to take the cutting although many herbs are easy from cuttings and will root at other times as well.

- **Bay:** Semi-hardwood, from early to mid-autumn. Notoriously slow to develop roots (can take up to a year), so be patient.
- **Box:** Semi-hardwood, from early to mid-autumn.
- **Oregon Box:** Semi-hardwood, from early to mid-autumn.
- **Catnip:** Softwood, in late spring.

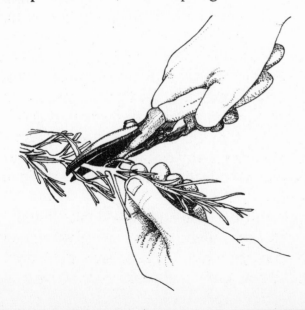

- **Chamomile:** (Perennial type) Semi-hardwood, from mid to late summer.
- **Curry Plant:** Semi-hardwood, in summer.
- **Geraniums, scented:** Use mature growth, can be taken any time between spring and early autumn. Unlike just about anything else, leave the cut ends of the cutting to dry out for a few hours before dipping them in rooting hormone and potting up.
- **Germander:** Semi-hardwood, from early to late summer; easy from cuttings.
- **Hops:** Softwood cuttings in late spring or semi-hardwood cuttings in summer.
- **Horehound:** Semi-hardwood, from early to mid summer.
- **Hyssop:** Softwood, from mid to late spring.
- **Anise-hyssop:** Semi-hardwood, from early to late summer. Take a tip cutting.
- **Kinnickinick:** Semi-hardwood, from early to late summer.
- **Lavender:** Semi-hardwood, from early to mid autumn.
- **Lavender Cotton:** Hardwood from late autumn to early winter or as semi-hardwood, from mid to late summer.
- **Lemon Verbena:** Softwood or semi-hardwood in summer. Take a heeled cutting.
- **Marshmallow:** Softwood, from mid spring to early summer.
- **Oregon Grape:** Semi-hardwood, from early to mid autumn.
- **Pinks & Carnations:** Stem tip cuttings in late spring or early summer.
- **Rosemary:** Semi-hardwood, from early to mid autumn.
- **Bog Rosemary:** Semi-hardwood, from mid to late summer.

- **Rue:** Semi-hardwood, from early to mid autumn.
- **Sage:** Semi-hardwood, from early to mid summer.
- **Salal:** Semi-hardwood, from late summer to early autumn.
- **Winter Savory:** Semi-hardwood from late spring to early autumn; heeled cuttings are best.
- **Soapwort:** Softwood, in early summer.
- **Southernwood:** Softwood in early summer or semi-hardwood from mid to late summer. Take a heeled cutting.
- **Sweet Gale:** Semi-hardwood, from mid to late summer.
- **Tarragon:** Softwood in early summer or semi-hardwood from mid to late summer.
- **Thyme:** Softwood cuttings in early summer or semi-hardwood in mid to late summer.
- **Red Valerian:** Softwood, mid spring to early summer.
- **Wormwood:** Softwood, mid-spring to early summer.

Layering

Layering is one of the easiest, although not one of the quickest, techniques for propagating plants. It works well with many perennial herbs that have stems

close to the ground. Some herbs, Thyme for example, will sometimes layer naturally. When the stems touch the ground they can develop roots and, once these new roots have formed, the new plant growing from them can be separated from the mother plant. To do your own layering, simply take a stem that is growing near to the ground and bend it down, burying a small portion in the ground and weighing or pegging it down so that it will stay in position. (See illustration.) Layering will likely have an even better chance of being successful if you slightly wound the stem by making a very shallow cut on it and dabbing the cut with rooting hormone powder before burying it. How long it will take for a layered piece of herb to establish new roots will depend on the time of year and on the plant but it can be a fairly slow process and take up to a year.

Herbs that are often propagated by layering are: Bay (start in September or October), Curry Plant, Dianthus (start in July or August), Germander, Hyssop, Lavenders, Lavender Cotton, Pinks & Carnations (start in August or September), Rosemary, Sage (start in April), Salal (start in April or May), Winter Savory, Southernwood and Thymes.

4 Saving Your Herbs

One of the delights of growing your own herbs is that the culinary and other herbs that you use need never be more than a year old. All herbs, even the ones that retain their essential oils the longest, eventually give out. When you buy herbs and spices the tendency is to hang on to them until they are used even though that bottle has been sitting on the shelf for five years and the ingredients have turned brown and have no fragrance whatsoever. When you grow your own you can renew your herbs on a yearly basis, this alone can make a huge difference in their ability to enhance your reputation as a cook!

In the first few years when I had a "real" garden, I ran around making myself a lot of "real" work when it came to harvesting my herbs. Just because it grew in my garden I felt duty bound to harvest it, preferably in vast quantities. How could you possibly have too much Oregano? I finally realized that I was not growing or harvesting herbs for the commercial market and that a major portion of those vast quantities which I had harvested were still sitting in their jars when I needed to make room for the following year's harvest. A lot of dried herbs ended up as mulch—nice mulch, but what a labour intensive way to make it! Harvesting herbs is fun, but like anything else it takes time and attention and the more herbs you harvest and the larger the amounts, the more time it will take. I suggest making a list of five or six of your favourite herbs and concentrating on them. If any additional herbs get picked and harvested it is a bonus, not a duty. Unless you choose to make harvesting herbs your business there is no reason to take on more work than you feel comfortable with. Just enjoy the herbs while they are in season and

appreciate what a long season so many of our favourites give us.

It will likely take a few years of harvesting herbs to get a feeling for how much of each herb you and your family can use in a year. You may want to give herbal gifts and that will add to the amounts of specific herbs that you will want to harvest. In our household I think that it is impossible to harvest too much Basil, but I only need a reasonably small amount of French Tarragon because I use it in few dishes and then only in small amounts. I try to harvest quite a lot of Peppermint because I love Peppermint Tea and I have never managed to harvest enough Echinacea to get through a full winter. Harvesting herbs is a learning process and if you want to save yourself work, you will learn to be realistic about the amounts that you harvest and store.

When to harvest

There are two basic rules for timing for herbs that are harvested for their leaves and flowers.

1. Don't harvest your herbs before the dew is off them in the morning and don't harvest them on a rainy day or when it has rained recently. You want the herbs to be as dry as possible when you pick them because wet herbs can easily go moldy instead of drying properly.

2. You want to pick your herbs when the sun is not so hot that it will dissipate the herb's volatile oils. The ideal time therefore is a sunny morning, just after the dew is off the plants.

In our rainforest climate you sometimes have to chose your moments and this is another reason to make sure that you first harvest the herbs that are most important to you. Think of it as a "window of opportunity" and use it wisely. That "window" will typically

appear in late June or early July but each year is slightly different.

With many herbs the volatile oils which give the most intense flavour are at their strongest concentration just before the flowers open so this is the optimum time for harvesting. As with every rule there are exceptions, and a few plants—Catnip, Hyssop, Lavender, the Mints, Oregano, Rosemary and Thyme—are best harvested when the plants are in full bloom. Annual herbs like Basil and Summer Savory that are not grown for seed can be harvested fairly severely, leaving only about 6 inches of the stem for later growth. Perennial herbs should not be cut back by more than one third at any time and this cutting can also be used to shape the herb and to keep it compact. If you have just started your herb garden, err on the side of caution when harvesting. Young plants need some time to establish themselves before they are harvested in a major way.

If you are harvesting seeds it is important to wait until the seed head is nearly but not fully ripened. In most cases (Fennel, Dill, Caraway, etc.) this will mean that the seeds have turned from green to brown but if you wait too long the seeds will scatter so watch the seed heads when they start to turn color. Herbs that are harvested for their roots are dug in the fall when the roots are plump with the food that they are storing for winter.

Drying Your Herbs

Many herbs can be dried quite easily if they are given dry conditions, shade, reasonable air circulation and a fairly warm temperature. Unless we are having a very wet and cold spell, herbs can be dried inside or out, but outside they must be out of the sun and undercover. If you are drying your herbs outside you will still need to bring them inside overnight so that they don't get

covered with dew. When you are harvesting whole branches and stems, the herb can be gathered into bundles of about eight stems that are tied together with string which can then be looped over a nail for hang drying. Be sure to label each bunch if you are doing a number of herbs so that you don't have problems identifying them once they are dried. This doesn't seem like it would be a problem when the herbs are fresh, but the dried herbs will look different and working it out by sense of smell can be tricky.

Hang drying can work well for drying outdoors and is also the easiest method if you have a spare room or attic that is warm, dry and out of the way. The place where it can be a disaster is in the kitchen. We have all seen those lovely photographs of great swags of herbs drying in a country kitchen. It makes a terrific picture but the reality is less enchanting. Drying herbs are fragile and bumping into them always makes a mess. In a kitchen setting herb bundles have an uncanny ability to pick up every bit of dust and grease in the atmosphere.

There is a method of hang drying which, although not so picturesque, eliminates most of these problems. Gather your herbs as described above and put them into a brown paper bag with stems extending out of the open end. Gather the opening tightly around the stems and wrap with string, leaving an end of string loose for hanging. Then take kitchen shears and cut enough holes in the bag to improve the air circulation (see illustration). You can write the name of the herb on the bag so you won't even need an extra label.

If you have the room, tray drying is even easier. You can dry everything this way although many people hang dry the larger herbs and then tray-dry individual leaves, short-stemmed herbs, seed heads or other smaller plant materials. Trays made for the purpose are typically

wood frames covered with wire mesh, a recycled old window screen works beautifully. Although these purpose-built trays are ideal because they allow good air circulation, I have successfully dried herbs on plain old flat trays. The secret is to not try to dry too thick a layer

of herbs on any one tray and to turn the herbs over every day or two. The cardboard flats that the nurseries give you for carrying home your purchased plants make good drying trays. The trays should be kept in a warm room in the dark until the herbs are dry. I dry my herbs until the leaves feel crisp. At this point the stalks may not be fully dry but that isn't a problem if I am stripping off the leaves. If the stalks are to be saved the drying will take a little longer. The exact amount of time it will take to dry your herbs will depend largely on the weather. It should take a couple of weeks, but if it is wet and humid outside it will take longer.

Freezing Your Herbs

Some herbs respond better to freezing than to drying, retaining more of their flavour and color. At other times freezing is simply a convenient method for processing your herbs, even if they are ones that would dry equally well. Frozen herbs will wilt once they are thawed, so they are fine in soups or for other culinary uses but won't appeal as a garnish. One handy method for later use in soups and sauces, is to puree the herb with a little water in a blender and then freeze the liquid in an ice cube tray. Once frozen, the cubes can be packed in freezer bags for storage. Another method is to gather small amounts of herbs and place them on a cookie sheet. Put the cookie sheet in the freezer for several hours and then remove the herbs and place them in labeled freezer bags. With some of the larger leafed herbs you might want to chop the leaves before freezing them. Single herbs can be frozen or you can make up mixed herb bouquets. Herbs that take particularly well to freezing are: Basil, Chervil, Chives, Dill (leaves), Fennel (leaves), Lemon Verbena, Lovage, Marjoram, Mints, Parsley, Rosemary, Sage, Winter and Summer Savory, Tarragon and Thyme.

Salting Your Herbs

Another classic method of preserving herbs is to layer them with sea salt or kosher salt in a wide-mouthed jar. For this method pick the leaves from the stems and use only the leaves. Start with a layer of salt and then a layer of herbs and then another layer of salt. Continue in this fashion until you get to the top of the jar, finishing off with about half an inch of salt. Cover the jar tightly and store it in a cool, dark place. When you want to use the herbs, remove them and shake the salt off them. Save the salt as one of the byproducts of this process is very nicely flavoured herbal salt. Rinse the leaves in water to remove the last bit of salt or, when adding them to a soup or stew just remember that you have also added some salt.

Long Term Storage

On some instances you may have dried both stalks and leaves but you only want to store the leaves. That is the case with Peppermint. Try to remove the leaves without breaking them and store them as whole as possible and this will help to retain essential oils. Crush the herbs before using, not before storing.

Once your herbs are dry you will want to store them in a fashion that will preserve the flavours for as long as possible. Herbs that are exposed to light and heat will deteriorate faster than those that are kept cool and in the dark. I keep small amounts of herbs in clear glass jars in the kitchen where I will use them, but the remainder is in the basement in a cool dark pantry. If you want your herbs for display and not to hide away in a cupboard, choose dark colored glass jars, crockery, or some other container that will not expose the herbs to the light. Remember that the jars should have tight fitting lids. If you have a dark cupboard for storage then you can get away with using clear glass jars. Since they

are hidden anyway, there are other containers that are perfectly adequate—yogurt and cottage cheese containers with tight fitting lids and old coffee cans work just as well. Again, being careful with your labeling will save you grief later on. It is a good idea to check your jars about a week after storing them just to make sure that the herbs are thoroughly dry. This is one of the reasons that I like using clear glass jars since any sign of moisture will show up on the jar. Take the herbs out of the jars and re-dry them if this is necessary.

5 Using Your Herbs

Herbs for Culinary Use

Culinary herbs are the best way I know to add a distinct and attractive difference to many dishes. The blandest omelet can be saved with Basil and just a hint of Tarragon. One of the added advantages of growing your own herbs is that you can test out a bounty of flavours and choose your own favorites with the assurance that these plants have never been sprayed with pesticides. You have control over their growing, harvesting and storage conditions. You can save them in larger pieces (thus retaining essential oils) than you usually find them in the stores and you know how fresh they are. When you have your own Sage plant for example, you can pick and dry leaves each year, discarding any leftover herb that is more than a year old. If you had bought the same herb it would likely have sat in your kitchen spice rack until it was used up, quite often long after it had any flavour left in it. Growing your own also allows you the opportunity to use a wide variety of fresh herbs as well as dried When was the last time you saw Borage flowers in the store?

When using your herbs for culinary purposes it is wise to test each batch by using 'just a pinch' before exercising a more liberal hand with them. Dried herbs can fluctuate in strength because of differences in when they were picked, how they were processed and stored and how old they are. Some herbs like Tarragon and Sage can be lovely in small amounts but overpowering if not used carefully. There are so many culinary herbs that it is easy to get overwhelmed. Ask yourself if you could only use five culinary herbs, what would they be? These should be the herbs at the top of your list for growing and harvesting.

The Fragrant Herbs

Some herbs are fragrant in the garden but quickly lose their scent once harvested and dried. Basil and Lemon Balm for example are almost always disappointing when it comes to long term fragrance. Others, and I would give the honors to Lavender, Lemon Verbena and Rosemary retain their fragrance quit well for a lengthy period. These are the herbs that are so useful in potpourris, sleep pillows, bath herb mixtures and sachets. Other herbs are included in these mixtures because of their healthful properties, Comfrey for example, and are not particularly strong smelling. These herbs are nearly always used in concert with the more fragrant herbs because our sense of smell is so important and can have such a strong impact on us. The essential oils used in aromatherapy, the thera-peutic use of scents, come from these same herbs and flowers.

Potpourris: Potpourris are typically made with a blend of different fragrant ingredients with dried flowers, herbs and spices all used to enhance the mix. Most recipes will also contain a fixing agent, the most common of which is Orris Root. The basic dry potpourri ratio is to use one tablespoon of ground spices (for example Cinnamon, Cloves or Nutmeg) mixed with one tablespoon of powdered Orris Root for every quart of dried flowers and herbs. Adding a few drops of an essential oil will also improve the blend. The mixture is then stored in an opaque container for about two months so that the fragrances can blend. Dry potpourri mixtures are also excellent for sachets. Herbs often used for potpourri mixes are: Angelica, Bay, Bergamot, Chamomile, Coriander (seeds), Costmary, Scented Geraniums, Hyssop, Lavender, Lemon Balm (as filler, not highly scented once completely dried), Lemon Verbena, Lovage (root), Marjoram, Meadowsweet,

Orris Root (fixative & fragrant), Pinks & Carnations, Rosemary, Southernwood, Sweet Cicely (seeds), Sweet Gale, Sweet Woodruff, Thyme and Vanilla Leaf.

Sleep Pillows: These are small and often prettily decorated pillows, about 8 inches square is a typical size, that are filled with sweet-smelling and sleep-inducing herbs and then tucked under your regular pillow. Often the herbs will be gathered into a muslin bag and then that bag will be tucked inside a slightly larger, and often highly decorated, cotton or linen pillow. Doing it that way makes the herbs more easily replaceable as they age. The herbs used for sleep pillows are often ones that are thought to have a soporific effect and you might use a herb like Lavender or a mixture of different herbs. The most commonly used herbs for sleep pillows are: Agrimony, Bay, Chamomile, Hops, Lavender, Lemon Verbena, Mugwort, Pinks & Carnations, Sweet Woodruff, Thyme and Yarrow.

Bath Herb Mixtures: These are herbs that are used in the bath both for their fragrance and for other life-enhancing properties—some are refreshing and stimulating, some are healing and others are relaxing and stress-relieving. If you want a strong herbal brew for your bath, the most practical method is to put your herbs in a saucepan, together with enough water to cover them, and to boil the mixture for at least fifteen minutes. You can then pour the liquid into your tub through a strainer. Gathering the herbs earlier and putting them in muslin or cheesecloth bundles which can be used as big teabags will make things even more efficient and you may want to add other water-softening ingredients like bran, oatmeal or powdered milk. These bundles also make excellent gifts. Another variation is a vinegar herb bath, said to soothe aching muscles and to soften the skin. Use about a cup of herbs (chopped) to three cups of cider vinegar, boil for fifteen

minutes and then let the mixture stand overnight before straining. This vinegar and herb mix can then be used right away or bottled and saved.

Herbs which are often used for the bath are: Bay, Bergamot, Borage, Calendula, Catnip, Chamomile, Comfrey, Fennel, Hyssop, Lavender, Lemon Balm, Lemon Verbena, Lovage, Marjoram, Meadowsweet, Mints, Mugwort, Pennyroyal, Peppermint, Rose Geranium leaves, Rosemary, Sage, Thyme, Valerian, Violets and Yarrow. If you check the notes under the individual herbs you will find information on their particular qualities. Most often you would not want to mix more than two or three herbs together and you might also decide if you want your bath mixture to be particularly relaxing or invigorating. For example, if I wanted a relaxing bath mixture I might mix Chamomile, Catnip and Valerian. If I wanted an invigorating mixture I could use Lavender, Rosemary and Thyme. If I had been overdoing it in the garden and had some sore muscles I would brew up a mixture of Comfrey, Sage and Marjoram. There are many more possibilities and making up your own mixes is great fun.

Sachets: Sachets are small cloth bags containing one herb or a herb mixture and perhaps the most popular of these is Lavender, partly for its wonderful fragrance and partly for the time the fragrance lasts without requiring a fixing agent. Lavender is also said to have insect repelling properties and this is the other use to which sachets are traditionally put. Sachets of insect repelling herbs were hung in closets and placed in drawers with clothing. If you have cats you might want to tuck a flea-repelling sachet or two under the cushions on your couch. Lavender, Lemon Verbena and fragrant potpourri mixtures all make lovely sachets if fragrance is your goal. If you want to build insect repelling sachets, the following herbs are most often

used for that purpose: Bay, Costmary, Cotton Lavender, Feverfew, Lavender, Mints, Mugwort, Pennyroyal, Rosemary, Rue, Southernwood, Tansy, Thyme and Vanilla Leaf.

Herbal Gifts

Once you grow your own herbs you have the opportunity to make some wonderful gifts for your friends and family. Herbs are also excellent trade items. I supply my sister with a selection of dried culinary herbs each year and she keeps me supplied with jars of Antipasto. Anyone moving into an apartment for the first time would be thrilled with a gift of their favourite culinary herbs, as long as those herbs are in good condition and presented well. Let's talk about that for a minute.

Dried herbs must be properly dried (see instructions on Page 71). You certainly don't want to give anyone a bag or jar of moldy greenery. If someone is just starting out they might appreciate a spice rack with a set of filled jars. If they already have their kitchen set up and their favourite herbs displayed they may not want yet more jars and bottles. In that case I would suggest packing the herbs in small individual plastic baggies with sealed tops. These can then be put together in a decorative tin, a box, a "party" bag or a pretty wicker basket for presentation. Do make sure that the herbs are well labeled. Here are some other possibilities for herbal gifts from the kitchen:

Bouquets Garnis: These are little muslin or cheesecloth bags filled with a mixture of herbs. They are used for flavouring soups, stocks, stews, vinegars, chutneys and ketchups and are meant to be removed from the finished product. Lifting a little baggy of herbs out of your stock is much easier and faster than fishing for the Bay leaves. Herbs that are most often used in bouquets

garnis mixtures are Basil, Bay leaf , Chervil, Chives, Marjoram, Parsley, Rosemary, Sage, Savory, Tarragon and Thyme. You wouldn't use all of these herbs in any bouquet garni mixture but would rather pick three or four that go well together. One of my favourites is a mixture of Parsley, Summer Savory, Lemon Thyme and Bay leaf. Using different varieties of herbs, Lemon Thyme instead of 'regular' Thyme for example, opens up still more opportunities for interesting flavour mixes. Many cookbooks mention specific bouquets garnis mixes for particular dishes. If you know someone who makes their own homemade soups and stocks, a pretty tin full of bouquets garnis bags would be a useful gift.

You should pick herbs for your gift bags that you know dry well and retain their flavour. Unfortunately a few of the herbs mentioned are good used fresh but don't dry well, Chives and Chervil in particular. A tradi-

tional *fines herbes* mixture which calls for equal parts of Chervil, Tarragon, Parsley and Chives chopped very fine for example, can be found in stores but typically the commercial method is to freeze dry the delicate herbs and this gives a much superior product than is likely to result from home drying these herbs.

Seasoning Mixes: Although getting individual herbs is good, you can also blend your own seasoning mixes. For example you can make an 'Italian Seasoning Mix' which is a real time saver when making spaghetti sauce or homemade pizza. This 'Mix' is a combination of Basil, Marjoram, Oregano, Rosemary, Sage and Thyme.

Herbal Vinegars: Herbal vinegars are easy to make and much appreciated. The classic is Tarragon Vinegar but many other herbs can be used such as Rosemary, Sage, Thyme and Bay. One of the prettiest is Chive Vinegar made with the flower heads of the Chive plant. As this brew blends the pink from the flowers comes out and stains the vinegar. For the first part of the process you will want a wide-topped jar, a quart canning jar with a tight fitting lid is ideal. You can use fresh or dried herbs but if you are using fresh herbs they should be collected on a dry day and when there is no early morning dew on them. Simply pour white wine vinegar into the jar along with about three-quarters of a cup of plant material. Tighten down the lid and leave this mixture to steep for about two weeks, turning the jar and mixing the contents every day or two. Then strain the contents, discard the herb and pour the flavoured vinegar into the bottle. Put a few sprigs of fresh herb in the vinegar for decoration—in the case of Tarragon vinegar one stalk of Tarragon is the perfect addition.

Herbal Jellies: The usual method for making herbal jellies is to start with apple jelly as a base. Rose

geranium jelly is made by laying several leaves at the bottom of each jelly jar and then filling the jar with apple jelly. Mint Jelly is made by adding about a tablespoon of freshly chopped Spearmint leaves to each jar of Jelly. These two are only the most commonly made but the possibilities are endless. Any book on canning and preserving will include a recipe for simple apple jelly.

Herbal Pickles: Although Dill Pickles are perhaps the most well known, many pickle, chutney, relish, and ketchup recipes call for a mix of herbs such as Bay, Basil, Caraway, Chervil, Ginger and so on. Freshly cut herbs make the best pickles. Sometimes these herbs are added loose and sometimes they are tied up in a bouquet garni bag for easy removal. A few jars of your gourmet pickles neatly labeled and made with your own home grown fresh herbs is a unique and lovely present.

Herbal Teas: Single herbs or your own herbal tea mixes can make lovely gifts. I do think that it is important to label these teas carefully as to ingredients because people can be allergic to some herbs or may have a medical condition which indicates that certain herbs should not be used. It is fun to blend herbs and come up with your own mixes, but here are a few of mine to get you started:

- **Lemon Mint Tea:** Combine Bergamot, Cologne Mint, Lemon Balm, Lemon Verbena, Peppermint and Spearmint.
- **After Dinner Palate Cleanser:** Spearmint, Lemon Balm, Lavender (small amount), Ginger and Elecampane (small amount).
- **Flu Season Tea:** Echinacea, Ginger, Lemon Balm and Peppermint
- **Sleepy Time Tea:** Chamomile, Lavender (small amount), Lemon Verbena and Valerian.

When considering herbal gifts, don't confine your thoughts to the kitchen. Sleep pillows, sachets and collections of bath herbs, all with descriptions of how to use the product and the plant materials used, make excellent gifts. Consult a good soapmaking book for recipes for making fragrant herbal soaps or shampoos. It is also possible to make lotions, cold creams and ointments, Calendula in particular is often used in this fashion. Remember that presentation is very important. I keep a "scrap jar" of bits of lace, pretty ribbons and other items that can be used to decorate herbal gifts. Decorative labels can be bought at most stationary stores, or if you have a computer and a printer consider making your own personalized labels. Software programs to help you with the decoration end of things and sheets of labels that can fit into your printer are widely available.

6 Introducing the Herbs

Agrimony ~

(Agrimonia eupatoria)

The skinny yellow spires of star-like Agrimony flowers are always a welcome sight in my summer garden. Agrimony is a robust perennial native to much of Europe but found all over North America growing wild. I was a bit nervous that I might be introducing a herb with rather weedy properties to my garden but that hasn't been the case. As it turns out, Agrimony does not seem to self-seed and in fact the seeds have a reputation for being difficult to germinate. Agrimony grows from 4 to 5 feet (1.2m to 1.5m) and those lovely little flowers are followed by sticky little burs which explain this plant's common names of Cocklebur, Stickwort and Sticklewort. Those yellow flower spires are the explanation for another common name, Church Steeples.

Growing and Harvesting Agrimony:

Agrimony likes a light, well-drained soil. My plant is growing in partial shade and appears to be quite content. I suspect that it will grow in a fairly broad range of conditions. Sometimes the tall flower spikes develop a distinct and rather graceful lean so you may want to stake this plant if it is growing in an area where that is going to be a nuisance. Usually I don't bother with staking but prune away any parts that are getting in the way and this has never appeared to harm the plant. Agrimony can be used fresh or the leaves can be dried. For drying the best time to take the leaves is in summer when the plant is flowering.

Aloe Vera ॐ
(Aloe barbadensis)

There has been an Aloe Vera plant on my kitchen windowsill wherever I have lived for as long as I can remember. The placement is purposeful. I want this plant ready for the minor burns and abrasions that sometimes come with cooking and preparing food. All that is required is to cut the leaf with my kitchen scissors and the soothing gel oozes out to take care of the next itchy insect bite or the next minor burn.

Growing and Harvesting Aloe Vera:

Aloe Vera is a tender perennial and is not hardy in our climate. It likes full sun and a sandy well draining soil. Let the soil dry out between waterings and keep it on the dry side during the fall and winter months. It makes an excellent container plant and it can be put outside for the summer if you wish or can be left indoors year round. Aloe Vera can be grown from seed but it is a rather slow process. It is best propagated by taking the little offshoots that grow around the base of the plant. They can be taken off and planted out as soon as they are about two inches high. As for harvesting, the leaves are used fresh so just take one as you need it, hopefully not so many that you denude the plant!

Angelica ॐ
(Angelica archangelica)

Angelica is a big, glorious sculptural plant. If it had no culinary uses and no delightful fragrance it would still be worth growing on looks alone. This giant member of the Parsley family can easily grow to 6 feet tall (1.8m) and 3 or 4 feet wide (.9m or 1.2m) and is a dramatic addition to the rear of a perennial bed. Regardless of its height, it is usually very sturdy and doesn't require staking. Angelica is usually a hardy

biennial, although if it is not allowed to flower or set seed, it can last an additional year or more. Ordinarily the plant forms a rosette of leaves in the first year and then flowers and sets seed and dies in the second year. If you want to try to get it to live longer, cut it back in May of the second year. In truth this is a bit of a shame since the plant is so spectacular when it is in bloom and the seed heads form. Angelica can make a terrific addition to your garden but it is not suitable for containers or growing indoors. This one takes up a lot of space.

Growing And Harvesting Angelica:
Angelica likes a rich, moist but well drained soil, light shade and lots of room. It will manage very well in a heavy clay soil so long as that soil is broken up with lots of organic matter so I dig manure and compost into the soil before planting my Angelica seeds. This is not a fussy plant, but I like to add a bit of bone meal or dolomite lime to the soil mix since Angelica seems to prefer a neutral or even a slightly sweet (alkaline) soil. The leaves die back in the winter, but the slightly frosty weather of our coastal climate will not bother this northern native. It would be a good herb to try in areas that get "real winter" since Angelica is reported to be able to stand temperatures below -68°F (-20° C). Since it prefers a moist soil you may want to check it if we have a late summer drought. That tap root grows deep to find the available moisture and this is a remarkably sturdy and trouble-free plant.

Angelica is usually started from seed but the seed must be fresh. Older seed is rarely viable. Try planting the seed in mid-summer or in autumn, very soon after collecting it. Since Angelica has a tap root, it is preferable to sow the seed where you mean the plant to grow although I have had some success transplanting

young seedlings. If you are buying your first Angelica as a plant from a nursery, remember the tap root and think "smaller is better". A single Angelica plant produces masses of seeds so you will have seed for as many plants as you could possibly desire once you have your first crop. If the seed heads are allowed to shatter Angelica will self-seed.

The seed heads should be harvested just before the seeds start to fall. I recommend placing the heads on a tray and then leaving them in a garage or some place outside but under cover for the first few days. The stems and leaves may be cut and used at any time and Angelica leaves can be easily dried, retaining their lovely fragrance.

A word of caution
Although varieties of Angelica grow in the wild it would be extremely unwise to try to collect and use a wild plant. Wild Angelica bears a close resemblance to the deadly poisonous water hemlock (*Cicula maculata*). There is some evidence that these two plants can hybridize if growing in the same area. Making a mistake on identification would be decidedly unpleasant.

Anise ☙
(Pimpinella anisum)
How much you enjoy Anise will depend on how you feel about licorice flavours. Anise is the queen of the herbs with this very distinctive taste that some love and some abhor. For all the familiar flavour, this herb is not actually related to 'true' Licorice root, which is a European perennial, *Glycyrrhiza glabra*. I love licorice flavours, but I must admit that I sometimes have to make do with Fennel because growing Anise is a bit of a gamble in our climate.

Anise is a warm weather annual, growing to about 2 feet (.6m) high, with feathery upper leaves and tiny white or yellow flowers. It is one of the most ancient of herbs, appreciated as both a culinary and medicinal plant by the Egyptians, Romans and Greeks.

Growing and Harvesting Anise

Anise needs full sun and a sandy soil with good drainage. It can be considered as one of the Mediterranean group of herbs (See Page 36). How well it will do here in the Pacific Northwest depends on the year. This is a plant that is better suited to hotter and dryer places. Anise is fairly slow growing and it needs at least four months of frost free weather to do much of anything in the way of seed. If you want just the leaves you are likely to have more luck. Anise has a taproot that resents being moved, so it is best to start it where it is to grow and do not plant the seed too early because this plant cannot handle any frosty weather. Once the Anise is up, thin the plants to about 6 inches (15cm) apart. The leaves can be harvested as needed. They don't dry really well but they can be frozen. Handle the seeds in the same manner that you would handle Caraway seeds.

Basils ᠉

(Ocimum basilicum, Ocimum spp.)

I grow Basil from seed every year and sometimes I think of it as an exercise in patience. The seed germinates easily and quickly but each year I have to stop myself from putting my bright green robust young seedlings outdoors too early. These plants are very tender and don't appreciate the kind of up-and-down weather conditions we often get in April and early May. It may be warm during the day but the nights are still too cool for this plant. My basic rule, learned the hard

way, is to not even think of putting the Basil outdoors until it is safe for the tomatoes.

Basil is grown around the world and comes in many sizes, ranging from about 6 inches high (15cm) to several feet high, depending on the variety. There are also a number of distinct fragrances and a range of leaf and flower colours. All the Basils are edible, but the flavours vary greatly so pick your variety carefully if you plan to use it for culinary purposes. No list of Basils could be complete since new types seem to come on the market every year, but here are a few of the most well known varieties:

- **African Blue Basil:** A sweet Camphor scent; purple leaf veins and flower spikes; used mainly as an ornamental variety.
- **Bush Basil/Globe Basil/Finissimo Verde/Tiny Leaf Purple/Piccolo Fine Verde:** Bush Basils are smaller and more compact in form than regular Sweet Basil. They are ideal for container growing as well as making an attractive seasonal edging plant.

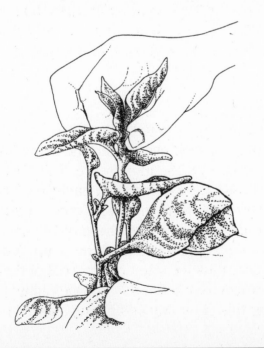

Bush type Basils typically range from 6 to 12 inches (15cm to 30cm) high depending on the particular variety.

- ❧ **Camphor Basil:** A Camphor scented Basil, usually grown as an ornamental.
- ❧ **Cinnamon Basil:** Cinnamon flavoured and about the same size as regular sweet basil with pink or purple flower spikes and bronze foliage; good for tea and dried for spice.
- ❧ **East India Basil:** Clove scented Basil; an interesting culinary herb to experiment with.
- ❧ **Genovese Basil:** This cultivar of Sweet Basil is the most famous of the Basils for making Pesto and in many opinions the best. Traditional pesto Genovese is a mix of Basil, Garlic, Olive Oil, Salt, Parmesan cheese, Sardo (Sardinian sheep's milk cheese) and Pine Nuts.
- ❧ **Lemon Basil:** Citrus flavour; a fine tea and potpourri herb and refreshing in salads. Has a fairly compact growing habit.
- ❧ **Lettuce-leaf Basil:** Has a bigger leaf than Sweet Basil and is often used for making Pesto. 'Mammoth', 'Napoletano' and 'Green Ruffles' are all cultivars of Lettuce-leaf Basil
- ❧ **Licorice Basil/Anise Basil:** an Anise flavoured Basil; makes a nice tea.
- ❧ **Opal Basil/ Dark Opal Basil/ Purple Ruffles:** Typical Basil flavour with pink flowers and purple foliage.
- ❧ **Sacred Basil:** A Clove scented Basil with narrow leaves and pink flowers, typically growing about 20 inches (50cm) high. This plant grows very evenly and would make an excellent specimen container plant for a sunny area.
- ❧ **Sweet Basil:** The basic and most well known form of Basil, used for many culinary purposes.

↝ **Thai Basil/Siam Queen:** An Anise flavoured Basil used in Vietnamese and Thai cooking. It has a darker leaf than Sweet Basil.

Sweet Basil's real claim to fame is as a culinary herb. It is used in salads, soups, stews and sauces, takes the starring role in Pesto Sauce, and is one of the staples of Italian cooking. Indeed no dish featuring tomatoes is complete without it. The relationship of Basil to tomatoes even extends to the garden where it is believed that Basil planted next to tomatoes will improve their vigor and flavour.

Growing and Harvesting Basil:
Basil likes a rich, moist but well-drained soil and, in our coastal climate, will benefit from as much sun as you can give it. The growing tips should be pinched back to make the plant bushier. If Basil flowers it will set seed, so remove all the flower spikes to prolong your harvest. In the middle of the summer you can cut your entire plant by about two-thirds and let it bush out again.

Unfortunately slugs also like Basil so a few precautions are necessary, particularly with young plants. I plant all my Basil in containers which are banded with copper tape. (See Page 40). If you have cutworms in your garden you will want to put a cutworm collar (a halved toilet paper roll works well) around your young Basil plants when you set them out. This stops the cutworm from wrapping himself around the stem for a good feed.

One other problem that Basil sometimes runs into is the fungal disease, Fusarium Wilt. As with most fungal diseases this one is spread by wind and rainy weather so it is hardly surprising that it should be a problem on the 'wet coast'. The disease causes nasty black patches to appear on the stems and leaves of the Basil and

there is no cure. Plant material exhibiting these signs should be removed and destroyed immediately; bag it and put it in the garbage, not the compost pile.

Fresh Basil can be harvested throughout the season and it is much superior fresh to dried. Basil still retains its flavour quite well when the leaves are frozen and many people make their supply of Pesto when the Basil is freshly harvested and then freeze the sauce in batches for later use. If the plant is in a container it can be brought inside before frost to live on a sunny windowsill. As long as the flowers are removed it will last for several additional months but sooner or later will become sickly and should be disgarded.

Bay ঌ

(Laurus nobilis)
There is an ongoing argument amongst herbalists in the Pacific Northwest as to the hardiness of Bay. In my opinion, Bay should be hardy if you can grow it in a well sheltered spot within ten miles of the ocean. Otherwise you will be likely to lose it if it is left outside during one of our colder winters. You could try mulching it heavily and in a mild winter it might die back to the roots and then shoot up again in the spring but Sweet Bay cannot be considered reliably winter hardy in our area. The good news is that Bay takes so well to container growing.

Bay, also known as Sweet Bay, Roman Laurel, Nobel Laurel and True Laurel, is a member of the Laurel family. In its native habitat of the Mediterranean it can grow to 60 feet (18.2m) or more but in a container it will rarely get larger than 10 feet (3m) and can be kept much smaller by pruning and shaping.

The Laurel family is large, containing over 2,000 species of trees and shrubs, many of them aromatic and most of them poisonous. It is therefore very impor-

tant that your identification of Sweet Bay be accurate. To confuse the issue some plants are called Laurels when they are not members of this family. The California Laurel (*Umbellurlaria californica*) also called Bay Laurel and Oregon Myrtle, is an example. You can use leaves from this tree as a Bay substitute although Bay has a stronger and better flavour. Bays, like Hollies, are either male or female. In sunnier and warmer climates female Bay trees bloom in the spring and the white flowers are followed by purple berries which turn black as they age. Apparently it is quite rare for a container grown Bay plant to bloom and mine never has.

Sweet Bay is a necessity in the kitchen. The flavourful leaves are added, and then usually later removed, to stocks, soups, stews, pickles and marinades. Bay is usually pest free except for Scale, the one insect that appears not to have read this herb's press as an insect repellent. Look for tiny shell-shaped lumps on the bark. These are caused by small insects that secrete a hardened shell over themselves as they feed from the plant's sap. Pick them off by hand or use insecticidal soap.

Growing and Harvesting Bay

When my Bay container is outside in the summer I keep it in a spot that is generally sunny but gets a bit of shade during the hottest part of the day. If you notice any leaves scorching, move your plant to a shadier spot. In the winter Bay prefers a cool room.

The soil should be rich, peaty and well-drained. I use a good container mix and then add extra peat moss and sand. In the summer I water the Bay container fairly regularly but in the winter I let it dry out a bit between waterings. Bay seeds do not germinate easily so the usual method of propagation is by cuttings or layering and if you want to try cuttings, take them in

the early fall as they can take up to a year to root. Buying it from a nursery may be more expensive than other similar-sized herbs, but that is acceptable considering the difficulties of propagating it.

Bays can be pruned in the spring or early summer and individual leaves can be harvested at any time to be used fresh or dried. Do not dry the leaves in the sun as this will cause them to turn brown and lose the essential oils. The leaves lose their fragrance as they age so preferably you should replace your stock every year or two.

Bergamot ❧

(Monarda didyma)

Bergamot has an astonishing number of common names. If someone mentions Oswego Tea, Bee Balm, Fragrant Balm, Red Bergamot, Scarlet Monarda, Indian Plume or Mountain Mint they are quite likely talking about the plant known botanically as *Monarda didyma*.

Bergamot is native to eastern North America, where it is often found growing along creek banks in clumps to about 4 feet (1.2m) in height. It is such a good looking perennial with its fragrant leaves and glorious flowers that it is now grown around the world as a popular ornamental plant. Bergamot is fully hardy in the Pacific Northwest and also adapts well to outdoor container culture. I planted a big container with a Bergamot in the middle and then surrounded it with a variety of Thymes and a Parsley or two that I knew would flop over the edges of the pot and in July, when the Bergamot came into bloom, it was a delight.

Growing and Harvesting Bergamot

Bergamot likes full sun and a rich moist but well-drained soil. This herb is a bit more selective about soil than it is about light and it manages very well in light

shade although you won't get as many flowers. Watch your Bergamot clumps in August if the weather is droughty because they will appreciate extra watering but, since this herb does not appreciate wet soils in winter, do not make the mistake of trying to grow it in soils that are too boggy. Bergamot is a member of the Mint family, and while not nearly as wildly invasive as a true Mint it should be watched as roots will be sent out from the edges of the clump particularly if it is in a rich soil. Since it is fairly shallowly rooted it is reasonably easy to pull up any Bergamot that is getting too aggressive.

Bergamot can be grown from seed or by division of the roots in spring or autumn. Every three or four years the Bergamot clump will start getting bare in the center and should be renewed. So, dig it up and divide the root mass, tossing out the middle of the clump and planting some of the smaller divisions from around the edges. Either plant them somewhere new or revitalize the soil before replanting with compost or manure. Bergamot leaves dry easily and retain their fragrance well.

Betony ⌁

(Stachys officinalis)

There are about 300 species in the Stachys genus but perhaps the best known plant as far as most gardeners are concerned is Lamb's Ears (*S. byzantina*), whose white woolly leaves do indeed look and feel like the downy ears of a young lamb. Less woolly but still quite hairy and perhaps of more interest to the herbalist are the group of plants known collectively as 'Woundworts'. These are Marsh Woundwort (*S. palustris*), Hedge Woundwort (*S. sylvatica*) and Betony (*S. officinalis*), also known as Bishopswort, Wood Betony and of course, Woundwort. As the name would imply, all three of these herbs have been used to help heal open

wounds, usually in the form of a poultice. Of the three, Betony is the most interesting and attractive.

Betony grows to a height of about 2 feet (.6m) and the red-purple flower spikes that bloom in mid-summer are quite beautiful and much loved by bees. This is a plant of shady and damp woodlands and if you have such a spot this hardy herb could be a handsome addition to a perennial border.

Growing and Harvesting Betony

Betony will handle a fairly wide range of conditions, but its preference is for dappled shade and a rich moist but reasonably well-drained soil. It can be propagated by seed or by root division in the spring or autumn. The part used medicinally is the leaves and they are best gathered for drying just as the plant is beginning to flower.

Bistort ✍

(Polygonum bistorta)

Bistort is one of those plants that I grow purely for looks although its history as a famine food and herbal medicine is lengthy. I have the variety 'Superbum', which has big arrow-shaped leaves and tall pink flower spikes which look rather like bottle brushes. They are a terrific addition to a perennial border.

Growing and Harvesting Bistort

Bistort is completely hardy in our climate, preferring acid, rather boggy wet soils. I believe that it will take either sun or shade, but my plant has a definite preference for sunlight. I suspect that it would grow quite well in dappled shade but you wouldn't get so many flower stalks. The easiest way to propagate it is by root division in spring or fall. Leaves can be harvested at any time.

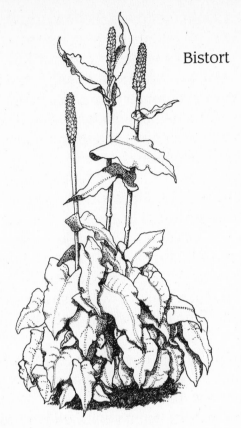

Bistort

Borage

(Borago officinalis)

Borage is a gypsy. Other herbs may self-seed around the mother plant but Borage is much more of a rambler, once planted it may show up just about anywhere in your garden in following years. I assume that this magic trick occurs because the birds like the seeds but every year I look forward to seeing where it has decided to grow this time. The first time that I planted Borage seed in its own little plot the plants germinated easily but although the blue flowers were wonderful, the plants themselves were big , growing 2 to 3 feet (.6m to .9m)—lanky, very floppy and not particularly attractive. I decided to give up on Borage but happily the Borage didn't give up on me.

Borage is said to increase the resistance to pests and diseases of the plants growing near it, so having it in the vegetable garden is rather a good idea. If I was planting it today I would pop it in amongst plants of equal size in a vegetable or perennial garden, somewhere where most of the foliage would be hidden and you would simply get the effect of those brilliant blue flowers flashing out here and there. If the Borage decides to grow somewhere completely unacceptable just pull it out. This herb has a shallow root system and is easily removed when necessary.

Lovely star-shaped blue Borage flowers have been a popular candied decoration for cakes and desserts and the fresh flowers are a stunning addition to salads or drinks; the blue petals pull away easily from the rest of the flower head, the calyx, if you grasp them by the black center and pull gently. (See illustration) Don't do this until just before you need them in order to prevent wilting. Young Borage leaves are hairy, and not at first glance something that you might think to eat. The taste is excellent however, being very similar to cucumber and with a similar cooling effect.

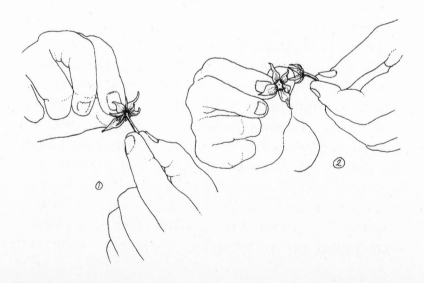

Growing and Harvesting Borage

Borage is one of the Mediterranean herbs liking sun-shine and a sandy soil (see page 36) although it is quite adaptable and far from finicky. The seeds germinate easily and this plant will self-seed prolifically, although not necessarily where you think it will. Although you might want to try to dry some leaves, Borage is much better fresh and the leaves lose their flavour fairly quickly when dried. Although Borage has been con-sumed for centuries with seemingly no ill effect, there is some modern research which suggests that it could be harmful in very large doses.

Box & Oregon Box ௸

(Buxus sempervirens & Pachistima myrsinites)
I have experimented with using all sorts of herbs as edging plants, Catmints, Germander, even Golden Oregano, but English Box or Boxwood (*P. sempervirens*) is the classic for this purpose. Photos of herb gardens and knot gardens nearly always include this compact evergreen as a border or hedging plant. Box is native to southern Europe, Eurasia and North Africa and gained its name because the wood was so useful for making fine wooden boxes, chess pieces and musical instruments.

Here in the Pacific Northwest we have a native plant, Oregon Boxwood (*P. myrsinites*) that deserves much more attention. Oregon Boxwood grows from British Columbia south into California and Mexico and east through the Rocky Mountains. This plant, with its small lush green glossy leaves, is known as both Myrtle Boxwood because it looks a bit like a Myrtle and as Mountain Lover because it grows naturally in many mountainous areas. Its third common name is False Box and that is rather telling. When our native plants were 'discovered' by Europeans they were compared to

their counterparts at home and when one was found that looked similar or could be used in identical ways to its European counterpart it was then called 'false' something-or-other, a designation that seems to carry with it an unpleasant sense of 'not-as-good-as'. This is prejudice, pure and simple.

Growing Box and Oregon Boxwood

English Box and Oregon Boxwood like the same general conditions although English Box is the more finicky of the two. They are both happiest in full sun to partial shade and a normal soil enriched with organic matter. Both require good drainage and the shallow roots make mulching underneath the plant a very good idea. They can be clipped to maintain compact-ness and this should be done in spring or summer but not in the fall since you do not want at that time to encourage new growth which might be injured by winter weather. Both plants can be increased by stem cuttings.

The trick with English Box is in selecting the right cultivar. There are two issues to consider—the size of the mature plant and its hardiness. Depending on the variety, English Box can grow anywhere from 3 feet (.9m) to 20 feet (6m) and since it is native to southern Europe it is hardly surprising that not all cultivars would be reliably hardy in our climate. A low growing variety often used for edging herb beds is 'Suffruticosa'. 'Varder Valley' is another low growing hardy variety and 'Argenteo-variegata' is a variegated Box. 'Angustifolia' has a tree-like growth habit. There are dozens of other cultivars, and the best plan is to buy your English Box at a nursery where the plants are well labeled so that you can check that the plant's growth characteristics and hardiness are appropriate to your needs.

It is much easier with Oregon Boxwood. The plant grows naturally from 1 (.3m) to 3 feet (.9m) and is reliably hardy in our climate so long as it has good drainage. Oregon Boxwood also has a reputation for drought tolerance and is used in the City of Vancouver's Waterwise Garden.

Bunchberry
(Cornus canadensis)
Bunchberry is the prettiest little deciduous groundcover for partial shade that I know and, joy of joys, the slugs seem to ignore it almost entirely. This hardy little member of the Dogwood family, also known as Creeping Dogwood, Dogwood Bunchberry and Dwarf Dogwood, is found across the north from Labrador to Alaska as well as in Northeastern Asia. On the Pacific Coast it grows as far south as Northern California. The plants grow thickly, about 6 inches (15cm) high with bright green leaves and has flowers in late spring which resemble those of other larger members of the Dogwood family. Actually, what look like large white

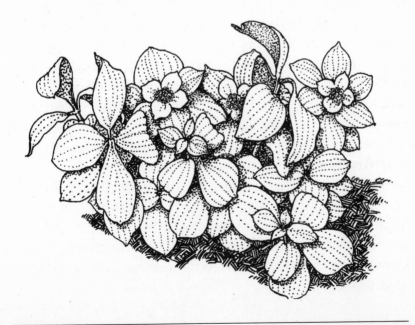

flowers are really the bracts and the tiny true flowers are greenish-white and found in the central cluster which the bracts surround. This attractive display is followed in the fall by red berries and the foliage also turns red.

Growing and Harvesting Bunchberries

Bunchberries are a fully hardy mat-forming deciduous groundcover. They prefer a dappled woodland setting and are often found in nature in Cedar and Spruce forests. They like an acidic, moist but well drained soil and are particularly fond of growing on rotten logs and stumps. The berries are bland but perfectly edible. Bunchberry can be grown from seed but germination is very slow and the seeds will require cold stratification. Usually plants are increased by division of the creeping rhizome.

Calendula ॐ
(Calendula officinalis)

When I first grew Calendula from a packet of seed I was delighted to discover that not only was this flower very easy to nurture from seed but that the range of difference in the flower heads was quite astonishing. Some were single flowers and some were doubles, some were large and some were quite small. The colour range gave me everything from pale yellow to an intense burnt orange.

Growing and Harvesting Calendula

Calendula prefers full sun and a rich moist soil although it is quite hardy and drought tolerant in less than ideal conditions. It grows easily from seed and the flowers, the only part used, are harvested as they open in the summer. Cutting the flower heads off will encourage the plants to produce yet more flowers.

The petals can be used fresh or you can dry the flower heads and, once dry, pull the petals away from the flower head, keeping the petals and discarding the centers. You can also dry the entire flower plus the stem for use in dried flower arrangements. If flowers are left to go to seed in the garden, Calendula will self-seed but never to the degree that it could be called aggressive. This is a mild-mannered and truly delightful plant.

Caraway
(Carum carvi)

Some plants—Mustard is a good example—are simply not worth growing in a garden setting for the seeds because you would need so many plants to get a decent number of them. Caraway is not in this grouping. One pretty little plant, easily tucked into a perennial bed, will give you about 3/4 of a cup of seeds, a bountiful harvest when you consider how many seeds most recipes call for. I first experimented with growing Caraway after tasting Kummel, a Caraway flavoured liqueur popular in Northern Europe. It was delicious and I wanted to make my own version. My recipe called for fresh Caraway seeds and I was delighted to discover how easy, although not quick, it was to grow my own plants for the seed.

Caraway is a hardy biennial. It grows to about 12 inches (30cm) in the first year and then shoots up to about 3 feet (.9m) by the time it flowers and sets seed in the second year. The foliage is bright green and feathery and the seeds are green, turning brown as they ripen. One of the great benefits of growing Caraway is that it gives you access to the entire plant for it isn't just the seeds that are useful. The fresh young leaves and shoots are a nice addition to a salad, can be chopped up and added to soups, and can also be added to the water when you are steaming or boiling vegetables to impart

a savory flavour. The slender roots can be used as a root vegetable and treated much as you would parsnips. They are best fairly young though and the plants won't have formed seed heads at this stage.

Growing and Harvesting Caraway

Caraway prefers a sunny location and a rich soil although this is a hardy and adaptable plant and will grow well in somewhat less than optimum conditions. The seeds can be sown in the autumn or the spring and most sources suggest sowing them where they are to grow. This is because Caraway, like other members of the Parsley family, has a long taproot which doesn't like to be disturbed. I have grown Caraway in flats and set them out as young seedlings with no difficulty, but the trick is to set them out when they are still quite small.

As mentioned, leaves and young shoots can be harvested from the first year. This is also the time to dig the root up if you want to use them as a vegetable. Harvest the seed heads when the older fruits on them have turned brown. This is a matter of careful timing— you want some of the seeds to have turned brown but if you wait for the entire head to turn brown it is likely to shatter and spread seeds all over your garden. I lay the heads out on trays to finish maturing and to dry thoroughly. (For more information, see the notes on harvesting Angelica.) Once the cluster is dry it is fairly easy to separate the umbels from the seeds and then it is an evening's work to separate out the last bits of chaff and stalk. Once the seeds are cleaned they should be stored in airtight containers.

Catnip & Catmints ᦥ

Nepeta cataria & Nepeta spp.
I have read that only 80% of cats love catnip and that the other 20% have an inherited immunity to its lures.

My own three cats are all in the catnip-loving majority.
In the past ten years I think I have tested out just about
every claim about Catnip and have come to the conclu-
sion that what you can get away with depends entirely
on the fanaticism of your particular cats. My cats don't
care if you planted it or transplanted it. They don't care
how old it is or how many plots of it you might be
growing. They rarely roll in it. They just park their little
furry bodies next to it and eat it down to the ground. I
even tried planting Catnip in a hanging basket. The
plant did better, but the post on which it was hung was
soon covered in claw marks and wood splinters. I
now grow my Catnip under an overturned wire bicycle
carrier which has been covered with a layer of 1/4 inch
(.6cm) hardware cloth. It looks like a tiny maximum
security prison, but it has kept the cats out, so far. A
friend of mine planted a thick patch of Catnip and
Pennyroyal together. Each time the cat rolled in the
Catnip he was also picking up the scent of the Penny-
royal which will help to repel fleas.

Catnip typically reaches a height of about 2 feet
(.6m), with woolly pale green leaves and small white or
pale pink flowers.

The Catmints do not have the herbal uses attributed
to Catnip but they are very attractive and are often
used in herb gardens as edging plants. Their flowers,
most often in a range of intense blues and purples, are
wonderful with Lavender and Roses. The trick here is
to get one that is the size that is appropriate for the
spot since there is a large range in size and there also
seems to be a range in aggressiveness. Remember that
these plants are of the Mint family and keep an eye on
them. One of the best, in my opinion, for use as a
border plant is *Nepeta × faassenii* cv. 'Dropmore Blue'.

Growing and Harvesting Catnip

Catnip and the Catmints like sun but can manage with some amount of shade. They are in the Mediterranean group of herbs (see Page 36). Catnip can be grown from seed or from plant divisions taken in spring or from softwood cuttings taken in late spring. If you have cats you will have to work out some method of protecting the plants from them. One of the most attractive I have seen is planting a fancy old birdcage over the Catnip plot. Seed taken from Catmints can sometimes produce interesting plants, but since many of the named varieties are hybrids they may be sterile or, in any case, will not breed true. Catnip leaves for drying are best gathered when the plant is in full bloom.

Cayenne Pepper

(Capsicum annuum or *C. minimum)*
For many years I found trying to grow peppers of any kind in our climate extremely frustrating. There are simply too many years when the growing season is not warm enough or long enough. By the time the peppers formed and were growing well it was already September and getting any of the fruit to ripen before the first frost was always a race. Then I learned that peppers are actually perennials that are only grown as annuals in our climate because they cannot handle any cold weather. The other key to the puzzle was learning that peppers, particularly the smaller types like Cayenne, are excellent container plants. I then planted my Cayenne in a gallon container and brought it inside in the fall. That one plant kept producing peppers until December. The following spring I kept it inside until the weather had warmed up, and then pushed it outdoors along with the Basil and tomatoes. By early July this plant was again deluging me with peppers. I managed to keep that little workhorse going for four years and I

only lost it because I foolishly put it outdoors too soon one year when the weather had not warmed up sufficiently. Most people think of peppers as a vegetable or, in the case of Cayenne, as a very hot spice, but this fascinating little pepper has a range of interesting medicinal uses which are currently being studied.

Growing and Harvesting Cayenne

Cayenne likes rich, moist but well-drained soil and full sun. It must not be put outside until after the last spring frost. If you plan to grow your Cayenne as a perennial, it must be brought indoors before the weather becomes too cold in the fall. Cayenne grows easily from seed. The peppers can be harvested when they turn red and they dry with no difficulty.

Chamomiles

Matricaria chamomilla & *Anthemis nobilis*
There are a number of plants that get called 'Chamomile', but there are two important ones, very distantly related, that are used almost interchangeably, depending on which expert you consult. Some herbalists, while praising the Chamomiles for their medicinal benefits, contend that Roman Chamomile (*Anthemis nobilis*) is better for internal use and German Chamomile (*Matricaria chamomilla*) is better for external use. Others maintain that Roman Chamomile is slightly more bitter than German Chamomile and doesn't make such a nice tea.

The rather prostrate, mat-forming perennial Roman Chamomile (*A. nobilis* or *Chamaemelum nobile*), also called English Chamomile, is native to western and southern Europe. There is a particularly pretty variety, 'Flore-pleno', which has a double flower. Another variety, 'Treneague', is a nonflowering very prostrate version which grows to a height of only about 2 inches

(5cm). It is particularly well suited for growing as a Chamomile lawn or a scented Chamomile seat. An annual, German Chamomile (*M. chamomilla* or *M. recuitita*) has a wider range. This plant grows to a height of about 2 feet (.6m).

Growing and Harvesting the Chamomiles

Both Chamomiles like full sun and a sandy well-drained soil. They can be considered in the Mediterranean group of plants (see Page 36). The perennial version is fully hardy in our climate so long as it gets the sharp drainage and sunshine it prefers. Both Chamomiles are easily started from seed in the spring but remember to plant them out while they are still quite young. Perennial Chamomile can be propagated by cuttings in summer or by division in the spring or autumn. Although both the leaves and the flowers are scented, other than for herbal tobacco mixtures, it is the flowers that are harvested for medicinal use. The leaves can be picked at any time and the flowers should be gathered when they are fully open. They are easily dried on trays. When your plants flower, pick every few days as this encourages more flower production.

A Word of Caution

Although the Chamomiles are mild and beneficial to most people, I must warn that they are members of the same family of plants as Ragweed and should be avoided by people with this type of allergy.

Chervil

(Anthriscus cerefolium)

The Chervil would probably have disappeared from my garden long ago if this herb wasn't such a marvelous self-seeder. It hasn't seeded throughout the garden. It hasn't made a nuisance of itself. It has just stayed in

the place that I put it and has kept on replenishing itself year after year. This is the most low maintenance herb of any that I know and for all its delicate looks it is completely hardy in our climate.

There are actually two Chervils, and this has created some confusion in various herb books where Chervil is sometimes listed as an annual and sometimes as a biennial. The Chervil that I grow is the annual, Salad Chervil (*Anthriscus cerefolium*), and the biennial is Parsnip-Rooted Chervil (*Chaerophyllum tuberosum*). This biennial version makes a rosette of leaves the first year and produces seed in the second year. It has a fleshy taproot which looks much like a carrot and it is used in similar ways. A few years ago I launched a quest to find seeds for this biennial Chervil and discovered that it is virtually unknown on this continent. At the time seed was only available in England and Holland and only in wholesale amounts. Unless someone decides to become the Parsnip-Rooted Chervil champion for the Pacific Northwest you are unlikely to find this herb in the nursery or in a seed packet.

Chervil is also known as Beaked Parsley, French Parsley and Queen of the Parsleys and it does indeed look and taste similar to a Parsley but with a finer and fernier leaf and just a hint of an anise flavour that Parsley lacks.

Growing and Harvesting Chervil
Chervil prefers a light moist soil and partial shade and grows well in a container. Sown in the spring, the plant will grow to a height of about 18 inches (45cm) before flowering, setting seed and dying. Chervil has a tap root and doesn't like transplanting, therefore sow the seeds where you want the plants to grow, covering them with only the lightest dusting of soil. Thin the plants as they emerge and use the thinnings in the kitchen. You can

sow seed at intervals to extend the crop and cutting back the flower heads before they bloom will stimulate new leaf growth. For regular picking try to take the outside leaves of each plant, leaving the younger leaves to continue growing. Planted only once in the spring and left to self-seed, Chervil will give you a late spring-early summer crop and another, from the seed, in autumn. Chervil is much the best when used fresh but if you want to harvest it you will find it retains its flavour better when frozen.

Chives & Garlic Chives ✣

(Allium schoenoprasum & Allium tuberosum)
I think of Chives (*A. schoenoprasum*) as the 'last minute' herb. It is at the last minute that I decide that a few spoonfuls of freshly chopped Chives would be a great add to the salad dressing or a lovely garnish for the soup or the tomato salad that is about to hit the table. A clump of Chives has bright green rounded grass-like leaves that grow about 10 inches (25cm) high and taste very much like green onions. In late spring they put out attractive pinky-purple ball-shaped flower heads that are just as edible as the leaves. Garlic Chives, as the name suggests, have a mild garlic flavour to add to the onion taste. The plants are larger and grow somewhat taller, the leaves are flat and the flower heads are white. If you are looking for an attractive versatile herb that is completely hardy in our climate, adapts well to container living, is wonderfully handy around the kitchen and has no bad habits (it doesn't put out aggressive roots, self seed or otherwise cause any bother) then Chives is your plant. Garlic Chives (*A. tuberosum*) are also a very useful herb although they can self-seed but luckily do it in a fairly restrained fashion.

If you are interested in companion planting, Chives are said to keep aphids away from Roses. Regardless of their abilities in that respect, Chives and Garlic Chives like the same conditions as Roses and they make a delightful grouping. Chives are also said to be beneficial when planted around grapes, apples, tomatoes and carrots and make a tidy and easily controlled edging for a herb or perennial bed.

Growing and Harvesting Chives and Garlic Chives
Chives and Garlic Chives prefer full sun and a rich, well-drained soil although neither plant is extremely fussy and they will usually manage to get by in less than optimum conditions.

They adapt easily to container culture and if you want to bring a clump of Chives indoors for the winter, they will do better if they have had a cold period. If possible leave your clump outside for a few freezing nights before bringing it inside.

Chives can be grown easily from seed but you will have to wait a year before using the crop so it is usually easier to acquire a clump at a nursery. If you want to try them from seed start it in the spring and cover the seed with about 1/4 inch (.6cm) of soil. Don't use or thin the plants for a year. The following year you can divide the clumps and they will be ready to use. About every three years you should, either in the fall or the spring, separate out your Chive clumps, thin them and reset them into enriched soil to which has been added some compost or manure. These plants are very shallowly rooted and digging and dividing the clumps is quite easy.

Many herbs are picked before they flower and if you want the largest leaf crop you must cut off the Chive flower heads. This is a shame because the flowers are pretty and since this is such a nice plant

the best solution is to grow lots of Chives and to just cut the flower heads on the batch you are keeping for kitchen use. Leaving the flower heads on will not damage the plant and it will not set seed and die. It will however be putting its energy into producing flowers and not into producing new leaves. If you are cutting your Chives for kitchen use from a patch that has started to flower, be sure to sort out the flower stems from the leaves as they are sturdy, stiff and not suitable for chopping. The flowers themselves are entirely edible and make a fine salad addition.

Chives and Garlic Chives are much the best when freshly cut and, particularly if you plant a clump in a container, you can have the fresh herb for much of the year. The leaves lose their flavour and colour quickly when dried by the ordinary methods so it is far better to freeze them.

Comfrey
(Symphytum officinale)
Comfrey reminds me of that rhyme about the little boy who "when he was good was very, very good and when he was bad he was horrid". This is a herb that I would not be without but it does require some careful watching if it is not to become a problem. Comfrey is a vigorous, sometimes too vigorous, perennial with big dark green hairy leaves, usually growing to about 3 or 4 feet (.9 m or 1.2m) tall. There is a close relative, Russian Comfrey (*S.* × *uplandicum*) which has all the same attributes but grows taller, sometimes to 6 feet (1.8m). Be very sure that you want your Comfrey where you plant it for it is almost impossible to get it out of an area once it is growing there. This plant has a long tap root and any part of the root that you leave in the ground will cheerfully start a new plant. Comfrey also self-seeds and if you allow it to do this your plant will

soon be surrounded with an expanding forest of Comfrey babies. The flowers are pretty, but as soon as I see them I know that it is time to get out and cut the Comfrey. This is easier said than done since the bees love those flowers and get seriously annoyed when you try to take them away.

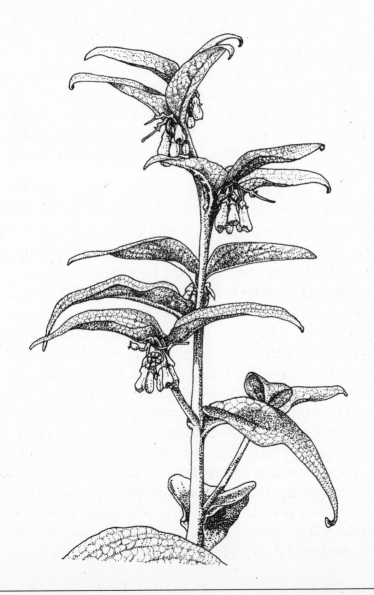

Growing and Harvesting Comfrey

Comfrey seems to be an exceptionally adaptable plant. It is fully hardy and prefers a rich moist soil. Both of my plants are growing in reasonably moist soil, one in light shade and one in dappled shade and both are as vigorous as I would want. I suspect that the range of soil and light conditions that Comfrey will accept is rather broad. Comfrey seed can be sown in the spring or fall.

I do not use Comfrey in the kitchen or medicinally although used externally it does make a soothing bath herb. For garden use, in tea for plants and as a compost ingredient, I typically harvest my Comfrey, the whole plant including the flower stalks, at least three times a year. I pick off the flower stalks before they can self-seed and I 'prune' it whenever it seems to be getting out-of-hand.

A word of caution

In the last few years there has been much controversy about Comfrey and the possibility that it might be a carcinogen. It is believed that long term internal use could cause liver damage. The jury is still out on these issues and until they are sorted out I won't use Comfrey internally and I suggest that you don't either.

Coriander & Cilantro

(Coriandrum sativum)

Coriander is one of the oldest known herbs, having been cultivated for over 3000 years in Europe, India and China. Most sources refer to the seeds of this herb as 'Coriander' and the fresh leaves as 'Cilantro' but it is all one plant at various stages of its life cycle. Cilantro is also sometimes called 'Mexican Parsley' or 'Chinese Parsley' and it is a flavour that many have become familiar with as Mexican food gains in popularity.

The name Coriander comes from the Greek

koriannon, the name for a type of bedbug, and is a reference to the unpleasant smell of the unripe seeds. As the seeds ripen they turn from green to gray and the odor changes until it is pleasant and aromatic. The outer seed casings do not have a strong scent, but as soon as the seeds are ground in a mortar the aroma becomes distinct. Another common name for Coriander is Dizzycorn, supposedly because the aroma of the seeds when freshly crushed can reduce dizziness.

Growing and Harvesting Coriander & Cilantro
Coriander is an annual and is grown from seed. It likes full sun and a well-drained soil and can be classed with the Mediterranean Herbs (see Page 36). Sow it in April for a seed crop in August or, sow every few weeks if you want a continuing leaf crop. Some strains are slower to bolt than others, so if you want the leaves in particular, get a type that has this characteristic. The plants can grow from 1 foot (.3m) to 3 feet (.9m) tall. Try to plant them where they have some protection from the wind as they can become top-heavy and are likely to blow over. If you are growing the plant for seed you must be observant as the seeds will start to fall as soon as they are ripe. After gathering the seed heads leave them outside but under cover to cure and dry for a few days and they can then be threshed.

Costmary ⨽
(Chrysanthemum balsamita)
If someone visits my garden and is interested in herbs I will almost always steer them towards the Costmary patch, where I will pick a leaf and ask them to rub it between their fingers and then identify the smell. They almost never can. They often guess that it might be a Mint, but not one that they have ever come across before. In fact this plant belongs to the Compositae

family and is related to Feverfew and Tansy. This is a herb that was very well known in the Middle Ages but seems to have gone out of fashion in modern herb gardens.

Growing and Harvesting Costmary

Costmary prefers full sun and a rich but dry and well-drained soil. It will grow easily in a fair amount of shade but will not produce flowers. It is fully hardy in our climate, but the young plants are attractive to slugs who can eat it down to the nubbins, particularly if it is growing in a shady site, so it is best situated where it gets lots of light. In a favorable site the creeping roots can spread quickly, so thin it every few years and take its slightly aggressive nature into account when planting it. Young Costmary plants do well in containers. The plants are propagated by root division in the summer or autumn. Harvest the leaves at any time during the season. They dry easily and retain their scent well.

Curry Plant ☙

(Helichrysum angustifolium)

This silvery gray-green evergreen shrub with its curry fragrance is a fairly recent addition to most West Coast herb gardens. Curry Plant makes an excellent edging and is also a handsome container plant. The yellow flowers in mid-summer are small, reminding me of a smaller version of Cotton Lavender flowers, but where this herb really comes into its own is in the winter. It seems to somehow be more fragrant in that season and a few sprigs of Curry Plant brought into the house will soon fill the air with their warm and spicy scent. The silvery leaves are a visual delight when combined with winter jasmine, fir and cedar.

Growing and Harvesting Curry Plant

This is another Mediterranean Herb (See Page 36) liking full sun and requiring good drainage. Many references list Curry Plant as a tender perennial but my experience has been that this plant is perfectly hardy in our climate so long as it has good drainage. I doubt that the mild Pacific Northwest climate would present any hardiness problems for this plant. Since Curry Plant is evergreen and available year round, you can harvest what you need as you need it. As mentioned, this herb comes into its own in the wintertime.

Dill ⟋

(Anethum graveolens)

I started growing Dill because I was interested in making Dill Pickles, but this plant has many more uses than that. Along with medicinal and endless culinary uses Dill has, like its close relative Fennel, a sculptural quality in the garden then can make it a most handsome addition to a perennial bed. Again like Fennel, Dill is very attractive to swallowtail species of butterflies and should be a part of any butterfly garden. Most Dill varieties grow to about 3 feet (.9m) in height and since this is a herb with a taproot only a fairly deep container will be appropriate.

Although all the Dill seed you buy will give you the same genus and species name, there are definite differences amongst the varieties so read your seed packet carefully. If you would like the smallest variety, and the one therefore most suited to container culture, try Fernleaf Dill. Dill leaves are best harvested before the plant flowers and goes to seed and some varieties have more abundant leaves and hold longer at the leaf stage before going to seed. If you are interested in your Dill for leaf production try growing 'Dukat' Dill or 'Tetra'

Dill. If you want your Dill mainly for the seeds try 'Bouquet' Dill or 'Long Island Mammoth' Dill.

Growing and Harvesting Dill

Dill is a fast growing annual herb liking full sun and a fairly rich soil. It likes a sandy soil and it can be considered as one of the Mediterranean group of herbs (see Page 36). Dill is easily grown from seed and, as with other taprooted plants, it is best sown where it is to grow or transplanted when it is still quite small. If you are growing more than one plant, you can sow the seeds thicker than you will want and then use the thinnings in the kitchen. You should end up with the Dill plants no closer than 8 inches (20cm).

The tall varieties of Dill tend to grow top heavy so they may need staking and remember not to plant your Dill near Fennel as they are closely related and can cross-pollinate. It is only during "pickle season" in late August that fresh Dill leaf or seed is generally available in the stores, so if you want to use these products at other times growing your own is a necessity. Dill leaf can be dried and powdered to use as a spice, but I think it loses rather a lot of flavour and the fresh leaf is much superior. You could also try chopping and freezing the leaves and this does retain more flavour. The seeds should be allowed to ripen on the plant to some extent so wait until they have changed from green to brown. For information on handling the seed heads, see the harvesting instructions for Angelica.

Echinacea

(Echinacea purpurea, E. angustifolia)
In the past few years Echinacea has become the trendiest of herbs. Taken in capsule form, as a tea or as a tincture, it has become one of the most popular remedies for colds and flu. Many people believe that

Echinacea regulates and stimulates the immune system and can thus help counter both bacterial and viral infections. How Echnacea does this is not yet fully understood, but most sources agree that it should be taken once symptoms of cold or flu appear but then only for a week or two.

I started growing Echinacea (*E. purpurea*) simply because it is such a stunningly beautiful plant. The fact that it is so useful medicinally came as a splendid bonus. This herb is a clumping perennial growing 3 or 4 feet (.9m or 1.2m) high and blooming in mid to late summer. Echinacea's flowers are pinky-purple and at their center is an intense orangey-brown spikey cone, giving rise to the plant's common name of Purple Coneflower. The Echinacea comes from the Greek word for hedgehog, again a reference to that prickly center cone. Other common names are Cone Plant, Black Sampson and Kansas Snakeroot. Echinacea is a North American native, a child of the great plains, where it grows wild from Western Minnesota to Eastern Saskatchewan and south to Tennessee and Texas.

There are several species of Enchinacea that you might hear mention of but the two best known, and the two most often used medicinally, are *E. purpurea* and *E. angustifolia*. *E. angustifolia* has a more westerly range than does *E. purpurea*, is a smaller plant typically growing less than 2 feet (.6m) high, and has narrower leaves. It is often called Narrow Leafed Purple Cone-flower. Plants in this genus are capable of hybridizing if grown together.

Growing and Harvesting Echinacea

Echinacea is completely hardy and drought tolerant in our climate. Since it naturally grows on dry open prairies and plains, it is important to situate it in full sun in a sweet (dig in a little lime) sandy well-draining

soil. A south facing slope would be ideal. Treated
in this fashion the clumps will get slightly bigger
every year.

This is a well-behaved perennial as it doesn't self
seed or take over too much territory or have any other
bad habits so far as I have discovered. It is a worthy
addition to a perennial bed even if you never use it for
anything else. Echinacea can be grown from seed or
root division.

The part of the plant most often used medicinally is
the root, and traditionally the roots of four-year-old
plants were lifted in autumn. I don't dig up the roots
because I want my clumps to get larger, but I do trim
the entire plant in autumn and dry all the material thus
obtained. My understanding is that all parts of the plant
have the same chemical constituents although the
roots are considerably stronger. The leaves, stems and
flowers can all be used for making tea. Cut the stems in
small pieces for ease of drying and handling.

A Word of Caution

Echinacea is a member of the same family of plants as
Ragweed so be very cautious about using it if you have
allergies. It should also not be used by anyone with an
autoimmune disease.

Elecampane ✍

(Inula helenium)
Elecampane is related to the sunflowers, in fact one of
its common names is Wild Sunflower, and the relation-
ship is obvious once you see the plant with its bright
yellow flowers, large leaves and impressive height. This
is another herb that might be great at the back of a
perennial border but is not really appropriate for con-
tainer growing. This plant is statuesque to put it mildly,
and a plant that is a few years old and well situated

can easily reach 6 feet (1.8m). You may want to stake it in late July, by which time it has usually grown so tall that a high wind can push it over.

Growing and Harvesting Elecampane

Elecampane is tough, versatile and completely hardy in our climate. It likes full sun although it can handle a fair amount of shade, and it likes a moist rich soil. The roots are pulled for use in the Autumn, and they should not be pulled until the end of the second or third year. By this time, your Elecampane will be big enough that you can pull lots of root and still replant enough pieces to keep the clump healthy. This plant is easily grown from root divisions or from seed. The root when first pulled has an odd and not particularly pleasant smell, but once dried it changes completely and is quite lovely. Cut your root into pieces while it is still fresh and leave it this way to dry. Once dry the root is hard as a rock and very difficult to cut.

Evening Primrose 🌱

(Oenothera biennis)

I have grown two varieties of Evening Primrose, *O. biennis* and *O. glaziovinia. O. biennis,* the one that Evening Primrose Oil is usually associated with, has smaller and much less flashy yellow flowers, grows to about 2 feet (.6m) tall, and is usually listed as a "biennial weed" although it has been well behaved in my garden and is not particularly weedy in appearance. *O. glaziovinia* is a taller plant, about 4 feet (1.2m), with fabulous big yellow flowers, (my husband calls it "the yellow cartoon plant"), but a self-seeding habit that requires careful watching.

Evening Primroses are so called because the flowers open up at dusk. People who grow *O. glaziovinia* have been known to throw 'primrose parties' to watch this

event which with this species is quite spectacular, the blooms opening fully in only two or three minutes.

Growing and Harvesting Evening Primrose

Evening Primrose likes full sun and an ordinary to sandy, well-drained soil. Germination from seed is a bit erratic but once you have a plant you can let it self-seed and then transplant the seedlings to wherever you want them. This plant is fully hardy in our climate, forming a rosette of leaves in the first year and flowering in the second year. Young shoots can be harvested fresh and roots are best at the end of the first growing year. After that they become too woody to be of much use. Growing this plant for the oil is, in my opinion, not worth bothering with as you would need so many plants to get any worthwhile amount of seeds (not to mention the business of how one would go about extracting the oil). If you want to try Evening Primrose oil, check out your local pharmacy or health food store.

Fennel

(Foeniculum vulgare)

Nearly every source I have checked says that the herb Fennel, although a perennial, is not quite hardy in our climate. If we get a mild winter it might make it through more than one year. No one has explained this to my Fennel plant which is now at least five years old and growing vigorously. Fennel is hardy to about 0°F (–17.7°C) but hardiness is difficult to assess and in a protected spot the Fennel may last for years. Even if I had to replant every year I would consider this herb worth growing. It has sculptural beauty, a wide variety of uses and is beloved of the swallowtail species of butterflies. If you see caterpillars on your Fennel leave them alone; they grow up into something wonderful.

I called it 'herb Fennel' because there is a vegetable

version of Fennel as well as a number of herb varieties, usually named for the countries in which they grow, Indian Fennel, Persian Fennel and so on. Vegetable Fennel (*F. vulgare var. 'Azoricum'*), also known as Florence Fennel, Bulb Fennel and FInocchio is grown as an annual for the bulbous stalk bases. Another variety grown in France for the young stalks is called French Fennel, Sweet Fennel, Roman Fennel, Carosella or Fenouil (*F. vulgare* dulce). Herb Fennel or Wild Fennel (*F. vulgare*) is grown for the young shoots and stems, the leaves and the seeds. Bronze or Smoky Fennel (*F. vulgare v. 'Rubrum'*) is typically grown purely as an ornamental although the leaves and the shoots are perfectly edible. Vegetable Fennel is a much smaller plant than the herb Fennels, growing to only about 21/2 feet (.7m). Herb Fennel can easily grow to 6 feet (1.8m) tall and is a stunningly good looking garden plant with bright blue-green feathery leaves and yellow flower heads followed by seed heads in late summer. These plants are big and the long tap roots indicate that they would not be suitable for any but the largest container.

Growing and Harvesting Fennel

All the Fennels prefer full sun and a rich, well-drained soil so be sure to work in lots of organic matter—compost and manure are both appreciated. Fennel is easily grown from seed but, because it has a taproot, should be planted where you mean to grow it or planted out from a flat when it is fairly small. In fact it grows so easily from seed that it is a nice choice for children's gardens. If you are buying your plant from a nursery, get the smallest one you can find. In mid-summer check to see if your herb Fennels needs staking. Unlike Angelica which grows just as big but is much sturdier, Fennel always seems to develop quite a lean when it

gets to any height. Remember also to not plant your Fennel near to your Dill as they can cross-pollinate and give you a crop of "Dennel" and "Fill", neither unfortunately as useful or tasty as the parent plants.

If you are growing Vegetable Fennel, sow the seeds in the Spring and thin them to about eight inches apart. As the bases of the plants swell up, push up the soil around them so that the bulb is covered as this blanches them. Remove the flower heads so the plant's energy is directed towards the bulb. This will still give you Fennel leaves but unfortunately no seed heads unless you save at least one plant for that purpose.

Fennel leaves are much the best when fresh and do not dry well. If you want to preserve the leaves, try chopping and freezing them. Fennel seeds can be easily dried. See the notes on Angelica as the method is identical.

Feverfew ॐ

(Chrysanthemum parthenium or *Tanacetum parthenium)*
The small white daisy-like flower heads of Feverfew give it a resemblance to Chamomile, to which it is botanically related (in fact Feverfew is sometimes called Wild Chamomile) and the leaves are reminiscent of Chrysanthemum, another member of the same family. This is a pretty and very trouble free garden herb here in the Pacific Northwest. It is usually listed as a short-lived perennial, a designation that quite often makes me avoid a plant. The beauty of Feverfew is that although the original plant does die out after a time, it never seems to do it without scattering enough seed to replenish itself several times over. This is not a weedy self-seeder, scattering the goodies to excess. You may have to pull up a few extra plants, but that is the limit of the work required. Once you have Feverfew in your garden you will never be without it.

Growing and Harvesting Feverfew

Feverfew likes sun but is a very adaptable plant and will grow in situations that get quite a lot of shade. It prefers a well-drained sandy soil on the dry side, so here on the 'wet coast' it is a good idea to plant it on a hill or otherwise situate it for excellent drainage. Feverfew can be propagated by seed or by division of the root in spring or fall. The part used medicinally for migraines is the leaves and they can be picked fresh while the plant is in season. For winter use they can be dried or frozen. For use as a tonic and for fevers, both the leaves and flowers can be utilized.

A Word of Caution

Feverfew is a member of the same botanical family as Ragweed so be very cautious about using it if you have allergies. It should never be taken by anyone using anticoagulant medication.

Garlic ✤
(Allium sativum)

Garlic is a root crop with an edible bulb or head that is composed of smaller cloves and it is very easy to get into an argument about the very best way to grow it. Do you plant it in the fall or the spring? Do you cut off the flower stalk? Do you trim off the leaves before curing or after? Each side has its supporters who can give you good reasons why their way of doing things is correct. I think that there are a number of reasons for this variation in opinions. For one thing Garlic is a tough plant and will manage to grow in a wide range of conditions. Since Garlic is grown all over the world, the "best" method can also vary in response to local conditions and climate patterns. Finally, although all Garlic is botanically *Allium sativum,* there is a huge variety in the strains of Garlic that may be grown.

Garlic variations can include size of bulb and plant, colour, shape, average number of cloves per bulb, whether the garlic is clustered in concentric layers with no central stalk or whether it has a central stalk around which the cloves line up adjacent to each other, ease of peeling, days to maturity, flavour and pungency as well as how well and for how long it stores. It is no wonder that people who grow Garlic manage to get into so many arguments.

If all the Garlic that you have ever seen came from the grocery store it is not surprising that you would be unfamiliar with the wide range of Garlics that can be grown. Our local stores typically carry only one strain (most often Artichoke Garlic from California), and if you want to widen your experience of this most interesting plant you will have to grow your own. Luckily Garlic grows very well in our climate. For all the disagreements amongst Garlic aficionados, Garlic is easy to grow, takes up comparatively little room in the garden, has no bad habits and is extremely good for you.

The many Garlic varieties are sometimes broken up into the hard-necked types and soft-necked types. The hard-necked varieties, *Ophioscorodon,* have fewer but larger cloves than the soft-necked varieties called *Sativum*. The hard-necked varieties usually send up a flower stalk a month or two before it is time to harvest the bulb. Soft-necked varieties usually don't send up a flower stalk unless they are stressed by too little water or too much heat. Here are the main types of Garlic:

- **Purple Stripe:** (*Allium sativum ophioscorodon*): Hard-necked Garlics. Purple striping on the bulb wrapper but great variation on this depending on particular strain and on growing conditions. Many are strongly flavoured and store well. A range in maturation dates, with some maturing late.

- **Artichoke:** (*Allium sativum sativum*): Soft-necked Garlics, a favorite of commercial growers, producing larger bulbs than some other soft-necked varieties.
- **Silverskins:** (*Allium sativum sativum*):Soft-necked Garlics and the best one for braiding. They have a very pliable neck and are very long storing. The flavour is typically hot and strong. Not as large as Artichoke Garlics.
- **Porcelain:** (*Allium sativum ophioscorodon*) Hard-necked Garlics with large cloves that store well. Outer skin is usually very white.
- **Rocambole:** (*Allium sativum ophioscorodon*) Hard-necked Garlics, also called Serpent Garlic. Fairly hot and easy to peel with thinner bulb wrappers than some other varieties. This strain has stems that grow in very strange curls, often a double loop. Considered by many to be the best tasting culinary Garlic but not as good for storing as some other types.
- **Elephant Garlic:** (*Allium ampeloprasum*) Not a Garlic but a giant Leek. Elephant Garlic is about twice as big as Garlic and has a milder taste. It stores for longer than Garlic, but has less of the chemicals which make Garlic so medicinally important.

Growing and Harvesting Garlic

Garlic likes full sun and a rich, well-drained sandy soil. If your soil is acidic add in some dolomite lime and, during the season, the plants will appreciate a few side-dressings of compost or manure. It is also a good idea to mulch your Garlic patch since this plant hates competition from weeds. To plant Garlic, break each head into individual cloves and then plant these with the root downward (pointy end up) at a depth of about 2 inches (5cm) and each clove about 5 inches (12cm)

from any other clove. As mentioned, the time to plant Garlic is a matter of debate, but I plant mine in the fall, usually mid-September.

If you are growing a type of Garlic that puts forth a flower head, you will find this easily recognizable as the flower stalk takes on a most graceful curl and the top thickens and takes on a bud-like appearance. There is debate as to whether it is a good idea to snip the flower bud off—and even on the exact timing of when to do it. I snip the buds off when I notice them, usually when the stalk has started to curl but before the bud had developed to any size. My belief is that you get better and larger bulbs when the plant is putting all its energy into producing the bulb, and not wasting any producing a flower.

There are many factors that can effect the timing when it comes to harvesting the Garlic. It will depend on what time of year the Garlic was planted, what the weather has been like, and what variety you are grow-ing. My Garlic, a hard-necked Purple Striped type, is typically ready for harvest in early to mid-August. My neighbour who grows Silverskins has Garlic ready for harvesting by late July. In general, the Garlic is ready to be pulled when most of the foliage has turned yellow. Depending on the nature of your soil, your Garlic may come up with a simple tug or may need a bit of delicate spade work. Try very hard not to cut or injure the bulbs as you bring them up and, once up, handle them with care so they are not bruised.

Pulled Garlic needs curing. Brush off as much dirt by hand as you can and then leave the Garlic outside but under cover where it will be protected from rain and dew for a few weeks. Don't wash it and leave the foliage on until after the curing period. As you may imagine, these are other areas of debate amongst Garlic growers.

There are a number of factors that will effect long term storage including the variety of Garlic, how it was grown and cured, temperature and humidity. I store my Garlic in a cardboard box in the basement where it is kept cool and fairly dry. The optimum storage temperature is about 60°F (15.5°C).

Geraniums, Scented ↝
(Pelargonium spp.)
A friend of mine once brought me three small plants. The flowers were pretty enough but pale and small. The leaves were pleasant enough but nothing exciting. And then I bent down and smelled them. These plants all looked very similar but one smelled strongly of limes, one was exactly like "Old Spice" cologne and the third was the most intense rose fragrance imaginable. It was a wonderful introduction to the extraordinary world of Scented Geraniums. Although the rose fragrances are the best known of the Scented Geraniums, there is a wide variety of other scents – Peppermint, Nutmeg, Lime, Apple, Orange, "Old Spice", Coconut and Ginger to name a few. The plants also come in a variety of leaf shapes and sizes with some species known for their leaf shape—Southernwood-leaved (*P. abrotanifolium*), Oak-leaved (*P. quercifolium*) and so on.

When you say the word "Geranium", most people think of the big brightly coloured flowers of a plant which is in the *Geraniaceae* family but is actually in the genus *Pelargonium*, not *Geranium*. The genus *Geranium* contains the "true" geraniums, the hardy members of the family usually called Cranesbills. This splitting off of *Pelargoniums* into their own genus happened in 1789 and most of us are still trying to catch up.

Growing and Harvesting Scented Geraniums

In their native South Africa members of this genus can grow into sizable shrubs, but these are tender plants and cannot survive a winter outdoors in our climate. They are however lovely container plants and winter indoors quite easily. Give your Scented Geraniums as much sunlight as possible and a fairly rich well draining soil. A mix that is equal parts sterilized potting soil, peat moss and perlite is ideal. Plants should be watered when the soil feels dry to the touch and they should then be watered thoroughly. Overwatering can rot the roots, so be careful to let your plants dry out somewhat between waterings. Remove any yellow leaves and in the summer fertilize the plants every two or three weeks. As the Geraniums age they start to get woody so you may want to take cuttings and start new plants every few years. The cuttings are best taken in the fall although they are quite easy to start at any time. Geranium leaves can be harvested in small amounts as needed. Pinching back the tops will keep the plants bushy and all such pickings can be saved and dried for potpourris.

Germander ✣

(Teucrium chamaedrys)

Although Germander, sometimes called Wall Germander, is rarely used in the kitchen and its medicinal reputation is certainly questionable, this is an extremely handy plant when it comes to designing a herb garden. Germander has a lengthy history of use as an edging plant for formal herb and knot gardens and it has much to recommend it for this specific use. It is completely hardy in our climate. It grows very easily from cuttings or root divisions, and the clumps grow so thickly that weeds are rarely a problem. It responds well to being trimmed and its roots are quite shallow

so it is relatively easy to dig it out of anywhere that it isn't wanted. Add to this the pretty dark green leaves and the pink flowers and you have a herb that is well worth paying attention to. Germander also responds beautifully to container growing and it will spill over the edge of a container in a most attractive way.

Growing and Harvesting Germander
Germander likes full sun and a well-drained soil but it is a very adaptive plant and will grow well in some amount of shade. It can be considered as one of the

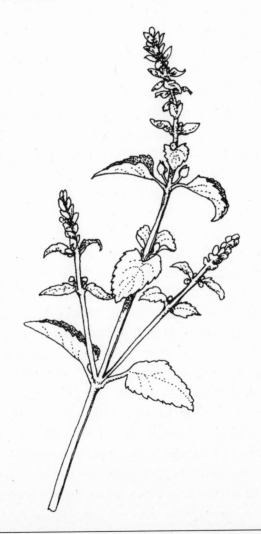

Mediterranean herbs (see Page 36.) Germander will grow from seed, but it is quite slow so I would suggest buying your first plant. As mentioned, it is very easy from cuttings or root divisions so increasing your supply is not difficult. I do not harvest Germander, but the leaves can be dried.

Ginger
(Zingiber officinale)

When I was a child I didn't like a lot of vegetables. Part of the reason was that my mother belonged to that famous English "boil it until it is good and dead" school of vegetable cookery. When I was out on my own I learned a little about Chinese cooking and bought my first wok so that I could experiment with stir frying. It was then that I came to love Ginger and to discover what a marvelous and subtle flavour it could add to so many dishes. Typically in wok cookery the Ginger is either grated and added to the dish or is just cut in larger chunks and used to flavour the oil before being discarded. Either way you need fresh ginger because the flavour you want comes from a volatile essential oil and powdered Ginger loses strength quite quickly.

Ginger is a tender perennial, not remotely winter hardy in our climate, but luckily it takes very well to container culture and can be a very attractive and unusual addition to your collection of potted herbs. Ginger stalks look to me rather like corn stalks and over a summer they will reach between 3 and 4 feet (.9m and 1.2m) high. Ginger produces its flower cluster on a separate stalk but it is very rare for it to flower when it is being grown in a container.

Growing and Harvesting Ginger

This is one plant that you buy at the grocery store instead of the nursery. Find a piece that looks nice and

plump and has several emerging buds on it. Plant the rhizome in a pot that is at least one gallon in size and even larger is better. The rhizome should be planted about two inches deep in a rich well draining soil mixture. Ginger is dormant during the winter months so you can plant in the fall or winter but nothing will happen until the spring when the first leaf stalks will appear. The Ginger pot can go outside for the summer if you have a sunny sheltered spot. Remember that this plant is native to humid tropical regions so water it frequently. In the fall the leaf stalks will go yellow and it is then time to dig up your Ginger root. Harvest the root by cutting off the larger portion, leaving a few pieces with buds to be replanted for your following year's crop. The taste of freshly harvested Ginger is quite unique, not exactly the same as "store bought". Although Ginger is readily available in the stores, it is that wonderful taste of the fresh product that encourages me to grow a Ginger pot. The easiest way to handle any Ginger for a single household is to cut it into chunks, about 1 and 1/2 inch square, and to freeze them in a plastic freezer bag. When you want a piece for chopping or grating just take a chunk out of the freezer and hold it under the hot water tap for about 2 seconds.

Ginger, Wild ॐ
(Asarum canadense & A. caudatum)
There are a number of Wild Gingers. Some that you might see in the nursery are Canadian Wild Ginger (*A. canadense*) which is native to eastern North America and Western Wild Ginger (*A. caudatum*) native to the Pacific Coast from Alaska to California and east to Montana and Idaho. These plants look very similar and have historically had similar uses. Wild Ginger is a lovely groundcover for a moist and shady spot and the

low growing showy leaves make a splendid woodland carpet. Unfortunately it is also popular with slugs. They haven't managed to destroy my plants yet but it isn't through lack of trying. Wild Ginger is definitely in the category of plants that need watching for these pests. The Wild Gingers are so called because the roots of these plants have been dried and used for a seasoning which tastes somewhat like Ginger.

Growing and Harvesting Wild Ginger

Wild Ginger likes shade and a moist soil. It spreads by rhizomes which can be dug and separated in the spring or fall to increase your supply of the plant. This is a herb of the forest floor and looks best in that type of situation. The part used is the dried root. I very much like the looks of this plant, but given that its herbal uses are suspect and the slugs are so enamored of it, I cannot recommend it.

A Word of Caution

Some current research indicates that this plant may be a carcinogen so it is best avoided for internal use.

Hops ᴈ

(Humulus lupulus)

We nearly always think of Hops in relationship to beer, but this perennial vine has a number of other interesting uses. Hops have been used medicinally, as a vegetable and as a source for material for basket weaving. They may take a year or two to hit their stride, but after that Hops grow vigorously to 20 feet (6m) or more in a season. They are often used to cover arbors and pergolas. In the winter the vine dies down to the roots but given good growing conditions the root is hardy and perennial and once established, your Hop vine will be with you for many years. Hops, like Holly trees, come

in two sexes and for herbal uses, or for beer making, you require a female plant.

Growing and Harvesting Hops

Hops prefer full sun, although they will take some amount of shade, and a deep rich somewhat sweet soil. Before planting work in lots of organic material like compost and manure and, if your soil is on the acidic side, some Dolomite Lime would also be a good idea. Hops do not like to dry out, so give your plants extra water if we have a late summer drought and be sure to mulch them. Hops can be propagated by taking suckers from the roots, preferably planting them out in the autumn, or by cuttings. The Hop flowers can be harvested in late summer or early fall when they have started to dry and have turned golden.

Horehound

(Marrubium vulgare)

One look at Horehound and you will be suspicious that it is of the Mint family although my plant has never shown the Mint's truly invasive nature. There are actually two Horehounds, White Horehound (*M. vulgare*) and Black Horehound (*Ballota nigra*) but it is only White Horehound that is used in the kitchen or medicinally. The easiest way to make sure that you have the right Horehound is to look at the plant when it is in flower. White Horehound has white flowers while Black Horehound has pale purple flowers. Horehound can be grown in containers and will adapt to indoor cultivation. It is entirely hardy in our climate.

Growing and Harvesting Horehound

Horehound likes full sun and, when being grown for medicinal purposes, produces the most essential oils if grown in poor, well-drained alkaline soil. It

can be propagated by seeds, cuttings or division. The leaves are best when freshly gathered although they dry well.

Hyssop and Anise-Hyssop

(Hyssopus officinalis and *Agastache foeniculum)*
I always think of Hyssop and Anise-Hyssop in tandem because I first grew one of these herbs, Anise-Hyssop, in the mistaken impression that it was Hyssop. Hyssop was a staple in medieval herb gardens and when I came across a plant labeled 'Hyssop' in a local nursery I was happy to acquire one. At the time I hadn't see a photograph of the plant and my new acquisition with its square stem and minty-anise fragrance was clearly a member of the Mint family so I didn't question the identification until my plant grew taller than I was expecting and put out some large purple flower spikes. Hyssop however has small blue flowers. They can rather more rarely be pink or white, but there was no mention of large and purple. About a year later I managed to acquire a true Hyssop and could then appreciate how different these plants really are. Although both are members of the Mint family and have the recognizable square stem, Anise-Hyssop has much larger leaves with a serrated edge and grows larger, to about 3 and 1/2 feet (1m). Hyssop only grows to about 2 feet (.6m) and for this reason is often used as the "ribbon" in English knot garden designs. Luckily neither plant has the unpleasant Mint habit of sending out roots to take over territory and both are very worthy and easy care additions to a herb or perennial garden.

Growing and Harvesting Hyssop and Anise-Hyssop

Hyssop is hardy in our climate and almost evergreen, losing its leaves only when we have a particularly harsh winter. It can be grouped with the Mediterranean herbs (see Page 36), liking full sun and a well drained limy soil. It makes an excellent border plant and can be pruned in the spring or early summer if it has gotten leggy. Hyssop is easily propagated from cuttings or root divisions. Anise-Hyssop is also fully hardy, but is not evergreen. Although it too likes full sun it is tolerant of shade and is also very tolerant of dry soils. It is usually propagated by cuttings or root division.

Kinnikinnick ﹌

(Arctostaphylos uva-ursi)

Kinnikinnick as a lovely trailing evergreen groundcover with shiny green leaves and red berries in the fall. It is particularly suitable for sandy slopes and bright sun-shine and is a great slope stabilizer. It is completely hardy in our climate and very drought tolerant. The name Kinnikinnick (the spelling changes somewhat depending on which authority you consult) is actually an Algonquin word for 'mixture' since many First Nations peoples used the dried leaves in smoking mixtures. After contact on the Pacific coast the leaves were often mixed with tobacco. On the west coast it is native from Alaska to Northern California. I have been referring to the wild plant, but we also have our own home-grown cultivar, the University of British Columbia's garden plant introduction, *Arctostaphylos uva-ursi* 'Vancouver Jade'. This cultivar has fragrant pink flowers in spring and a more rapid growth habit than the wild version.

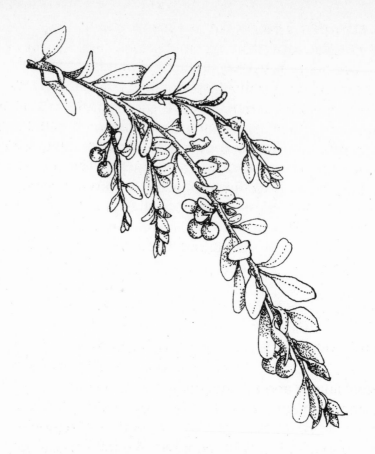

Growing and Harvesting Kinnikinnick

Kinnikinnick does best in a sunny location but it will tolerate some shade. It likes gravelly well-drained sandy soils and is particularly good on slopes. It can be increased by cutting or layering best done in the fall. The leaves can be picked any time from spring until early autumn when the berries ripen.

A Word of Caution

Because the leaves have a high tannin content they should be used with care and never for more than a few days. They should be avoided by pregnant women or anyone suffering from kidney disease.

Labrador Tea ✤

(Ledum palustre subspecies *groenlandicum, L. palustre* subspecies *decumbens)*
Labrador Tea is sometimes confused with Bog Rosemary. Both are native evergreen shrubs of similar size and appearance, liking the same boggy situations and often growing together. This can be a fatal mistake since Bog Rosemary is quite poisonous. When the two plants are in flower in the spring they are quite distinct with Bog Rosemary having pink bell-like flowers and Labrador Tea having white flowers with five petals in clusters on the ends of branches. If the two plants are not flowering the best way to tell them apart is that on Labrador Tea the leaves have a fuzzy brown underside and the leaves themselves are fragrant.

Growing and Harvesting Labrador Tea
Labrador Tea is fully hardy in our climate. It is not terribly finicky about light conditions, growing in everything from sun to a fair amount of shade, but it does need an acidic boggy soil. This plant can be grown from seed, which will require cold stratification, but it is usually propagated by division of the rhizome. There is some disagreement about when the leaves should be picked. There is a faction which maintains that they are much the best when picked while the plant is in flower. This would certainly help in avoiding making any mistakes in identification if you are picking in the wild. Others maintain that the best tea is made from leaves picked after mid-summer. The leaves can be dried for use as a tea but, should only be used in moderation.

A Word of Caution
Labrador Tea is slightly laxative and contains a narcotic, ledol. It should be avoided entirely if you have high

blood pressure or heart problems. Overdoses can irritate the nervous and digestive systems.

Lady's Mantle

(Alchemilla mollis)

The best time to first see Lady's Mantle is just after a rainstorm. The fan-shaped leaves hold the silvery droplets of water in an almost magical way. This same magic is performed with early morning dew and it is easy to see why Medieval alchemists would have believed that this liquid was the secret ingredient that could help turn base metals into gold. It is from this source that the botanical name *Alchemilla* derives. The *mollis* is Latin for soft or flexible, a description of the leaves which are indeed soft and somewhat hairy in texture. The common name of Lady's Mantle refers to the shape of the leaves and also indicates that this plant historically belongs to the Virgin Mary, an appropriate patron since the medicinal uses of this plant have given it the further common name of 'The Women's Best Friend'. Other common names like

Bear's Foot and Lion's Foot also refer to the shape of the leaves as does Nine Hooks, a reference to the number of lobes on the typical leaf.

All the Lady's Mantles are used similarly and are completely hardy in the Pacific Northwest although it is *A. mollis* which is most often grown in our gardens. This is a lovely plant for the border of a herb or perennial bed but I would avoid putting it in the middle of the bed as it self-seeds rather prolifically. It is easy to control if carefully situated however and is extremely handsome and adaptable. The bright chartreuse flower sprays are long-lived and can brighten up many a dull corner. It also adapts very well to containers.

Growing and Harvesting Lady's Mantle

Lady's Mantle grows best in partial or dappled shade although the range it will accept is very wide. It prefers a rich, moist but well drained soil but does not like soil that is too dry. Check your plants if we have a late summer drought but in general this is a very hardy and adaptable plant. It can be propagated by division or by seed and once you have a plant you will have no end of self-sown seedlings to use if you want them. This plant gets a little sprawly once it has flowered, so cutting back the flowers will tidy its appearance and stop some of the self-seeding. The leaves can be used fresh or harvested for the winter in mid-summer when the plant is in bloom. They dry easily.

Lavenders ✌

(Lavandula angustifolia & Lavandula spp.)
There are so many different Lavenders these days that you can find one for nearly every purpose. There are cultivars that make an excellent shrub border, a ribbon in a knot garden, a glorious companion plant to a rose bush or an eye-catching container plant. The trick is in

finding a variety that will be hardy in our climate and will be of a size and colour of flower that you prefer. Luckily the Lavenders take beautifully to container culture so even the less hardy varieties can be grown successfully if you can bring them inside for the winter. If you don't have room for the large Lavender shrub that you may be familiar with, don't despair. Some of the new dwarf cultivars require very little space and can even adapt to a fairly small container.

There are over 25 species in the *Lavandula* genus. The botanical name *Lavandula* is believed to come from the Latin verb *lavare,* to wash, and is a reference to Lavender's long use as a perfume for the bath. Lavender was used by the Phoenicians and the Egyptians and it is believed that the Romans brought Lavender to England. At one time English washer women were known as 'lavenders'. This was also one of the first plants brought by colonists to North America.

The type of Lavender that we are most familiar with in the Pacific Northwest is English Lavender (*Lavandula angustifolia,* previously known as *L. officinalis, L. spica* or *L. vera*) and it is this type that has the strongest fragrance and is most often used commercially to make Lavender Oil for perfumes and soaps. There are dozens of cultivars of English Lavender although 'Munstead' and 'Hidcote' are perhaps the best known. In the last few years cultivars of French Lavender (*L. dentata*) and Spanish Lavender (*L. stoechas*) have become increasingly available. Lavenders can range in colour from intense purple through blues, roses and even white. The flower form varies widely between species. When choosing your Lavenders you may find the following groupings helpful:

ᗡ **Spica Lavenders:** This group includes English Lavender (*L. angustifolia*) and Spike Lavender (*L. latifolia*). *L. angustifolia* is the hardiest of all the

Lavenders and so long as the soil and light conditions are appropriate, is fully hardy in our climate. *L. latifolia* is somewhat less hardy and blooms later in the summer.

- **Stoechas Lavenders:** This group includes French Lavender (*L. dentata*) and Spanish Lavender (*L. stoechas*). These Lavenders are less hardy than the Spica group and are definitely borderline in our climate. In a very sheltered spot near the ocean you might get away with growing them outside all year round but otherwise they are best used as container plants.

- **Pterostachys Lavenders:** This group includes Jagged Lavender (*L. pinnata*) and California Lavender (*L. multifida*). These are the least hardy of all the Lavender groups mentioned.

Given its insect repelling reputation it will hardly come as a surprise that Lavender is usually pest-free. The only minor problem that I have ever noticed is spit bugs. These are those globs of what looks like white spittle that you may see on some Lavender stalks. Inside each spittle glob is a little green bug with big red eyes. They take a little sap, but I have never noticed that they damage the plant to any extent and I consider this to be purely a cosmetic issue. If they bother you, just knock them off with a jet of water from the hose. Otherwise ignore them.

Growing and Harvesting Lavender

All the Lavenders likes full sun and a Mediterranean soil type (see Page 36). As with Tarragon, good drainage is the critical factor. Although Lavender can be grown from seed, germination is slow and the plants themselves are slow to grow to their mature size. By far the easiest method of increasing your stock is either by layering or by taking stem cuttings in the fall or early

spring. After the plants have flowered you can prune the shrubs back to keep them compact and neat. Lavender should be cut for use before the last flowers on each stalk are entirely open. Lay the flower stalks on trays or tie in bundles to dry. Once dry the flowers are easily stripped off the stalks and can then be placed in airtight containers for storage. Lavender holds its fragrance extremely well and even without fixatives a sachet will hold its scent well for at least a year.

Lavender Cotton ॐ
(Santolina chamaecyparissus)
Lavender Cotton is often used as the 'ribbon' in knot gardens because it takes so well to being sheared and shaped. This characteristic also makes it an excellent plant for hedging and edging. The gray-green leaves and button yellow flowers are attractive and this plant, given a situation that it likes, is fully hardy and extremely drought tolerant in our climate. Typically Lavender Cotton will grow to about 2 feet (.6m) high and wide, but it can be kept smaller with trimming or, if you prefer, there is a dwarf form available, *S. chaemaecyparissus* var. 'Nana'. This cultivar grows to about 12 inches (30cm) high.

Growing and Harvesting Lavender Cotton
Lavender Cotton is a Mediterranean herb (see Page 36), needing full sun and a well-drained soil. For planting as a hedge, place plants about 15 inches apart and pinch out the tops to encourage a bushy habit. The plants get straggly if left to their own devices, so cut them back hard in the spring. Lavender Cotton is propagated by cuttings. The leaves can be picked and dried at any time but it is probably easiest to do it when you are shearing the plant anyway.

Lemon Balm ✍

(Melissa officinalis)

The square stalk of Lemon Balm is a clue that this fragrant herb is related to the Mints. Because of that association I was worried, when I first started growing it, that it would have the invasive root system that the Mints are known for. Instead I discovered that the roots were not particularly invasive but that it was necessary to keep a sharp eye on the area downwind of the plant because it likes to self-seed. I like Lemon Balm but

without a certain amount of watchfulness this herb can become a minor nuisance. It is completely hardy in our climate and will take well to container growing.

Growing and Harvesting Lemon Balm

Lemon Balm likes full sun to light shade although it will grow in a wide range of light conditions. It prefers a somewhat dry, well-drained soil. This herb can be grown from seed although the seedlings are slow to germinate so it is usually propagated by cuttings or division. Once you have one plant you just have to check downwind to find all the self-seeded babies you will ever need. The leaves dry easily and can be harvested at any time but I find that they do not hold their aroma very well. I nevertheless dry enough to make tea during the winter months when the fresh leaf is not available. This is one herb that is much the best when used fresh.

Lemon Grass ⌇

(Cymbopogon citratus)

There are several related species which go by the common name of Lemon Grass and are sold as such. I have seen plants labeled "Lemon Grass" at several nurseries which seem to have a clumping form, a fairly short growth habit and skinny dark green leaves. While this plant obviously belongs to the grass family and does have a fragrant lemon aroma, it is clearly not the same plant that I am growing. My plant is much taller, lighter green in colour, with wider leaves and a plump scallion-like base. I acquired my plant at a sale given by the Canadian Herb Society and I noticed that on the tag, along with the common and Latin names, was the printed comment "The real one!"

Growing and Harvesting Lemon Grass

Lemon grass likes full sun, a sandy soil and plenty of moisture during the summer. During the winter cut down on the watering. In the Pacific Northwest this plant is definitely not winter hardy but luckily it takes very well to life in a container and is an attractive and unusual addition to a container garden. I put my plant outside for the summer in mid-May and bring it inside before frost. If you are planning to bring your Lemon Grass inside for the winter, cut it back to about eight inches and dig it up and pot it if it doesn't live in a container year-round. All the cuttings can be dried or frozen for later use. If you are using dried cuttings in a dish it is a good idea to soak them in a little hot water for about 20 minutes first.

In the tropics Lemon Grass can grow to 6 feet (1.8m), but in our climate don't expect more than 3 feet (.9m). Lemon Grass can be grown from seed but many sources suggest that the easiest way to acquire Lemon Grass is to go to your local Asian market and simply look for a plant that still has some root attached. Cut the stems short and plant the roots in a moist sandy soil and they will root easily. Lemon Grass can be harvested at any time. Just cut off the stalks, always leaving enough so that the rest of the plant can regenerate.

Lemon Verbena ❧

(Aloysia triphylla)

I grow my Lemon Verbena in a container. It lives outdoors in the summer and comes indoors for the winter and I always try to put it somewhere where it is easy to brush against or to pluck a leaf from, at least that is my strategy in the summer. This plant has the most intense pure lemon scent of any of the lemon scented herbs and that fragrance is very long lasting. The dried leaves are wonderful for potpourris and sachets.

The problem that I first had with Lemon Verbena was that every year when I would bring it inside for the winter it would grow long and stringy and lose all its leaves. The first time this happened I decided that the problem was probably lack of light so in January I moved the container to the sunniest spot in the house, crossed my fingers, and cut it back hard. Since I have difficulty throwing much away, I potted up the cuttings in a few spare containers. Within a few weeks the mother plant, which had been reduced to a pathetic bare stick, was greening up and bushing out and nearly every one of the cuttings had rooted. The following year, under the mistaken impression that I now understood the situation, I brought the plant in and placed it in the sunniest spot possible. Over the course of the winter the Lemon Verbena did indeed get less long and stringy but it still lost nearly all its leaves and looked very ratty and unattractive.

Most herb books refer to Lemon Verbena as being "half hardy". Other call it a "tender perennial". Some species which are fairly delicate houseplants in our climate are landscape plants in their tropical or semi-tropical homelands and I discovered that Lemon Verbena was one of these. This plant is native to Chile and Peru where it grows as a deciduous shrub. Deciduous? No wonder it was dropping its leaves! Now I don't worry about the Lemon Verbena. I no more expect it to have leaves in midwinter than I would a maple tree. I give it the sunniest spot possible, prune it back in late January and by March it has greened up, bushed out and is ready for business.

Growing and Harvesting Lemon Verbena

Lemon Verbena likes full sun and a rich well-drained soil. I let mine dry out slightly between waterings, particularly in the winter. This plant can be easily grown

from seed or from cuttings. I have never left a plant outside for the cold time, but I make the assumption that Lemon Verbena is not winter hardy in our climate. I put mine outdoors in mid-May and take it in again before frost. Although growing in the warm countries around the Mediterranean Lemon Verbena can reach 6 feet (1.8m) or more in height, it is a good candidate for a container, adapting well and not requiring that container to be huge — my plant has been living in a two gallon container for a number of years without any problems.

As mentioned, I prune my plant every year and thus keep it at about 1 and 1/2 feet (.4m) in height. Although not particularly attractive in midwinter, it soon shapes up after it is pruned back in January. The only pest problem that Lemon Verbena ever seems to have is in the spring when it is still slightly too cold to put the plant outdoors. At that time it becomes attractive to whiteflies. If they become a problem, give the plant a spray with Safer's Soap or a good vacuuming with the small brush attachment. Be sure to spray the undersides of the leaves. The leaves can be harvested at any time that they are available so long as you don't take so many that the plant will have difficulty photosynthesizing.

Lovage ✣
(Levisticum officinale)

Before I ever grew Lovage I remember listening to a couple of Lovage enthusiasts who couldn't understand why everyone in the known universe wasn't growing this herb. After all, here is a completely hardy non-invasive good looking plant that is incredibly useful in countless ways. Why wasn't everyone growing it? I venture to suggest that one of the reasons might be its size. A plot of Lovage, given a few years to reach

maturity, can easily reach 6 feet (1.8m) high by 6 feet (1.8m) wide. As Culpeper noted in his Complete Herbal, "It is usually planted in gardens, where, if it be suffered, it groweth huge and great." This is not a plant to bring indoors, but it might be a show-stopper in a very large outdoor container. How long it would be happy in that situation I don't know, but you could probably get a few years out of it and then turf it out, divide it and root a cutting or two in fresh soil.

As I researched Lovage I soon found that there is no agreement about how one grows Lovage or about its final size. I have seen the figure for height given as anything from 4 feet (1.2m) to 7 feet (2.1m). I suspect that there are a few different issues at play here. firstly, Lovage takes a few years to reach its mature size. A year old plant may only reach three feet. Secondly the type of soil and amount of sunlight can have an influence on the size of the herb. Thirdly in some instances there may be a confusion as to what plant is being called "Lovage". The plant that I am referring to, *Levisticum officinale,* is native to the Mediterranean and Asia Minor. There is a very similar plant, used in precisely the same ways, called Scottish Lovage, Sea Lovage or Sea Parsley (*Ligusticum scoticum*) native to the rocky coasts of Northwest Europe. This herb grows about half as tall as *L. officinale* and has little white flowers instead of little yellow flowers. To add to the confusion there is a third herb known as Alexanders (*Smyrnium olusatrum*) which is very similar in appearance and is sometimes called "Black Lovage".

Growing and Harvesting Lovage
How much sun Lovage needs depends on which book you read. This is another area where arguments abound. I have grown it in everything from full sun to partial shade and I believe that while it may prefer full

sun it is very adaptable and can easily handle quite a bit of shade. Regardless of the amount of light, give it a rich, moist, but well-drained soil. As mentioned, this plant gets very large so have a care about where you plant it. It does particularly well at the back of a perennial border. In the autumn the leaves turn yellow and the entire plant can be cut back.

Lovage is easy to grow from seed or root divisions. Lovage stalks are best used fresh and the leaves can be harvested as they are needed. Some sources suggest pruning the flowers when they bloom in early summer so as to encourage more vegetative growth. Lovage leaves can be dried for winter use or pureed and frozen. Harvest the seeds by cutting the entire seed head and putting it on a tray to dry. See the instructions under Angelica for more detail.

Marjoram ⟿

(*Origanum majorana*, also called *Origanum hortensis*) Although Marjoram is not winter-hardy in our climate, it is such an attractive and useful plant and grows so well in a container that I would not be without it. Marjoram doesn't need a huge pot as it typically grows only about 12 inches (30.48cm) high. The leaves are gray-green and the flowers can be white or pale pinky-lilac. Those flowers come from the rather odd looking pea-like buds and it is these 'knots' which give the plant the common name of Knotted Marjoram.

Botanically speaking, Marjoram and Oregano are very closely related. Marjoram is referred to as 'Sweet Marjoram' and 'Knotted Marjoram' while Oregano is sometimes called 'Common Marjoram' and 'Wild Marjoram'. Then there is Pot Marjoram (*Origanum onites*), which also gets called 'Cretan Oregano', Hop Marjoram (*O. dictamnus*), often called Dittany and Winter Marjoram (*O. heracleoticum*).

Growing and Harvesting Marjoram

Marjoram is one of the Mediterranean herbs (see Page 36) liking full sun and a light well-drained soil. Give it wind protection if possible. It is not hardy in our climate and is either treated as an annual or is over-wintered indoors. It makes an excellent container plant. Marjoram can be grown from seed but it is slow to germinate so it is usually bought as a small plant from a nursery. In either case, do not plant it out until the weather has warmed and there is no danger of frost—it is as tender as Basil. Marjoram can be clipped several times during the year which will keep the plant shrubby as well as supplying a harvest. The leaves can be dried or frozen. Slugs sometimes go after the Marjoram so check for signs of any slug damage. This is another reason why Marjoram is a good herb for a container as a ring of copper tape will solve the problem.

Marshmallow ✎
(Althaea officinalis)

Marshmallow, when in bloom, is almost as tall as its sister plant, Hollyhock (*Althaea rosea*) and although the flowers are neither so large nor so gloriously coloured, it has its own charms. Some say that this hardy perennial herb would be forgotten today if it wasn't for the name. Marshmallow was the original source for the confection of the same name although the commercial product no longer contains anything from this source.

Growing and Harvesting Marshmallow

Marshmallow likes sun but is quite versatile and will grow in a site that gets some shade. It prefers a rich, moist but fairly well-drained soil. This herb can be grown from seed or propagated by stem cuttings in spring, or root division in spring or autumn. The leaves

can be harvested for drying at any time although some sources say that they are at their best just before the plant comes into flower in mid-August. The roots can be dug in the fall.

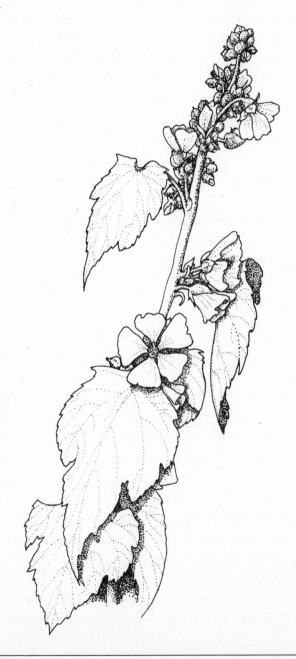

Meadowsweet ❧

(Flipendula ulmaria)

Salicylic acid is found in a number of plants and a few of these, White Willow (*Salix alba*) and Meadowsweet for example, have a long standing reputation for pain relief and the reduction of fevers. It was reportedly from Meadowsweet that salicylic acid was first obtained in the early 19th century and eventually synthesized into acetylsalicylic acid, what we know as aspirin.

Meadowsweet is a hardy perennial usually growing to about 4 feet (1.2m) tall and may be a perfect candidate for that low spot in your garden as it is one herb that positively relishes marshy soils.

Growing and Harvesting Meadowsweet:

Meadowsweet does well in sun or light shade but it must have moist soil and the preference is for a soil that is rich but not too acidic. In nature it is often found growing by rivers or streams in open meadow situations. If we have a late summer drought you may want to give this plant extra water. Meadowsweet can be propagated by seed in the autumn or by division of the root in spring or autumn. For harvesting the root can be dug in autumn and the flowers can be taken while they are in bloom in mid-summer. The leaves can be taken at any time they are available.

Mint ❧

(Mentha spp.)

I love the mints, particularly my two favorites Spearmint (*M. spicata*) and Peppermint (*M. × piperita*), but I am very careful about where I plant them. The Mints are renowned for their aggressive root systems and must therefore be treated with respect when it comes to planting. A piece of Mint planted loosely in a herb

garden will soon take over the entire plot and be quite difficult to remove. The only time I would plant Mint directly in the garden is in its own plot with a very easily defensible and obvious border.

Luckily the Mints adapt well to containers. Even there however they should not be planted with other herbs since they are bullies and will soon take over all the available territory. One trick that works very well is to plant your Mint in a big plastic container (at least 2 gallons and 5 is better) and then to sink that container up to its lip in the garden. That avoids the extra watering and overwintering problems that an above ground container necessitates while stopping the mint roots from taking off. Mint is fairly shallow rooted and I have never had a problem with roots trying to get out the bottom of the container. On the other hand I do keep an eye on the lip of the pot just to stop any roots attempting to make a break for freedom over the edge.

There are at least 25 different species and hundreds of varieties of Mints. The name Mentha is thought to come from the name of a nymphe, *Menthe,* who was turned into the plant by a jealous goddess when Pluto paid her too much attention.

I have heard that Peppermint is sterile but this is not true. It is simply that being a hybrid, the seeds will not breed true. If you want a Peppermint you must grow it from a cutting and not from seed. It is important for gardeners to know these things because not only is it necessary to separate your mints from the rest of your herb garden, it is also a good idea to segregate your mint varieties from each other. I learned this lesson the hard way when I made the mistake of planting Peppermint and Eau-de-Cologne Mint (*M. citrata*) in the same bed. I soon became the possessor of their offspring which I called 'Ghastly Mint' (*M. horrabilis?*) I certainly understand why no one has been interested in

inventing Peppermint perfume! It wasn't long before I discovered that the youngster was even more vigorous and aggressive than the parents and was rapidly taking over. The only solution was to dig out the entire bed and start over.

All the Mints that I have grown have been fully hardy in our climate with the exception of Corsican Mint (*M. requienii*) which I would classify as only borderline hardy. That is a shame because this low growing ground cover Mint is exceptionally pretty. It is also the only Mint to use if you plan to make home-made Creme de Menthe. I tried making it with Spearmint and the result tasted like a particularly nasty alcoholic toothpaste.

Along with Spearmint and Peppermint there are many more mints now available at the nurseries. Like the Basils there is a very wide range of fragrances and tastes and they cannot be used interchangeably. All tend to have a minty fragrance and many are a combination of mint with a fruity essence—Grape Fruit Mint, Lemon Mint, Lime Mint, Lavender Mint, Pineapple Mint, Orange Mint and so on. How fond you are of them will depend on how much you like a mixture of the two fragrances. Quite frankly I would rather use real Ginger and real Spearmint than have to make do with Ginger Mint which is quite pleasant but is not the best of both worlds. Here are a few that you might find at the nursery:

- **Apple Mint** (*M. suaveolens*): leaves are sweeter smelling than many mints with a hint of apple fragrance. This is a useful culinary variety and is also excellent for potpourris. It can handle drier sites than some others mints.
- **Bowles Mint** (*M. rotundifolia*): Said by some to be even better than Spearmint for making Mint Sauce.

- **Chocolate Mint** (*M.* × *piperita* "Mitcham"): It really does have an interesting chocolate-minty fragrance. A nice tea herb.
- **Corsican Mint** (*M. requienii*): Very small ground cover mint, not reliably hardy in our climate.
- **Curly Mint** (*M. spicata* 'Crispata'): has crinkled leaves and a milder Spearmint flavour than does true Spearmint.
- **Eau-de-Cologne Mint/Bergamot Mint** (*M. citrata*): Very fragrant and does smell like Eau-de-Cologne. Not a fragrance I would use in cooking, and it is not used medicinally, but an excellent potpourri, sachet and bath herb.
- **Ginger Mint** (*M. gentillis*): A ginger-mint combination, perfumey and nice for teas and as a bath herb.
- **Pennyroyal** (*M. pulegium*): See Page 168 for information.

Growing and Harvesting Mints

The Mints need more shade than many other herbs, another reason to avoid putting them with the sun-loving Mediterranean herbs. They grow well in partial or dappled shade, liking a rich moist to downright boggy soil. Although they prefer a rich soil, and I usually top dress the Mint patch with manure or compost in the spring, they are very far from fussy. These are very easy care perennials except for their invasive root systems. As mentioned, you propagate the Mints by division and any bit of root dug up from a Mint patch will root again given the opportunity.

The Mints can be harvested just before flowering for your winter supply. Otherwise you can take fresh leaves at any time. These plants dry easily and well and retain their fragrance for a good length of time.

Mugwort ⌁

(Artemisia vulgaris)

Mugwort is one of those large rather weedy looking plants with a reputation for being 'vigorous' that should only be planted with great caution in an area that can be fairly easily controlled. This herb can grow to be 5 feet (1.5m) or more in height and has a spreading rhizome which should be treated with respect. Mine is

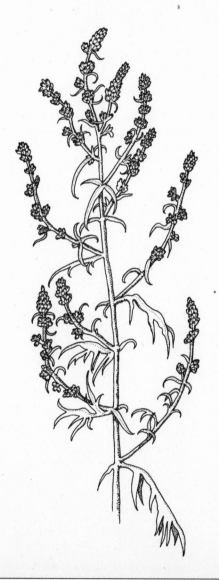

growing in rather poor soil under the shade of a fir tree, conditions which it doesn't like but in this case the plant is so sturdy that giving it a situation where it must struggle only serves to keep it in bounds. Given sunlight and a rich soil it would be positively frightening.

Growing and Harvesting Mugwort

Mugwort likes full sun and a fairly dry, well-drained soil. It can be considered as one of the Mediterranean group (See page 36) of herbs, however in this instance I suggest not giving the plant what it particularly likes because it can get out-of-hand all too quickly. My plant does as well as I would ever want it to do in dappled shade and that is what I recommend. Mugwort can be grown from seed or root divisions taken in the spring or fall. The leaves can be harvested and dried at any time they are available.

Nasturtium

(Tropaeolum majus)

Nasturtiums are a versatile annual, easily grown from seed. They are ideal for getting children interested in gardening because the seeds are big and easily handled and the germination rate is excellent. There are sizes and growth habits to suit just about any taste, from dwarfs and semi-dwarfs ideal for containers and window boxes to larger climbing varieties. While Nasturtiums are sturdy and easy to grow, they are not low-maintenance plants. Individual Nasturtium flowers are relatively short-lived and, as is the way with annuals, the plant wants to flower and then go to seed. If you desire a continuous display of flowers over the summer months you must deadhead (cut off the spent flower) frequently. This cutting off of the older flowers will encourage the plant to put forth more blooms. These flowers are very attractive to hummingbirds and

planting Nasturtiums is a good way to encourage these beautiful birds to visit your garden.

The only pest problem that Nasturtiums seem to fall prey to is black aphids. Although there are poison sprays available, the idea of using one on something that both I and the hummingbirds plan to use for culinary purposes horrifies me. If you must spray use insecticidal soap. A jet of water from the garden hose will knock off most of the aphids or just get out your scissors and a plastic bag and cut off any flowers, stems or leaves that are covered with aphids. The female aphid is a remarkably prolific insect and the real key to control is to look at your plants often and to take care of any problems while they are still minor.

Growing and Harvesting Nasturtiums

Nasturtiums like full sun and a well-drained soil. You will get more flowers if the soil is not overly rich so don't fertilize them. They are very easy from seed but don't like being transplanted so wait until the weather is warm, after the last spring frost, late May is usually the best time, and plant the seeds where they are to grow. Nasturtiums leaves are used fresh during the season but otherwise these plants are not harvested except for the seeds. If you plan to make Nasturtium "capers", pick the seeds while they are still green.

Oregano ✑

(Origanum vulgare)

Oregano is one of the trickiest herbs to buy in a nursery. You are running a good chance that a plant with a tag on it that says 'Oregano' really is *O.vulgare*, but this herb is so variable and hybridizes so easily that the tag alone will not tell you how good it will be in the kitchen. Oregano grows wild from Europe to central Asia and is now naturalized in North America. The

plants vary greatly, sometimes to the point that I think every Oregano plant differs slightly in flavor and pungency. In general the Oreganos from northern Europe are milder and far less interesting than those from around the Mediterranean. My favorite is Greek Oregano. Good Greek Oregano is so pungent that just rubbing a leaf will pick up the aroma with no trouble. If the leaf of any Oregano appears to have little or no fragrance don't buy the plant for culinary purposes; this is a case of what you smell is what you get!

Another 'Oregano' that often shows up in local nurseries is Cuban Oregano (*Plectranthus spp.*). This herb has fleshy, almost succulent-like leaves with small teeth on the front edges. It has a camphor-like scent, makes a nice container plant but it isn't hardy in our climate and is not used in the kitchen.

Growing and Harvesting Oregano

As with most Mediterranean type herbs (See Page 36), Oregano likes full sun and a well-drained soil although it is much more accepting of some amount of shade than are some of the other plants in this category like Marjoram or Basil. Although my Greek Oregano comes from the Mediterranean my experience with it is that it is fully hardy in the Pacific Northwest. This is a tough and adaptable plant and it takes well to container growing as long as the container is large enough.

Oregano is of the Mint family and needs some watching. Although not as bad a spreader as the Mints and easier to lift out of a bed when necessary, it does have a spreading root system which can take over a lot of territory if you don't beat it back from time to time. It can also self-seed. Propagation is by root division, but once you have a clump a sharp tug will be enough to bring out a few pieces with enough of a root to start new plants.

Oregano is best harvested in early summer when the plants are in full bloom. The leaves are easily dried and the fragrance becomes even stronger when they are dried.

Oregon Grape ᠵ

(Mahonia acquifolium, Berberis acquifolium)
Although some older sources still list the Oregon Grapes as members of the *Berberis* genus, they are now usually split off and listed as members of the smaller genus of *Mahonia*. The name *Mahonia* is a reference to Bernard McMahon, an Irish horticulturist at whose kitchen table it is believed the Lewis and Clark expedition to Oregon was planned. These *Mahonias* are easily recognizable as they are the only evergreen native species with a holly-like leaf. All of the Oregon Grapes are useful landscaping plants. They can stand up to our rains and at the same time are exceptionally drought tolerant and are often used in xeriscaping projects.

I say "all of the Oregon Grapes" because there are a number of related species, all carrying the common name of Oregon Grape. These plants are native throughout Western Canada and the United States, growing from British Columbia and Alberta south to California, New Mexico and West Texas.

The most important difference between the Oregon Grapes is the size of the plant. For example, Tall Oregon Grape (*M. acquifolium*) is a large shrub which can grow to about 10 feet (3m) although it is more common to see specimens at about 5 or 6 feet (1.5m or 1.8m). The intensely yellow flowers which cover the top of the bush are one of the delights of April as is the new growth which comes in quite coppery in colour, turning dark green as the year progresses. Dull-leaved Oregon Grape (*M. nervosa*) is a much shorter plant,

growing to about 2 feet (.6m) and Creeping Oregon Grape (*M. repens*), is smaller again and is typically used as a ground cover.

Growing and Harvesting Oregon Grape

The Oregon Grapes are enormously tough versatile garden plants, completely hardy and evergreen in our climate. *M. aquifolium* works well as a hedge or as a single specimen plant. All can manage in a fairly wide range of light conditions but *M. aquifolium* likes the most sun. *M. nervosa* and *M. repens* prefer dappled shade. In nature *M. aquifolium* in particular often grows on dry soils, so making sure that these plant have good drainage is important. *M. repens* likes a wetter soil although it is not a bog plant.

All the Oregon Grapes are easiest to propagate from seed and apparently even easier if the seed has been through a bird first. Since the plant is evergreen, the leaves are available throughout the year. The berries ripen in the fall and it would be wise to remember their laxative quality and to ingest them conservatively.

Orris Root ᴠ

(Iris pallida & Iris germanica var. *florentina)*
The name Iris comes from the Greek word for rainbow, which is fairly descriptive of the wide variety of colours that the flowers of this genus offers to gardeners. The 'orris' comes from Iris and refers to the root stock which is justly famous as a fragrant plant-based fixative for perfumes and potpourris. The root has been used for this purpose since ancient times and it was familiar to both the ancient Egyptians and the Greeks.

The powdered root which is used in this fashion comes from several species of Iris, most notably the

big white *Iris germanica* var. *florentina* and the smaller pale blue *Iris pallida*. Even if you never dig them up for the roots, these Irises are lovely garden-worthy plants. The white florentine Iris has grown near Florence since medieval times and it appears on that city's heraldic crest.

Growing and Harvesting Orris Root

Although these Irises come from a warmer climate than ours, they are completely hardy in the Pacific Northwest so long as they are given a sunny site and ordinary soil with good drainage. A sandy, sweet Mediterranean soil type (See Page 36) is the ideal. They are propagated by division and the best time to do this is after they have bloomed in the late spring.

The biggest problem with growing them is that the slugs and snails love them. They will rasp their way up the strapping leaves leaving unsightly tears and holes. They will, like miniature lumberjacks, gnaw through the flower stalks until they fall over. However the slugs might make a mess but they won't kill the plants.

The roots should not be dug until the third year and some books say the fourth year. They can then be cut into small pieces and dried. As they dry they will take on the lovely and characteristic scent of violets. They are typically dried for two years before being ground into Orris powder.

Parsley ᔰ

(Petroselinum crispum & P. crispum var. neopolitanum)
Of all the herbs I could mention, Parsley is perhaps the most well known. It is the most common garnish for any number of foods and as such is often put to the side of the plate as mere decoration. This is a shame since this biennial herb is an excellent source of Vitamin C, iron and iodine and, aside from being very

good for you, will sweeten your breath. It is particularly useful in this regard if you have been eating foods containing Garlic.

There are over 20 cultivars of what we would recognize as Parsley including some interesting dwarf and compact forms, but the three basic types are Curly-leaved or Curled Parsley (*Petroselinum crispum*), Celery-leafed Parsley (*P. crispum* var. *neopolitanum*), also known as Italian Parsley, Flat Parsley and Plain-leaved Parsley and Turnip Rooted Parsley (*P .crispum* var. *tuberosum*), also known as Hamburg Parsley. Italian Parsley is hardier than Curled Parsley but Curled Parsley is the type most commonly sold and the type most often used as a garnish. Having grown both types I would give Italian Parsley somewhat higher marks for kitchen use, but both sorts appear to be fully hardy in our climate. In a mild winter they may even remain evergreen. Curled Parsley in particular can make a very attractive border plant in an herb or vegetable garden.

Growing and Harvesting Parsley

Parsley likes sun although it will manage fine in light shade. It prefers a rich, moist, well drained soil. This herb is a biennial, forming leaves the first year and flowering and producing seed heads in the second year. In that second year you can remove the flower stalks as they appear and this will prolong the life of the foliage. Parsley is grown from seed, but as mentioned, germination is notoriously slow. Soaking the seeds before planting will speed germination but if you are starting your Parsley outside you might want to plant a few Radish seeds along with it just to mark the area until the Parsley comes up. If you are sowing seed indoors be sure to transplant the seedlings when they are quite young as this is another plant with a taproot that doesn't like to be disturbed. Parsley is also a good

self-seeder and if it is growing somewhere where it is happy will quite likely replenish itself. In the third year check for 'volunteers' in the area in which it was planted and these can be separated and transplanted should you wish.

Parsley is much the best when it is fresh. Home dried Parsley is weaker in flavour and almost not worth bothering with. Parsley can be frozen which keeps the flavour nicer but it is useless as a garnish. Perhaps the best idea if it is possible is to grow a few plants in containers and to bring them indoors for the winter for fresh harvesting as needed.

Pennyroyal

(Mentha pulegium)

Pennyroyal, often called English Pennyroyal, is a low growing member of the Mint family native to Europe. It was first brought to North America by the Pilgrims. Its prostrate habit and bright green colour make it particularly appealing when it is grown between paving stones. Most of the Mints are natural insect repellents to some extent, but the very best of these is Pennyroyal. The Latin name *pelegium* indicates that this was the plant one used to rid the house of pulices— fleas. Since the Middle Ages this plant has been used as a strewing herb and as an ingredient in sachet mixtures. The leaves were also dried and burned to produce an insect repelling smoke. The 'royal' comes from its use in keeping the English royal apartments clear of fleas.

Growing and Harvesting Pennyroyal

Pennyroyal will take more sunlight than most of the mints so long as it is in a rich moist soil. It must not dry out, so it is easier to grow it in partial shade if your sunny areas get bone dry in our summer droughts. It

can be started from seed and it very easily propagates from pieces of the rooted stem. The leaves can be harvested throughout the season.

A Word of Caution

Pennyroyal contains a toxic oil which can cause irreversible kidney and liver damage. Do not take it internally for any reason and do not use Pennyroyal oil on cats.

Pinks & Carnations

(Dianthus spp.)

Be warned. Members of the *Dianthus* genus can have a curious effect on a sensible person's buying habits. This is an addictive group of plants. The American Dianthus Society has a header on their membership brochure which reads "This brochure may be hazardous to your petunias." They aren't kidding. It is rare to find a gardener who can limit himself to only one variety. If you decide to collect *Dianthus* cultivars you will be busy for a long time since the Royal Horticultural Society's "International Dianthus Register" records about 30,000 of them. Unfortunately some of the wonderful old-fashioned varieties, the kind you might remember seeing growing in grandmother's garden, are no longer commercially available. Equally unfortunately the breeders who have gone for size of flower, colour, number of petals and so on seem to have forgotten about fragrance. Some of the modern cultivars look lovely but are almost scentless. If you want fragrance, try to buy your plants when they have a few blooms already open so that you can tell you are getting something you will be happy with.

Pinks and Carnations are a natural addition to a cottage garden and are very much at home amongst herbs. Even when they are not in bloom the gray-green

foliage of most varieties is very attractive. Their variety of sizes and growth habits gives much scope to the garden designer. Some are small and compact, ideal for the front of the border. Others have a more lanky growth and are at their best spilling over a garden wall or gracing the side of a big container. None of these plants are aggressive and although there is a range of hardiness (my experience is that Pinks tend to be somewhat hardier than Carnations), most appear to be hardy in the Pacific Northwest so long as they are given the siting and soil that they prefer. Well situated they are drought tolerant and usually pest-free. A few of the better known Dianthus are:

- **Alwoodii Pinks:** (*D. caryophyllus* × *plumarius*) Hybrid perennial Pinks. As the botanical name indicates, they are a range of hybrids produced by crossing Cottage Pinks and Carnations derived from *D. caryophyllus*.
- **Carnation/Clove Pink:** (*D. caryophyllus*) Thought to be the parent of all garden carnations.
- **Cheddar Pinks:** (*D. gratianopolitanus*) Usually very fragrant. Perennial.
- **China Pinks:** (*D. chinensis*) Used to hybridize for its repeat flowering characteristic. Biennial or short-lived perennial.
- **Cottage Pinks:** (*D. plumarius*) This is the parent of many of the "old-fashioned Pinks" and they have the characteristic central "eye".
- **Deptford Pinks:** (*D. armeria*) Biennial.
- **Maiden Pinks:** (*D. deltoides*) Perennial.
- **'Mrs.Sinkins':** (*D. plumarius*) Strongly scented with white fringed petals.
- **Sweet Williams:** (*D. barbatus*) Multi-headed, unlike other plants in this genus. Biennial or short-lived perennial

Growing and Harvesting Pink & Carnations

All the members of the *Dianthus* genus like an open
sunny situation and are amongst the Mediterranean
group of herbs (see Page 36). As with many herbs in
that group, these are plants that require excellent
drainage to do their best. As for pH, they prefer a situa-
tion that is at least neutral—they are not happy in an
acidic soil and I suggest adding a bit of dolomite lime
to the soil mix when planting and top dressing with a
bit more from time to time.

Perennial Pinks can be grown from seed but they are
generally propagated by root division or layering in late
summer. Dianthus can also be grown from cuttings
taken in late spring or early summer. Since the majority
of these plants are hybrids you might get some interest-
ing plants from growing them from your own seed but
you cannot expect them to breed true. Pinks and Carna-
tions look better and have a longer bloom period if they
are deadheaded. Some plants will have an additional
bloom period in the autumn if this is done. The only
part of these plants that is harvested are the flowers.
Take them as needed to be used fresh or, to dry them,
try to collect them in the morning, once the dew is off.

Rosemary ⟩⟩

(Rosmarinus officinalis)

Just how tough is Rosemary? Is it capable of dealing
with our climate? There is an ongoing argument
amongst Northwest Coastal gardeners on this point.
Perennial grey-green Rosemary with its shrubby good
looks and endless culinary and household uses is a
delight, but it can also be one of the most frustrating of
plants where winter hardiness is concerned. Rosemary
is not tender in the way that Basil is. It will typically
stand up to three out of four of our winters but just
when it has grown up into an exceptionally lovely

shrub, we will get that particularly hard winter and the Rosemary succumbs. That had been my experience until I discovered 'Arp', a Rosemary cultivar which I have found to be significantly hardier than any other.

If you talk to a gardener who lives closer to the ocean than I do you might get an entirely different story. The Pacific Northwest has a number of climate zones and, more to the point, a lot of microclimates. Some plants are fully hardy anywhere in the area and others, like Rosemary, walk on the borderline. Whether Rosemary will be hardy in your garden is something that you must discover for yourself. Having said that, there are some basics that will give your Rosemary the best possible chance and I have included them in the growing instructions.

Growing and Harvesting Rosemary

Rosemary grows naturally in rocky, fast draining limy soils and full sunlight. It is very definitely one of the Mediterranean group of herbs (see Page 36). In reference to the remarks I have already made about Rosemary's winter hardiness, there are several strategies that will give you the best chance of success in our climate. This is a herb where good sharp drainage is absolutely key to long term survival and Rosemary also doesn't appreciate cold winds so a very sheltered sunny spot is required. I have also found that the variety or cultivar of Rosemary makes a big difference. Prostrate and creeping varieties of Rosemary tend to be less hardy than upright forms and the hardiest upright cultivar that I have grown is 'Arp'. Another hardier Rosemary that I haven't grown yet is 'Hill Hardy'. 'Arp' has a slightly bigger leaf, and is a bigger plant altogether, than the form you might be used to, but it is every bit as kitchen worthy.

Rosemary is a terrific container plant so I now grow

'Arp' in the garden and a creeping Rosemary in a container that I bring inside for the winter. It is possible to grow Rosemary from seed, but it is quite slow. This plant grows very easily from cuttings and for years, when I was growing less hardy varieties, I would take cuttings off the mother plant in the fall to grow indoors over the winter. Rosemary can be used fresh or dried although the fresh herb is stronger. Since the plant is evergreen, leaves can be taken as needed. You can use the rosemary sprigs "as is", much as you would a bay leaf for flavouring and then removing or you can strip off the leaves and mince them. Rosemary is quite strong, so be moderate with your use until you are sure that you like it.

Bog Rosemary ᧕

(Andromeda polifolia)

I have a horror that because this plant is called "Rosemary" some people may be under the mistaken impression that it can be used in the kitchen. Although I have read that some First Nations healers made a medicinal tea from the leaves it must be noted that Bog Rosemary contains a toxin, andromedotoxin, which is quite dangerous. It can cause diarrhea, convulsions, paralysis and even death. This is one plant that is pretty to look at but best left out of the kitchen. Its physical resemblance to a Rosemary is the only connection that these plants have.

Bog Rosemary is a grey-green evergreen shrub native to northern North America. In spring the plant is covered with small but very pretty pink flowers. In the wild it is most often found in peat bogs where it grows beside Labrador Tea to which it also bears a strong resemblance when the plants are not in flower.

Growing and Harvesting Bog Rosemary

Bog Rosemary is fully hardy in our climate with a liking for very boggy acid soils and sunlight. If you have a boggy sunny spot in your garden this is a very attractive shrub but it is not easy to grow in other circumstances. Bog Rosemary hates to dry out and in a situation which is not to its liking it will soon become a problem. Harvesting of Bog Rosemary is not recommended.

Rue ᒡ

(Ruta graveolens)

Rue's vivid blue-green leaves make it a handsome ornamental plant for the middle of a perennial garden. This shrub grows to about 3 feet (.9m) high and has small greenish-yellow flowers in mid-summer but I think it looks better when it is not in bloom. There is now a cultivar, 'Jackman's Blue' which produces no flowers so obviously others have had the same opinion. There is also a cultivar with cream or white variegations called, logically, 'Variegata'.

Growing and Harvesting Rue

Rue likes full sun and a well-drained soil and is in the Mediterranean group (see Page 36) of herbs. It can be propagated from seed, cuttings or root divisions in spring or fall. The part used are the leaves which can be harvested at any time; but only harvest this herb if you wish to use it as a strewing herb for its insect repelling qualities.

A Word of Caution

Wear gardening gloves when handling Rue. Some people are allergic to it and it can cause a dermatitis and even skin blistering.

Sage

(Salvia officinalis)

The Salvias are a huge and attractive genus with over 900 species world-wide, but the one that both the herbalist and the cook are most interested in is *Salvia officinalis,* also known as Garden Sage. Garden Sage is a small sub-shrub, typically growing to about 2 feet (.6 m) with grey-green leaves and, when in bloom, beloved of bees and butterflies. *S. officinalis* is immensely variable in both leaf and flower colour. The flowers can be white, pink, purple or lavender although the lavender form is most common. This plant is so attractive when in flower that it is well worth growing as a fine garden perennial, regardless of any other use you may put it to.

The leaves can be as diverse as the flowers, sometimes variegated with purple, rose, yellow and cream in a variety of patterns. This has given rise to many cultivars with particular leaf shapes and colours. Perhaps the best known of the cultivars are:

- *S. officinalis* **'Albiflora'**: leaves are green, flowers are white.
- *S. officinalis* **'Aurea'**: leaves are golden.
- *S. officinalis* **'Berggarten'**: wider and more rounded leaves.
- *S. officinalis* **'Compacta'**: narrower leaves, a smaller plant altogether.
- *S. officinalis* **'Icterina'**: leaves are green with a gold margin.
- *S. officinalis* **'Purpurascens'** or **'Purpurea'**: leaves are purple-red.
- *S. officinalis* **'Tricolour'**: grey-green leaves with cream, yellow and rose markings.

The old-fashioned grey-green Garden Sage is hardy in our climate, but all the cultivars are less hardy than the old original. Of the cultivars that I have grown I

would categorize 'Aurea' and 'Purpurescens' as only slightly less hardy and 'Tricolour' as much less hardy. Of course protection from winds, good drainage and all the other usual factors will determine the winter hardiness of these more borderline plants in your garden. Other Sages which sometimes appear in herb collections are Fruit Sage (*Salvia dorisiana*), Pineapple Sage (*Salvia elegans* or *S. rutilans*) and Spanish Sage (*S. lavandulifolia*). All are tender perennials and must be brought inside for the winter if you wish to grow them. Pineapple Sage in particular is extremely attractive with bright red flowers which bloom in late summer and pineapple-scented leaves. It makes an excellent container plant.

Growing and Harvesting Sage

All the Sages prefer full sun and a well-drained soil. They are in the Mediterranean herb group (see Page 36). Sage is typically propagated by root cuttings, division or layering. Garden Sage can be grown from seed, but the cultivars are a trickier item. Even if you can get them to flower and set seed, you can still not count on them to breed true. Although this plant is perennial it becomes woody and straggling as it ages so the old plants are usually dug up and replaced every few years. The older plants also seem to lose vigor and you are more likely to lose an older plant in a harsh winter. Sage leaves can be taken off the bush as needed. When harvesting for winter use, the best time to gather the leaves is just before the plant flowers. The leaves take well to either drying or freezing.

Clary Sage

(Salvia sclarea)

Another Sage which sometimes shows up at local nurseries is Clary Sage, a large biennial herb growing to a

height of approximately 3 feet (.9m) with white, light blue or purple flowers.

Growing and Harvesting Clary Sage:
Clary Sage is another herb of the Mediterranean group (see Page 36) liking full sun and a well drained soil. It is usually grown from seed and is borderline hardy in our climate and may require some winter protection.
Leaves can be used fresh or dried. For drying they are best picked before the plant flowers.

Salad Burnet ⬎
(Poterium sanguisorba)
As the name suggests, Salad Burnet is a useful plant to have around when it comes time for making salads. This hardy perennial with its small and lacy leaves with their mild cucumber flavour are a welcome addition to just about any salad. To add to its charms, this plant is almost evergreen in our coastal climate so the leaves are available at times of the year when not much else is showing in the garden. The Burnet leaves grow along a wiry stem but it only takes a moment to run your hand top to bottom down the stem, removing the edible leaves from the tougher stem. The younger leaves are by far the most tender so I give my plants a trim several times a year, thus promoting new growth. The 'Salad' part of the name is easily understood and the 'Burnet' was originally 'brunette', a description of the colour of the reddish-brown flower heads which look rather like tiny pine cones. These appear in summer, shooting up on long stalks from the middle of the clump.

I really don't understand why Salad Burnet is not a more popular herb in North America. It is completely hardy in our climate, easy to grow, available when other fresh greens from the garden are in short supply,

pleasantly flavoured and high in vitamin C. The leafy clumps are attractive and this herb does not have an aggressive root system to worry about. The flowers are not particularly exciting but most sources suggest that you cut them off to encourage leaf growth anyway. Some of those same sources indicate that this is also a good idea because Burnet can self-seed, but I have never known this to be a problem—certainly not on the scale that Lemon Balm can become if you are not watchful.

Growing and Harvesting Salad Burnet
Salad Burnet can be considered as one of the Mediterranean herbs (see Page 36) and most accounts make note that it prefers a chalky (limy) soil so, if you have the typical acidic soil of our area you will want to dig in some extra dolomite lime when planting. This herb also likes full sun but it is far from finicky and will grow quite well in less than optimum conditions. Burnet can be propagated by seed sown in the spring or fall or by root division in autumn. The leaves don't dry very well and are better frozen but, since it is prac- tically evergreen in our climate, I usually don't bother with this and just harvest fresh leaves as needed.

Salal 〜

(Gaultheria shallon)
In talking to another gardener, I heard about a problem that a number of West Coast gardeners must deal with She told me that she had a large Cedar tree in her back yard and could find nothing that would grow under it. Most plants found the shade, competitive cedar roots and the acidic soil quality far too difficult to deal with. She was thinking of giving up and just placing a group of containers under the tree but that seemed like a lot of maintenance. It occurred to me that Salal might be

the answer to her problem. This tough native plant can deal with this type of situation with equanimity. When I suggested Salal she looked at me in horror and replied "But that is what I just finished digging out from under there!" For once in my life I managed to keep my mouth shut.

Salal would typically be thought of as a medium-sized shrub, but its height is extremely variable—anything from about 1 to 10 feet (.3m to 3m) or more in particularly favorable conditions. In the Native Plant Garden at VanDusen Botanical Gardens in Vancouver it can be seen growing as a thick ground cover, about 3 feet (.9m) high under a canopy of trees. Such Salal thickets are important cover for many wildlife species and many small mammals and birds enjoy the berries. The shiny leathery Salal leaves are browsed by both deer and elk and this plant is an important winter food for deer. If you want to attract wildlife to your garden, growing a Salal thicket will certainly help.

Growing and Harvesting Salal

When once established Salal is a very tough fully hardy drought resistant plant which will grow in a fairly wide range of circumstances. This plant has a spreading root system and can become very aggressive so situate it

with care. Salal can tolerate anything from full sun to rather a lot of shade and is often found naturally growing as thickets under a canopy of trees. In full sun it will grow very quickly which is why it is so often seen taking over clearcuts. It prefers a moist, peaty soil but again, it is fairly broad in what it will accept. Salal is typically grown from cuttings. Growing from seed is a slow business.

Salal is now quite widely available at nurseries and I urge you to acquire your plant from that source and not to pick it in the wild. Given how slow Salal can be to root and grow when started, you will be much happier with an older, nursery grown plant and you will be helping the environment instead of disrupting it.

Winter and Summer Savory ∽

(Satureja montana & Satureja hortensis)
Winter and Summer Savory have a similar flavour although Winter Savory is a bit stronger and sharper. Both herbs have been used in the kitchen although most critics agree that Summer Savory is the better culinary herb. The big difference between these two herbs is that Summer Savory is an annual growing to about 1 and 1/2 feet (.4m) and Winter Savory is a hardy perennial rarely growing to more than 1 foot (.3m) in height.

Growing and Harvesting Savory
Both the Savories like full sun and are in the Mediterranean group (see Page 36) of herbs. I treat my Summer Savory like I do my Basil, starting it indoors in spring and not putting it outdoors until the weather has warmed up. Once established, Summer Savory may self-seed for you. Although the leaves of Summer Savory may be picked at any time, and a little tip pruning makes a bushier plant, the main harvest for

drying is just before the plant flowers in late summer. My experience with Winter Savory is that it is completely hardy in the Pacific Northwest. It simply grows slightly bigger every year in a very neat and mannerly way. Like Sage, it can get woody with age, but new plants are easily started from cuttings or division in spring or autumn.

Soapwort

(Saponaria officinalis)

I am still trying to get the Soapwort out of some parts of my garden. This is a useful herb and the clusters of fragrant pink flowers are delightful but in our climate the root system can be as invasive as the Mints. There are now Soapwort hybrids available at local nurseries which are smaller and much better behaved, but the original plant should be treated with caution.

Growing And Harvesting Soapwort

Soapwort does well in an average moist soil, preferring full sun but accepting light shade. This is a tough hardy plant and has no problems with our climate or soils. As far as I have observed, the slugs leave it entirely alone. Propagation is by division of the plants in spring or fall. Just about any piece of the underground root is quite capable of forming a new plant. As mentioned, those roots can be invasive (See the section on Mints for planting suggestions) so choose the site carefully. The plant can be harvested as required.

A Word of Caution

Soapwort has in the past been used as a fish poison, so don't plant it anywhere near your fish pond and don't use it internally.

Sorrel ∿

(Rumex acetosa & Rumex scutatus)

There are several plants that get called 'Sorrel', but the two that are of most interest to the herbalist or the cook are Common or Garden Sorrel (*R. acetosa*) and French Sorrel (*R. scutatus*). Garden Sorrel is native to temperate climates around the world and French Sorrel is native to Southern Europe and the Mediterranean. Both Sorrels are entirely winter hardy in the Pacific Northwest.

The leaves of both of these plants have a lemony sourness and it is from this trait that the common name of Sorrel comes, from the old French surele, meaning sour. From this source also comes the common name of Sourgrass. French Sorrel is also called Buckler-leaved Sorrel, a description of the shield-shaped leaves. It is a smaller plant than Garden Sorrel and the leaves are less bitter. This is the type that is best for use in the kitchen.

Garden Sorrel has another use of interest to gardeners. The leaves accumulate phosphorus, calcium and magnesium so they are an excellent addition to your compost heap.

Growing and Harvesting Sorrel

Sorrel does best in full sun and a rich, moist soil. This plant loves compost and will benefit by a top dressing every spring. Cut off the flower stems as they appear so that the plant is spending its energies producing the succulent leaves. Removing the flower stalks also prevents the plant from self-seeding and becoming invasive. Sorrel can be grown from seed or propagated by division in the spring or fall. The leaves are most tender in early spring and it is at this time that they would be taken for salads. They can be taken later in

the year if you are planning to cook them but they should not be eaten in quantity.

A Word of Caution
Sorrel contains a lot of Oxalic acid which can be poisonous in large doses. This plant should be avoided entirely by small children and anyone with kidney problems, rheumatism, asthma or gout.

Southernwood ᧞
(Artemisia abrotanum)
Southernwood grows into a bushy shrub, about 3 feet (.9m) square. The strongly scented soft green feathery foliage looks wonderful when planted next to herbs with grayed foliage like Lamb's Ears or Lavender and a group of Southernwoods planted together as a small hedge can be quite spectacular in the right season. This shrub is perfectly hardy in our climate, but because it is deciduous, it doesn't look terrific in winter. Take this into account when planning its placement. Southern-wood's natural tendency is to get bigger and more straggly than you would like, but that is easily remedied by an early spring's pruning. Once clipped and shaped, Southernwood will soon plump out with fresh growth and it will do it from everywhere on the plant. You will not be left with green on top and unsightly bare branches on the bottom.

Growing And Harvesting Southernwood
Southernwood is one of the Mediterranean group of herbs (See Page 36). It will grow in nearly any soil but does require good drainage. It is best propagated by cuttings taken in the spring or fall. The branches can be harvested at any time they are in leaf.

Sweet Cicely ৵

(Myrrhis odorata)

Fragrant Sweet Cicely with its bright green anise-scented ferny foliage and its liking for shade is one of those herbs that I would grow as a landscape plant even if I never used it in any other way. It is particularly effective grown amongst Hostas, where the difference in leaf texture and colour makes an effective garden picture. This is a large and sprawling plant, growing 4 or 5 feet (1.2m or 1.5m) high, but if you have room for it, its many charms will soon capture you. Every part of this plant is fragrant and when Sweet Cicely is in flower it is beloved by bees.

Growing and Harvesting Sweet Cicely

Sweet Cicely is an adaptable plant although it prefers a shady sitation and a rich, moist but well-drained soil. It is completely hardy in the Pacific Northwest. Sweet Cicely can be propagated from seed and has a somewhat self-seeding habit so it should be watched to see that it doesn't get out-of-hand. It has a taproot which, in the spring or fall, can be divided so long as each section has a bud. The self-sown seedlings are also easily dug and replanted and are one of the few taprooted plants that doesn't seem to mind this treatment. The fresh herb is available over a long season and the leaves and seeds can be dried. See the entry on Angelica for information on dealing with the seed heads of umbelliferous plants.

Sweet Gale ৵

(Myrica gale)

If you rub a leaf of Sweet Gale the fragrance given off is both spicy and sweet and unlike any other herb I know. The closest approximation would be Bay leaves and

indeed some people use Sweet Gale leaves in place of Bay leaves for culinary purposes.

Sweet Gale is a deciduous shrub, growing to about 5 feet (1.5m) and preferring a boggy soil which accounts for one of its common names, Bog Myrtle. Like its close cousin Bayberry (*M. pennsylvania*), or the Hollies for that matter, Sweet Gale bears male and female flowers on separate plants and you will need two plants of different sexes growing in the same area if you want the 'berries', actually little green nutlets. The entire plant is fragrant and Sweet Gale buds and leaves can also be harvested. They are often dried and then ground into a spicy powder for kitchen use. Other common names for this plant are Wax Myrtle and Candle Berry, names it shares with Bayberry.

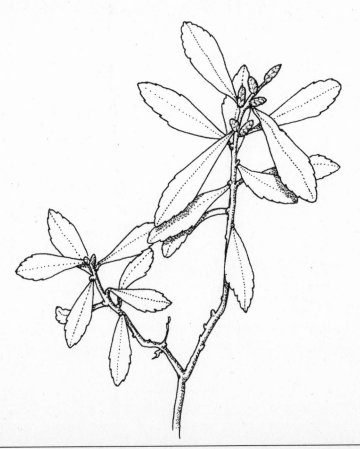

Harvesting and Using Sweet Gale

Sweet Gale grows naturally in bogs so look for a low spot. A waterlogged, peaty, acidic soil is ideal. As for sunshine, I found one source that said to grow this plant in shade and another that suggested full sun. My plant is growing in light shade and appears very happy so perhaps the range it will accept is quite broad.

Sweet Gale can be propagated by division or from cuttings. The leaves can be harvested at any time they are available in the spring or summer. The buds can be harvested in early spring.

A Word of Caution

Sweet Gale contains a volatile oil which can be toxic. This oil evaporates easily when making tea but could be quite dangerous if you made a decoction in a covered pot. No such mixture should be taken internally.

Sweet Woodruff

(Galium odoratum)

Sweet Woodruff is a very pretty low-growing ground-cover. Depending on the amount of sunlight that it is getting it will grow anywhere from 6 to 8 inches (15cm to 20cm) in height. The four-petalled little starry white flowers bloom in the spring at the same time as the Grape Hyacinths and Tulips, not only making a lovely picture, but also hiding the bulb foliage as it dies down. One of my great learning experiences with gardening in our climate has occurred when I have planted some pretty little pot of something-or-other and then watched in horror as the plant in question proceeds to take off and spread absolutely everywhere. In our rainforest climate the difference between a good ground-cover and an invasive menace can be very slim indeed and Sweet Woodruff walks that borderline.

Growing and Harvesting Sweet Woodruff

Sweet Woodruff likes a rich moist soil and dappled shade although the range of light conditions that this plant will tolerate is very wide. It is best grown from the division of the clumps in either spring or fall and to say that they will root easily is an understatement.
Once a clump is established it will spread out by underground roots and the next piece of Sweet Woodruff you

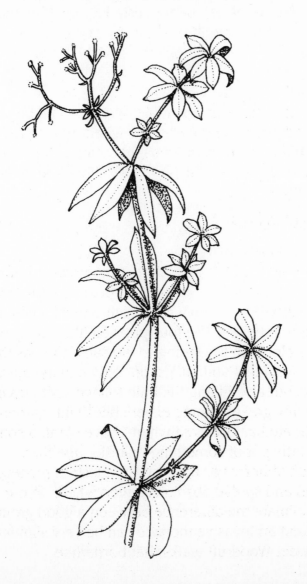

see will be coming up 12 inches away from the mother clump. Although this plant does not send roots deep into the soil it is extremely difficult to get out of a bed when once planted unless you are willing to take absolutely everything else out of the bed at the same time. Sweet Woodruff roots are small and skinny and have a positive genius for wrapping themselves around the root systems of every perennial growing near them. If you have a clearly defined area for your Sweet Woodruff to inhabit and can keep it under control this is a useful and beautiful plant. Sweet Woodruff flowers are used fresh when they are available in the spring. The leaves can be picked and dried at any time during the season.

A Word of Caution

Taken internally in large doses Sweet Woodruff can be poisonous. It contains coumarin, a chemical about which there is current debate. No amount should be taken internally by pregnant women or anyone taking anticoagulant medication.

Tansy ✿

(Tanacetum vulgare)

Tansy, in particular the variety known as Fernleaf Tansy (*Tanacetum vulgare* var. *'Crispum'*), is a very attractive plant growing about 1 and 1/2 feet (.4m) high with yellow button flowers. Having said that, I must admit that even this variety, which is shorter and less invasive than the wild version, has an aggressive root system which is a match for the Mints. This is another herb that is best grown in a container or otherwise seg-regated from other herbs and kept in a controlled situation. Along with the root system Tansy self-seeds fairly prolifically so if you want to grow it remember to cut off the flower heads or you will have it everywhere.

Tansy is native to Europe and Asia although it is now naturalized in many parts of the world including the Pacific Northwest. You can find the wild plant growing in abundance in many country areas, road allowances and abandoned lots. In my neighbourhood there is so much of it growing wild that I don't bother with it as a garden plant. A short walk around the neighbourhood is all it takes to gather as much Tansy as I will ever need.

Growing and Harvesting Tansy
Tansy likes full sun and a Mediterranean soil type (See page 36). It can be propagated by seed or by root division in the spring or autumn. As mentioned, this is an aggressive and invasive plant; some would be even more blunt and call it a weed. Even the more garden-friendly varieties should be treated with caution. The leaves can be harvested and dried throughout the season.

A Word of Caution
Tansy is in the same plant family as Ragweed so it can cause allergies. It should never be taken internally by pregnant women.

Tarragon
(Artemisia dracunculus sativa)
The first thing to know about Tarragon is that there are two of them and if you plan to use this herb in the kitchen it is important to buy the right one. The right one is French Tarragon (*Artemisia dracunculus sativa*) and the wrong one is Russian Tarragon (*Artemisia dracunculus inodora*). These two herbs have quite different flavours and the Russian version is considered to be much inferior for culinary use. Buying the right one is not always easy since some nurseries sell all their

Tarragon simply as 'Tarragon' and don't make the distinction. As you can tell from the botanical names, these two plants are very closely related and although Russian Tarragon typically has somewhat paler leaves, I would have great difficulty telling the two plants apart in a nursery on looks alone. The only way I know to identify French Tarragon is to rub a leaf and then smell my fingers. French Tarragon is stronger in aroma and has a very unique slightly anise fragrance that Russian Tarragon lacks. As with Oregano, if you come across a plant with little or no fragrance don't buy it for culinary use.

Tarragon is a perennial herb with narrow shiny leaves, growing to about 3 feet (.9m). It can be grown in a container if the pot is big enough as this is a plant with a large root system. The second thing to know about Tarragon is that the proper kind cannot be grown from seed. True French Tarragon rarely, if ever, sets viable seed and is always grown from root divisions or cuttings. If you find Tarragon seed you can be sure that it is Russian Tarragon you are buying.

The third thing to know about Tarragon is that although this herb is perennial and theoretically winter-hardy in our climate, almost everyone I know, including me, has lost plants during the winter. Over the years I have come to the conclusion that the problem with Tarragon rarely has to do with cold weather alone. What this herb cannot stand is a combination of cold and wet feet. With many of the Mediterranean herbs good drainage is important and with Tarragon it is vital. This herb can stand up to quite a severe winter as long as it has excellent drainage. I have even grown it in containers that I sunk into the ground up to the rim for the winter and it came through just fine. I am absolutely convinced that good drainage is the key.

Growing and Harvesting Tarragon

Tarragon likes full sun and is one of the Mediterranean group of herbs (see Page 36). As mentioned, good drainage is critical and I mix extra sand into my soil mix for this herb. Tarragon is easy to propagate by division, so divide your clump every few years. If your plant isn't big enough to divide, take a few tip cuttings in the spring. I sometimes stake my Tarragon as it grows tall and has a tendency to be floppy. Fresh Tarragon leaves can be picked as needed. Stalks can be cut several times during the summer to dry for winter use. This herb also freezes well.

Teaberry ✐

(Gaultheria ovatifolia & G. procumbens)
Shiny leaved Teaberry (*G. procumbens*) and Western Teaberry (*G. ovatifolia*) are two closely related plants, one native to Northeastern North America and the other native to the Pacific Northwest. Both are cousins to a better known Pacific Coast native, Salal (*G. shallon*), although these are true groundcovers in form, only reaching about 6 inches (15cm) in height. The eastern version of this plant (*G. procumbens*) is native from Newfoundland and New England south to Georgia and west to Minnesota and is perhaps better known by its other common name of Wintergreen. The western version is sometimes called Oregon Wintergreen or Slender Wintergreen. There are all sorts of additional common names — Checkerberry, Mountain Tea, Ground Holly, Spring Wintergreen, Chickenberry, Deerberry, Spice Berry, Canada Tea and Partridgeberry among others. Some of the common names indicate that these plants are as useful to wildlife as they are to humans and the edible red berries which ripen in the summer are indeed known to attract many bird species.

The tea for which Teaberry is named is made by an unusual method. The fresh leaves, which are only mildly aromatic, are put in a jar and then covered with boiling water. The jar is sealed and the mixture is allowed to brew for about twenty-four hours until small bubbles appear. The wintergreen flavour develops as the mixture ferments.

Growing and Harvesting Teaberry

The Teaberries like shade and acidic peaty soils with good drainage. They are an excellent woodland groundcover under Cedars and look lovely beneath Rhododendrons. The slugs appear to ignore them entirely. The leaves can be harvested at any time as this plant is evergreen and they are better used fresh than dried.

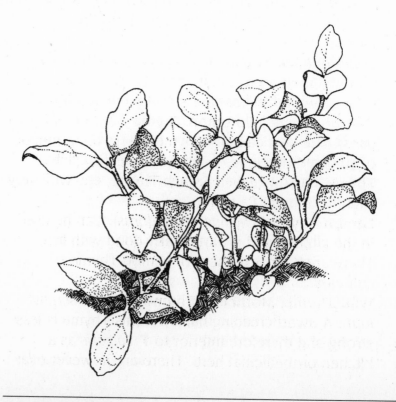

A Word of Caution

The distilled Oil of Wintergreen has been used externally for sprains, and to massage sore muscles and joints but it should never be taken internally because it can be toxic.

Thymes ✋

(Thymus vulgaris, Thymus spp.)
Thyme has been in use since ancient times, but there are a lot of different Thymes. This is a genus with about 350 different species and a large number of varieties and cultivars, many of them aromatic, but only a few used in the kitchen or for medicinal purposes. The one most often used in the kitchen these days is Common or Garden Thyme (*Thymus vulgaris*). A few other Thymes which are often found at local nurseries are:

- **Caraway Thyme** (*Thymus herba-barona*): A low growing plant with a distinct Caraway-Thyme flavour.
- **Doone Valley Thyme:** (*T. × citriodorus* 'Doone Valley') An attractive cultivar of Lemon Thyme with dark green leaves that are splashed with gold.
- **Garden Thyme, Common Thyme** (*Thymus vulgaris*): The best culinary Thyme. There are a number of cultivated varieties — broad-leaved English Thyme, narrow-leaved French Thyme, etc. with very slightly different flavours.
- **Lemon Thyme** (*Thymus × citriodorus*): Can be used in the kitchen and is particularly good with fish. There are a large number of Lemon Thyme cultivars.
- **Wild Thyme, Mother-of-Thyme** (*Thymus serphyllum*): A dwarf creeping habit but this Thyme is less strong and therefore inferior to *T. vulgaris* as a kitchen or medicinal herb. There are however over

40 cultivars and many are exceptionally attractive garden perennials, particularly when they are in flower. Three of the best known cultivars are 'Coccineus' (dark red flowers), 'Annie Hall' (pale pink flowers) and 'Snowdrift' (white flowers).

- **Wooly Thyme** (*Thymus pseudolanuginosus*): Not used as a culinary or medicinal herb, but an excellent low mat-forming grey-green ground cover. Lovely between paving stones or creeping over low rocks and very hardy.

In general the Thymes used for culinary purposes grow larger and shrubbier than those used as ground cover ornamentals. In our climate all the varieties and cultivars that I have tried so far appear to be entirely hardy so long as they are given excellent drainage. These are tidy, non aggressive sweet smelling plants, excellent in containers and beloved of bees.

Growing and Harvesting Thyme

Thyme likes full sun and all the Thymes belong to the Mediterranean group of herbs (see Page 36). *Thymus vulgaris* can be grown from seed but the cultivars must be propagated by division, cuttings or layering to remain true to type. The easiest way to propagate the groundcover Thymes is by root division of the mature plants. Thyme can be used fresh throughout the season and for drying should be cut while the plant is flowering. Thyme leaves can also be frozen.

Valerian & Red Valerian

(Valeriana officinalis & Centranthus ruber)
What Valerian and Red Valerian have in common is that they are both attractive plants for your garden although they differ entirely in looks as in nearly ever other aspect of their personalities. Red Valerian (*Centranthus ruber*) is a hardy clump-forming garden

perennial growing to about 3 feet (.9m) with light blue-green foliage and dark pink flowers. It is attractive and long blooming and other than a tendency to self-seed, it is one of my favorites. Some books refer to it as 'Red Valerian' and others just as 'Valerian', confusing common names when this plant isn't a Valerian and has none of the herbal uses of true Valerian.

True Valerian (*Valeriana officinalis*) is also a completely hardy clump forming perennial but with bright green toothy leaves that become feathery towards the top of the plant. When it is in flower it can easily reach 6 feet (1.8m) with the airy clusters of pale pink or white flowers sending off a glorious fragrance on every

Red Valerian

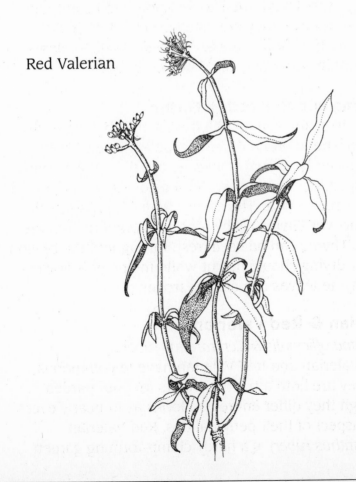

summer breeze. Since it starts to bloom in June, it is absolutely stunning when planted with June-blooming old garden roses.

The scent of Valerian root is attractive to both cats and rats. My cats ignore the Valerian until I am digging around it or bringing up a root. Then they definitely notice that something important is going on, even if they don't get quite so wild as they do with Catnip (*Nepeta cataria*). The root is so enticing to mice and rats that it has been used as a rodent bait and it is said that this is what the Pied Piper had in his pockets when he successfully lured the rats away from Hamelin.

Growing and Harvesting Valerian and Red Valerian

Red Valerian (*C. ruber*) likes full sun but will accept less and is happiest in a rich, well-drained soil. It is easily propagated by root division or seed. It is not harvested.

True Valerian (*V. officinalis*) will grow in sun or a fair amount of shade. It prefers a rich, moist soil with adequate drainage. It can be grown easily from seed or root divisions. The root is harvested in the fall of the second year and, unfortunately since they are so pretty and fragrant, if you want the plant for the root, it is better to cut the flower heads off so that the plant is putting all its energies into the rhizomes. The root is dried and then chopped or powdered for use.

Vanilla Leaf 𝒳

(*Achlys triphylla*)
Vanilla Leaf is a lovely little deciduous woodland groundcover, native to the Pacific Northwest from southern British Columbia to California. An underground rhizome sends up leaf stalks topped with three bright green fan-shaped leaves. That accounts for the

triphylla (tri—three, phylla—leaves) and the Achlys, meaning 'mist' is a reference to the spikes of little white flowers that are sent up on a separate stalk in the spring and have a rather misty appearance. As a groundcover in a shady wooded area or wandering under rhododendrons, this plant is a treasure.

Vanilla Leaf is also called Deer Foot, I assume in reference to the shape of the leaves, as well as Sweet-After-Death, a comment on the curious fact that the fresh plant has no scent to speak of, but once dried a lovely vanilla-like fragrance develops due to the presence of coumarin, the same chemical that is present in Sweet Woodruff.

Growing and Harvesting Vanilla Leaf

Vanilla Leaf grows naturally on the forest floor. It likes shade and a moist soil, preferably one with lots of

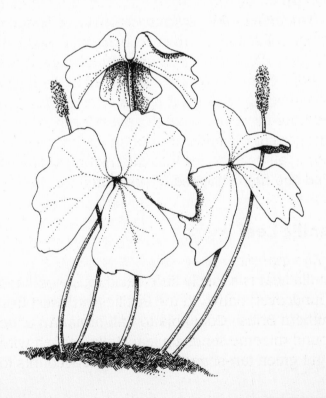

decayed leaf litter in it. It can be propagated from seed or from the rhizomes. The leaves can be picked at any time they are available.

A Word of Caution

As mentioned, Vanilla Leaf contains coumarin a chemical constituent about which there is some debate currently. It should not be taken by pregnant women or anyone taking anticoagulant medication.

Violets ॐ

(Viola spp.)

Perennial Violets are always a delightfully fragrant surprise when you see them peeping up from a shady nook or self-seeding in the lawn. There are a number of Viola species, but the one most often found in herb books is the European Sweet Violet, *Viola odorata*. Our own Pacific Northwest is not without its host of lovely home grown *Violas* however. Early Blue Violet (*V. adunca*), Canada Violet (*V. canadensis*) and Yellow Wood Violet (*V. glabella*) are all Northwest natives. Violas, depending on the species, grow in every condition from sunny gravel slopes to shady moist woodlands. All are edible and all appear to share a similar history of medicinal uses.

Growing and Harvesting Violets

Sweet Violets (*V. odorata*) do best in dappled shade and a rich, moist soil. The plants are spread by runners but are not particularly invasive. Early Blue Violet (*V. adunca*) prefers a drier site and does well in open woodland settings. Canada Violet (*V. canadensis*) grows naturally in wet meadows and Yellow Wood Violet (*V. glabella*) prefers a woodland setting and a moist soil. Yellow Wood Violet can be somewhat invasive so use it with care. It would be a natural addition to a wooded

and semi-wild corner of the garden. Violets grow easily from runners and divisions. Some varieties are fairly easy from seed and some appear to be more difficult. Slugs like violets so the patch should be watched for their depredations. For harvesting, the leaves and flowers can be gathered in the spring and used fresh or carefully dried.

Wormwood

(Artemisia absinthium)

Wormwood is yet another of the *Artemisia* genus to which Southernwood, Mugwort and Tarragon also belong. I first heard of it when I was taking art history classes since it was the substances extracted from the root of Wormwood that were used to make Absinthe, the dangerous and addictive French liqueur that destroyed the careers of a number of artists, most famously that of Toulouse Lautrec. Making Absinthe became illegal in 1915 but I still notice from time to time that herb chat groups on the internet get requests for the recipe.

These days Wormwood's importance in a herb garden has to do almost entirely with its uses as a landscape plant. It will grow in full sun and dry soils and its decorative lacy silver-grey foliage is stunning in combination with plants with dark green foliage or purple foliage, 'Purpurea' Sage for example. Common Wormwood typically grows to a height of about 3 or 4 feet (.9m or 1.2m) and, like Southernwood, always looks best if it is clipped and shaped. Unlike Southern-wood, Wormwood is evergreen and can therefore be used in situations where Southernwood's ratty winter-time appearance would be a problem. Two Wormwood cultivars have been growing in popularity in recent years. These are 'Lambrook Silver', growing only to 1 and 1/2 feet (.4m), and 'Lambrook Giant, growing to

about 2 and 1/2 feet (.7m). These smaller Wormwoods can make excellent container plants.

Growing and Harvesting Wormwood

Wormwood likes full sun although it can take a small amount of shade and is a member of the Mediterranean group (see Page 36) of herbs. This herb can be grown from seed or propagated from root divisions or cuttings. Wormwood leaves should only be harvested if they are wanted for their insect repelling qualities and for this purpose they can be taken at any time during the summer.

A Word of Caution

Never use Wormwood internally. It is both powerful and dangerous and can cause lasting damage to the central nervous system.

Yarrow ⨯

(Achillia millefolium)

Many a gardener has discovered and appreciated the cultivars of common Yarrow as outstanding garden plants without ever knowing a thing about this herb's fascinating history. The Yarrows are sturdy, drought tolerant plants with an exceptionally long bloom period in mid to late summer. With their fernlike foliage and flat-topped flower clusters they are winners as mid-sized perennials in the garden and are also very long lasting as cut flowers. Unfortunately Yarrow has a root system that can be somewhat aggressive so it is best to watch the outside edges of the clump. Although we usually think of Yarrow flowers as being white, in fact there is a natural range in colour and this variability is well represented in the cultivars and hybrids now available which come in an astonishing variety of shades and combinations. Old-fashioned white Yarrow typically

grows to a height of about 3 feet (.9m), but there are some differences in height amongst the cultivars and hybrids as well as differences in the degree of aggressiveness of the root system. This is a plant where new versions seem to show up on a yearly basis, but some of the best known at the moment are:

- **Burgundy:** Grows to about 3 and 1/2 feet (1m), flowers are dark wine red.
- **Cerise Queen:** Grows to about 3 feet (.9m), flowers are bright pink.
- **Fawcett Beauty:** Grows to about 2 and 1/2 feet (.7m), flowers are dark lavender.
- **Fire King:** Grows to about 3 feet (.9m), flowers are red.
- **Hoffnung:** (*A. millefolium* × *A.* 'Taygetea') Grows to about 2 and 1/2 feet (.7m), flowers are bright yellow.
- **Lavender Deb:** Grows to about 2 and 1/2 feet (.7m), flowers are pastel lavender.
- **Moonshine:** Grows to about 2 feet (.6m), flowers are yellow, foliage is silvery.
- **Paprika:** (Galaxy Hybrid) Grows to about 2 feet (.6m), flowers are bright red with yellow centers.
- **Red Yarrow** (*A. millefolium* 'rubra'): Grows 1 to 2 feet (.3m to .6m), bright red flowers, roots not as aggressive as White Yarrow.
- **Rosea:** Grows to about 3 feet (.9m), flowers are pink.
- **Terracotta:** Grows to about 2 feet (.6m) flowers are orange.

Growing and Harvesting Yarrow
Yarrow likes full sun but will accept some shade and prefers a sandy, well-drained soil. Once the clumps are established they are very drought tolerant. Yarrow can be propagated by seed and by division of the roots in

spring or autumn. The clumps should be divided every few years when they become too crowded. When the flowers have died, cut the plants back and put the cuttings on the compost heap where they will act as an excellent compost activator. Yarrow leaves and flowers can be dried whenever they are available. Some strong decoctions use Yarrow root and this should be taken from plants that are two or more years old in the autumn.

A Word of Caution:
Care should be taken with Yarrow because prolonged use can cause allergic reactions that can cause the skin to become more sensitive to sunlight. It should never be taken by pregnant women.

Yerba Buena ᢙ

(Satureja douglasii)
Yerba Buena is a Pacific Northwest native, a tea herb with a lengthy history of use by First Nations people and early settlers alike. It was the Spanish priests who came to what is now California who gave this plant its common name of Yerba Buena or 'Good Herb'.

Yerba Buena is a creeping short-stemmed herbaceous perennial with small round leaves and a pleasing scent when the leaves are rubbed. Most references that I have found refer to that scent as "minty" although I think that it is closer to the Thymes. It can be used as a small groundcover and also looks very attractive spilling over walls or in pots and it is naturally found growing in open forested areas alongside Garry Oaks and Arbutus trees. Yerba Buena grows on southern Vancouver Island, the Gulf Islands and the Lower Mainland and from there south to Los Angeles.

Growing and Harvesting Yerba Buena

Yerba Buena is happiest in dappled shade in an open woodland situation with good drainage. It is reliably drought tolerant and is used in the City of Vancouver's Waterwise Garden so it could be a good groundcover choice for rather dry areas under trees where many plants have difficulty growing. The leaves can be picked at any time to be used fresh or dried.

Acknowledgments

For me, learning about herbs has always been part of the larger process of learning about gardening and in that endeavor I have been encouraged and guided by some wonderful people.

My mother, Joyce Carpenter, my uncle, Tom Brawn and my aunt, Phyllis Thomson—enthusiastic gardeners all, they gave me an early start for which I will always be grateful.

The volunteer Master Gardener Program at VanDusen Botanical Garden was instrumental to my gardening education and the Master Gardeners I met there were always generous in sharing their knowledge and experience—Colleen Adam, Odessa Bromley, Ann Buffam, Therese D'Monte, Reta Gray, Marg Meikle, Mike Nassichuk, June Pierson, Terry Villeneuve—and so many more.

Dorothy Horton of Gardens West Magazine who encouraged my first efforts at writing about herbs and whose ongoing support and interest is so much appreciated.

My garden buddies and mentors, Christine Allen and Joanne Baskerville whose expertise, keen eyes and abundance of wit and wisdom are such an ongoing delight—and thanks for all the plants, too!

The folks at Steller Press, Guy Chadsey, Colin Fuller, and Sandra Hargreaves who made it happen and kept me on track.

My husband Barry who encouraged me every step of the way, lifted more rocks and built more raised beds than any human should have to, and kept his sense of humour through it all.

Appendix

Finding Your Herbs

Nearly every nursery carries a selection of the most common and popular herbs and in the last few years the selection that is easily available has improved enormously. Be sure to check the selection of seed packets as well as the plants. If you are looking for something a little more unusual your first stop should be the specialty herb nurseries in your local area. Some plants are not well known or easily available and for these you may discover that finding seed and growing your own is the only way to acquire them. Joining a herb society will put you in touch with other enthusiasts who may have plants to exchange and many of these groups have annual sales of plants which are always well worth attending if you are in plant hunting mode. Washington, Oregon and British Columbia all have active Master Gardener groups and they are a terrific source of all kinds of gardening information including the whereabouts of specialty nurseries, growing tips for specific plants and so on. The internet is becoming increasingly useful when it comes to searching for difficult-to-find plants. See the section below on 'Herbs on the Internet'.

Finding Native Plants

Some native plants do not grow well "in captivity". Some do not transplant easily. Others, very sadly, are becoming endangered in their natural habitats. In some instances finding a plant in the wild can be dangerous because there are poisonous look-alikes—Angelica is a case in point. Simply because a plant is native does not mean that foraging in your local woods is either practical, sensible or ethical. If gardeners do not have a respect for the environment, who will?

I am delighted to be able to say that within the last year many more nurseries have taken note of the growing interest in native plants on the part of the public and this trend is continuing. When you buy your plants or seeds from a neighborhood nursery you are encouraging them to propagate even more and you are helping a local business. If your favorite nursery doesn't carry native plants, just ask them about it. If there is a demand for these plants they will respond to it. All the native plants that I grow were either growing naturally at the bottom of my garden, were acquired through nurseries or were given to me by gardening friends. If you have an internet connection, doing a web search on "native+plants", followed by your area to narrow the search, will produce a list of commercial sources and non-profit associations to help you get started.

Herbs on the Internet

If you have an internet connection you will soon find that there is an enormous amount of information (and misinformation!) on the web when it comes to herbs. There are chat groups, on-line herbals and all sorts of folk pushing this or that medicinal herb, often with extravagant claims. There is no lack of snake-oil sales-men on the cyberspace frontier. At the same time there are a lot of gardeners and herbal enthusiasts who are sharing useful information and when you are searching for a specific plant or seed the internet can be very helpful. If you have tried using one of the internet search engines you will have discovered that one of the big problems is not in finding information, but in sorting the vast array of data that you find. It can be overwhelming. One trick I have learned is that when you are searching for a specific plant it always cuts down the extraneous junk if you search by using the

full botanical name rather than the common name. Another trick for narrowing a search is to use a plus (+) sign between words. If you are looking for seeds, try typing 'herb + seed' into a search engine like Alta Vista. If you are just discovering the internet and need a place to start, here are a few herb related sites that you may find interesting:

Non Commercial Sites

ᥬ **Algy's Herb Site:** This web site was started by a herb enthusiast and is dedicated to an ongoing discussion of herbs and their uses with useful links to other sites. The address is:

> http://www.algy.com/herb/index.html

ᥬ **A Modern Herbal:** This is the online version of Mrs. M. Grieve's herbal, originally published in 1931. The address is:

> http://www.botanical.com/botanical/mgmh/ mgmh.html

ᥬ **Directory of Herbs:** Informational FAQ (Frequently Asked Questions) Sheets about herbs from the Department of Horticulture at Pennsylvania State University. The address is:

> http://hortweb.cas.psu.edu/vegcrops/ herbs.html

ᥬ **Herb & Botanical Alliance:** The HBA is a nonprofit organization dedicated to promoting awareness, education and an understanding of plants in their natural habitats. Their address is:

> http://www.expresspages.com/h/ herbbotanical/

Commercial Sites

A number of commercial sites are well worth checking not only as a source for hard-to-find seeds or plants but also because they are often good sources of

general herb information. A few of these sites are listed below.

A. Canadian Sites

- **Richters Herbs:** Richters is the largest source for herb plants and seeds in Canada and was one of the first companies to put their entire catalogue on line. It is loaded with specific information on the herbs they offer. The address is:

 http://www.richters.com

- **West Coast Seeds:** This company specializes in seed for the Pacific Northwest. They have a good selection of herb seeds and the catalogue is very informative about the specifics of growing plants in our climate. The address is:

 http://www.territorialcanada.com/
 index3.cfm

B. American Sites

- **Frontier Co-Operative Herbs:** A commercial enterprise with much helpful background information on specific herbs. The address is:

 http://www.frontierherb.com

- **Garden Guides:** From Garden.com, click on to their 'Herb Guide', for a searchable database of herb information. The address is:

 http://www.gardenguides.com/

- **Horizon Herb Seed Farm:** This commercial site in Oregon has specific information for growing many herbs from seed and is also a good source for seed for unusual herbs. The address is:

 http://www.budget.net/~herbseed/

Herb Gardens to Visit

Botanical gardens often include both herb gardens and native plant gardens amongst their attractions and are well worth a visit. In the Pacific Northwest a few of the best are:

- **VanDusen Botanical Garden:** In Vancouver, British Columbia. Has a formal herb garden and a Northwest native plant area. For more information call their general information line at (604) 878-9274. Internet address:

 http://www.hedgerows.com/VanDusen/index.htm

- **UBC Botanical Gardens:** On the University of British Columbia campus, Vancouver, B.C. Has a fine 'Physick Garden' (as of this writing it is under renovation so check before visiting) as well as a B.C. Native Garden. Take a virtual tour at:

 http://www.hedgerows.com/UBCBotGdn/index.htm

- **Horticulture Centre of the Pacific:** In Victoria, B.C. Has a herb and drought-tolerant plant garden featuring culinary, medicinal and special use herbs. Their internet address is:

 http://www.islandnet.com/~hcp/lily.htm

- **Royal British Columbia Museum:** In Victoria, B.C. Has a native plant garden on the grounds surrounding the Museum. For more information:

 http://rbcm1.rbcm.gov.bc.ca/

- **University of Washington Medicinal Herb Garden:** On the University of Washington campus in Seattle, Washington. Take a virtual tour at:

 http://www.nnlm.nlm.nih.gov/pnr/uwmhg/

- **Lakewold Gardens: In Lakewood, Washington (near Tacoma).** Features an Elizabethan knot garden—also check the boxwood parterres and topiary. Go for a virtual tour at:

 http://www.lakewold.org/gardens.html
- **Leach Botanical Garden:** In Portland, Oregon. Specializing in Northwest native plants. For more information:

 http://www.parks.ci.portland.or.us/services/publicgardens.htm

Plant Societies

Joining a Herb Society or a Native Plant group your community is one of the best ways to continue learning about herbs and will put you in touch with people with similar interests.

- **Canadian Herb Society:**
 www.herbsociety.ca/intro.html
- **Herb Society of America:**
 http://www.herbsociety.org/
- **Washington Native Plant Society:**
 http://www.wnps.org/
- **Native Plant Society of Oregon:**
 http://www.npsoregon.org/

Glossary of Terms

Acid soil: Soil with a pH lower than 7.0. The more acid the soil, the lower the pH number will be.

Alkaline (or Limy) soil: The opposite of an acid soil with a pH higher than 7.0

Biennial: Plants that grow for two years, flowering and dying in the second year. It is possible to make some biennials last longer by cutting the flower heads and quite a few are excellent self-seeders.

Cold Stratification: Some seeds to break dormancy must go through a cold period. The seed is placed in a cold and moist environment for a period which may range from only a few days to several months.

Cultivar: A distinct plant variety brought about through cultivation, by selection or hybridization. (See Variety) Cultivars are usually denoted by single quotation marks, for example: *Thymus × citriodorus* 'Doone Valley'.

Deciduous: A plant that looses all its leaves at a particular time of year, usually autumn. The opposite of evergreen.

Groundcover: a low growing plant that covers the soil, can be deciduous or evergreen.

Genus: a group of related Species. A group of Genera (plural) make up a Family.

Hardening off: Acclimatizing a plant to a lower temperature by slow stages.

Herbaceous perennial: A perennial plant that dies back to the ground in autumn and grows from the roots in spring.

Hybrid: The product of two different parents, usually two separate species. This is usually denoted with an ×, for example *Nepeta* × *faassenii*.

Mulch: A material that is spread around the base of plants (but shouldn't touch the stem). The main purposes of a mulch are to conserve water, cut down on weeds and enrich the soil. Both organic materials like compost, leaf mould, manure and bark mulch and inorganic materials like landscape cloth and plastic are used.

Native: A plant which occurs naturally in a specific area and has not been introduced from another location.

Naturalized: Plants that have become completely established in an area that is different from their original location.

Pinching Out: Using the thumb and finger to pinch off the growing tip of a plant to encourage it to branch and grow bushier; also used in the case of Basil to take off flowers.

Rhizome: An underground stem that is usually perennial.

Runner: Some plants—strawberries for example— send out prostrate shoots which form roots at intervals and from this point a new plant can form. These shoots are called runners.

Self-Seed, Self-Seeders: Plants which set seed and, without human intervention, that seed is capable of germinating and growing in your garden in future years. This can be a good or an irritating trait depending on the plant. Some plants do it to the extent that they become weeds.

Species: (Spp.) Includes like individuals that can breed with each other.

Suckers: A shoot growing from the roots or under-ground stem of a plant coming up at some distance from the main stem.

Top-dressing: Adding organic materials like compost or manure to the soil around a plant without digging the materials into the soil.

Umbelliferous: Having umbels; a flower head composed of several branches that radiate from the same point. Examples are Parsley, Fennel, Sweet Cicely.

Variety: A group within a species that has small differences from the rest of the members of that species. These differences arise in the wild. If differences arise through cultivation, the plant is a Cultivar.

Selected Bibliography

Dobelis, Inge N. (Editor), 1986, *Magic and Medicine of Plants,* Readers Digest Association Inc., New York.

Phillips, Roger & Foy, Nicky, 1990, *The Random House Book of Herbs,* Random House, New York.

Riotte, Louise, 1975, *Carrots Love Tomatoes: Secrets of Companion Planting for Successful Gardening,* Garden Way Publishing, Vermont.

Stevens, Elaine, Hungerford, Dagmar, Fancourt-Smith, Doris, Mitchell, Jane, Buffam, Ann, 1991, *The Twelve Month Gardener: A West Coast Guide,* Whitecap Books, Vancouver.

Stuart, Malcolm, 1989, *The Encyclopedia of Herbs and Herbalism,* Crescent Books, New York.

Index of Botanical Names

Chrysanthemum balsamita, see Costmary
Chrysanthemum parthenium, see Feverfew
Coriandrum sativum, see Coriander & Cilantro
Cornus canadensis, see Bunchberry
Cymbopogon citratus, see Lemon Grass

Dianthus spp., see Pinks & Carnations

Echinacea spp., see Echinacea

Filipendula ulmaria, see Meadowsweet
Foeniculum vulgare, see Fennel

Galium odoratum, see Sweet Woodruff
Gaultheria ovatifolia, see Teaberry, Western
Gaultheria procumbens, see Teaberry
Gaultheria shallon, see Salal

Helichrysum angustifolium, see Curry Plant
Humulus lupulus, see Hops
Hyssopus officinalis, see Hyssop

Inula helenium, see Elecampane
Iris spp., see Orris Root

Laurus nobilis, see Bay
Lavandula spp., see Lavender
Ledum spp., see Labrador Tea
Levisticum officinale, see Lovage

Mahonia spp., see Oregon Grape
Marrubium vulgare, see Horehound
Matricaria chamomilla, see Chamomile, German
Melissa officinalis, see Lemon Balm
Mentha pulegium, see Pennyroyal
Mentha spp., see Mints

Monarda didyma, see Bergamot
Myrica gale, see Sweet Gale
Myrrhis odorata, see Sweet Cicely

Nepeta cataria, Nepeta spp., see Catnip & Catmints

Ocimum basilicum, Ocimum spp., see Basil
Oenothera biennis, see Evening Primrose
Origanum hortensis, see Marjoram
Origanum majorana, see Marjoram
Origanum vulgare, see Oregano

Pachistima myrsinites, see Box, Oregon
Pelargonium spp., see Geraniums, Scented
Petroselinum crispum, see Parsley
Pimpinella anisum, see Anise
Polygonum bistora, see Bistort
Poterium sanguisorba, see Salad Burnett

Rosmarinus officinalis, see Rosemary
Rumex acetosa, see Sorrel
Rumex scutatus, see Sorrel
Ruta graveolens, see Rue

Salvia officinalis, see Sage
Salvia sclaria, see Clary Sage
Sanguisorba officinalis, see Salad Burnet
Santolina chamaecyparissus, see Lavender Cotton
Saponaria officinalis, see Soapwort
Satureja douglasii, see Yerba Buena
Satureja montana, see Savory, Winter
Satureja hortenis, see Savory, Summer
Stachys officinalis, see Betony
Symphytum officinale, see Comfrey

Tanacetum parthenium, see Feverfew

Tanacetum vulgare, see Tansy
Teucrium chamaedrys, see Germander
Tropaeolum majus, see Nasturtium
Thymus spp., see Thymes

Valeriana officinalis, see Valerian
Viola spp., see Violets

Zingiber officinale, see Ginger

Index

Marigold, Pot (see Calendula)

Marjoram 8, 9, 26, 34, 38, 44, 53, 57, 74, 78, 80, 82, 83, 153

Marsh Tea (see Labrador Tea)

Marshmallow 31, 57, 66, 154

Masterwort (see Angelica)

Meadowsweet 34, 57, 60, 78, 80, 156

Meadsweet (see Meadowsweet)

Meadwort (see Meadowsweet)

Mealberry (see Kinnikinnick)

Meeting Seed (see Dill)

Meeting Seed (see Fennel)

Milfoil (see Yarrow)

Mint, Mountain (see Bergamot)

Mints 8, 9, 17, 21, 26, 31, 44, 60, 71, 74, 80, 81, 84, 156

Monarda (see Bergamot)

Moth Herb (see Labrador Tea)

Mountain Lover (see Box)

Mountain Tea (see Teaberry)

Mountain Tobacco (see Kinnikinnick)

Mugwort 34, 57, 60, 79–81, 160

Muskeg Tea (see Labrador Tea)

Myrtle, Bog (see Sweet Gale)

Myrtle, Wax (see Sweet Gale)

Nasturtium 8, 16, 22, 26, 31, 34, 38, 57, 161

Night Willow Herb (see Evening Primrose)

Nine Hooks (see Lady's Mantle)

Nosebleed (see Yarrow)

Old Man (see Southern-wood)

Oregano 8, 26, 31, 34, 38, 57, 60, 71, 83, 162

Oregon Grape 16, 34, 38, 57, 66, 164

Orris Root 16, 34, 38, 57, 60, 78, 165

Oswego Tea (see Bergamot)

Parsley 8, 9, 26, 31, 34, 45, 57, 74, 82, 83, 166

Parsley, Beaked (see Chervil)

Parsley, Chinese (see Coriander)

Parsley, Curled (see Parsley)

Parsley, Flat (see Parsley)

Parsley, French (see Chervil)

Parsley, Hamburg (see Parsley)

Parsley, Italian (see Parsley)

Parsley, Love (see Lovage)

Parsley, Mexican (see Coriander)

Parsley, Plain-leafed (see Parsley)

Parsley, Sea (see Lovage)